# A Year in the Life
# of a "Working" Writer

# Also by Ernie Witham

**Books**
*Ernie's World the Book*

**Anthologies**
*A Community of Voices – Fishing for Words*
*A Community of Voices – Winging It*
*A Community of Voices – Horsing Around*
*A Community of Voices – Hot Dog!*
*A Community of Voices – When We Were Young, Childhood*
*A Community of Voices – When We Were Young, Adulthood*
*Chicken Soup for the Golfer's Soul*
*Chicken Soup for the Sports Fan's Soul*
*Chicken Soup for the Father's Soul*
*Chicken Soup for the Soul Christmas Treasury*
*Chicken Soup for the Baseball Fan's Soul*
*Chicken Soup for the Golfer's Soul II*
*Chicken Soup for the Romantic Soul*
*Chicken Soup for the Beach Lover's Soul*
*Chicken Soup for the Soul Christmas Collection*
*Chicken Soup for the Soul in the Classroom*
*Chicken Soup for the Soul: 101 Best Stories: The Wisdom of Dads*
*Chicken Soup for the Soul: 101 Best Stories: Tales of Golf and Sport*
*Chicken Soup for the Soul: 101 Best Stories: Happily Ever After*
*Chicken Soup for the Soul: 101 Best Stories: On Being a Parent*

# What Readers Are Saying...

*"Ernie Witham's laugh-out-loud columns are conclusive proof that the heart is indeed connected to the funny bone."*
Richard Barre — Shamus Award-Winner, Author of *The Innocents* and *Blackheart Highway*

*"Funny, whimsical, satirical: Ernie Witham is a very entertaining writer. Read him if you can. If not, get someone to read him to you."*
Ian Bernard — Producer, Writer, Composer, LAUGH-IN

*"The funny bone's strong and irresistibly delightful in Ernie Witham's delicious book. With Ernie you get the real thing, cock-eyed, hilarious, and true."*
Gayle Lynds — Author of *The Last Spymaster*, *Mesmerized*, *Mosaic*, *The Coil*, and *The Paris Option* and *The Hades Factor* with Robert Ludlum

*Ernie Witham is an Everyman with a wonderfully quirky sense of humor. He takes us in many unexpected directions, often shopping, but no matter where, it's a place that is safe for kids and grandmothers. And it's always funny."*
Grace Rachow — Columnist, Editor, Publisher of the *Community of Voices* Anthologies

*"Dear Ernie, I brought your book on my Disney cruise and loved it.* Ernie's World traveled from San Francisco to Boston to Key West, Grand Cayman, Cozumel, Mexico and back home. Anyway, I just wanted to tell you that I now aspire to be a female Ernie!"
Michelle Bermas — Writer, Boston, Massachusetts

*"I am LOVING your book. Besides its charm, it's also a wonderful primer for writing humor. I assume you use it that way in your workshops and talks. If not, you should."*
Phyllis Gebauer — Writer, Teacher, Workshop Leader, Lecturer, Author of *Pagan Blessing* and *Hot Widow*

*"Ernie, that Vicodin story has to be one of the best humor columns you've written. Maybe it's because it's about your natural state — I believe it's a joy to be intoxicated on life. Thanks for making me laugh."*
Loretta Hudson — Editor, Paso Robles, California

# A Year in the Life of a "Working" Writer

## A Memoir to the Best of the Recollection of Ernie Witham

Fithian Press, McKinleyville, California 2009

Individual stories in this book previously appeared in the *Montecito Journal*, *Chicken Soup Magazine*, and *Chicken Soup for the Soul* anthologies. They are used here with permission from these previous publications.

*A Year in the Life of a "Working" Writer. A Memoir to the Best of the Recollection of Ernie Witham*
© 2009 Ernie Witham

Printed in the United States of America.

Published by Fithian Press
A division of Daniel and Daniel, Publishers, Inc.
Post Office Box 2790
McKinleyville, California 95519
www.danielpublishing.com

Library of Congress Cataloging-in-Publication Data

Witham, Ernie, 1950-
  A year in the life of a "working" writer : a memoir to the best of the recollection of-- / by Ernie Witham.
     p. cm.
  ISBN-13: 978-1-56474-487-6 (pbk. : alk. paper)
  ISBN-10: 1-56474-487-6 (pbk. : alk. paper)
   1. Witham, Ernie, 1950- 2. Journalists--United States--Biography. 3. Humorists--United States--Biography. 4. Syndicates (Journalism) I. Title.
  PN4874.W683A3 2009
  818'.6 B--dc22
                              2009007983

This book is dedicated to
my wife and best friend, Patricia Sheppard.
Without her there would be no Ernie's World.

# Acknowledgements

There are so many people to thank for making this book possible. First of all, thank you to all the people who read my columns and magazine pieces, the friends, family and fellow writers who bought and continue to buy copies of my first book and thank you in advance for buying (multiple?) copies of this book. And thank you to those folks out there in cyberspace who now listen to my podcasts. I never, ever tire of someone telling me they enjoyed something I wrote (hint, hint) and I'm always flattered.

They say it takes a village to raise a child. It also takes a community to grow a writer. So thank you to my writing community, including my good friend Marcia Meier, Director of the Santa Barbara Writers Conference (SBWC), who not only lets me lead the humor workshop, but also lets me emcee at the conference. I also want to thank the Founders of the SBWC, Barnaby and Mary Conrad, who have befriended me and so many other writers over the 36+ years they have been involved with the conference. I want to thank Cork Millner, who invites me back every year to lead a workshop for Santa Barbara City College. I want to thank my closest circle of writing friends (also known as the Pudding Line), Jim Alexander, Grace Rachow, Susan Chiavelli, Linda Stewart-Oaten, Karl Bradford, Susan Gulbransen, Bradley Miles, Jocelyn Kremer, Bob and Cathy DeLaurentis, Steven Anders, Lucy Llewellyn Byard, Fran Davis, Toni Lorien and Julia Dawson.

I want to thank everyone who has ever published me, especially Jim & Tim Buckley of the *Montecito Journal* and Jack Canfield, publisher of the *Chicken Soup* anthologies. I want to thank Chuck Kent, president of the Screen Writers Association of Santa Barbara for all his support over the years; Harold Adams, who introduced me to the world of podcasting; and John and Susan Daniel, who published both my books.

I want to thank my family, Pat, Christy, Jon, Patrick, Shane, Stacey, Ashley, Leila and Charlie for being such an important part of my life and "Ernie's World."

Finally, I want to thank everyone who appears in this book for sharing a bit of your life with me and the world.

# Table of Contents

Foreword by Catherine Ryan Hyde                                    13

Introduction                                                      15

Chapter One: Rub, Tub & Grub                                      19
*My wife's a bit stressed simply because I almost killed her boss with a golf ball. So I take her to Sycamore Mineral Springs in Avila Beach, California, where we soak in the same curative water that W.C. Fields once soaked in—sort of.*

Chapter Two: Old Beginnings in Avila Beach, CA                    30
*Next morning we visit Avila Beach and Port San Luis and I outline my goals for the upcoming year, which are similar to my goals for last year, mainly making a lot of money without getting a real job though "real job" does come up.*

Chapter Three: Between A Rock and a Hard Place                    39
*Back in Santa Barbara, we have Leila and Charlie for a sleepover and I find out the true meaning of getting up early. Then we go the Santa Barbara Zoo and ride the little train. Later I go to a rock store with my stepdaughter Christy, but being from the Granite State where rocks are more common than dirt, I refuse to buy one. Fortunately, we find some free rocks on San Marcos Pass.*

Chapter Four: Nothing Says "I Love You" Like Flora...            50
*It's my best friend's birthday and I'm terrible at planning things. Even worse, my best friend is also my wife, Pat. As if that isn't enough, nine days later I have to deal with Valentine's Day and the last-minute "guy rush" at the flower stand.*

Chapter Five: The Glamorous World of Freelancing                 56
*The good thing about freelancing is that you are your own boss; the bad thing is sometimes you have to find work, so I give being a "mystery shopper" a shot, then I get a real gig as a workshop leader at the San Francisco Writers Conference where I make a new friend.*

Chapter Six: The Name Game                                        66
*It's "stop the aging" month. I have my hearing checked at the clinic. Finally, as I lament about my inability to remember names, we end up in Los Olivos for lunch at a gourmet restaurant that serves (yuck!) beet soup and we reminisce about "Cow Sundays" in the Santa Ynez Valley.*

Chapter Seven: In the Eye of the Beholder                        74
*We visit the Los Angeles County Museum of Art, where I discover how weird everyone else is. Then we head off to the Holiday Inn in Burbank for a karaoke family night, which — I think through a carefully executed plot — I never get to participate in.*

Chapter Eight: Finding Educational Humor                          81
*Next stop in the greater Los Angeles area is the Huntington Library in Pasadena, but we are not here for books, we are here for the bonsai show. How did we end up at a bonsai show? Blame it on Pat and* Chicken Soup For the Soul Magazine. *After the show we share a very cozy ride with a decorative shelf from Island View Nursery in Carpinteria.*

**Chapter Nine: Visualizing a Sea Change**    **87**
*Across the channel from Santa Barbara is Anacapa Island, home to seagulls that get more respect than I do. Later, my wife and I have a discussion about retirement after my sister-in-law admits that she now collects fruit peels. Then we go to San Miguel for food and wine – lots of wine.*

**Chapter Ten: Fame is Where You Find It**    **97**
*Four aging golfers talk about their aches and pains on the way to the Alisal River Golf Course in Solvang, California. At the course I share my recent brush with fame—being an extra in the movie "Sideways."*

**Chapter Eleven: The Name Game**    **107**
*After golf, Pat invests more time in my cultural well-being by taking me to the Elverhoy Museum in Solvang. We top that off with a trip to Bridlewood Winery.*

**Chapter Twelve: Secrets of the Universe**    **114**
*Pat reminds me I offered to help her redecorate the house. Yikes! This leads to some valuable introspection about the opposite sex and I come up with a plan to better understand women. This definitely doesn't work out!*

**Chapter Thirteen: Where Columns Come From**    **120**
*While searching for my new column I end up in jail at the Old Santa Ynez Day parade. When my bail is posted I head to Santa Barbara and the Cat Show at Earl Warren Showgrounds. For some reason the cats remind me of seniors and I wonder why they don't have a Santa Barbara Senior Show. Next it's time for the Santa Barbara Writers Conference and I made my workshop participants write my column for me as a "Class Exercise."*

**Chapter Fourteen: Humor is Everywhere – Especially Florida**    **132**
*After a harrowing plane trip we explore Miami, then drive down through the Florida Keys experiencing many wonderful things like Pat's close encounter with a manatee at Pennecamp State Park, a sexual dolphin experience at the Dolphin Research Center, and almost getting caught skinny-dipping at Bahia Honda.*

**Chapter Fifteen: Risking Life and Limb For a Story or Two**    **156**
*We arrive in Key West and ride the death-defying Conch Train, visit Hemingway's House, go to Mallory Square for sunset entertainment like the guy with the trained cats and the guy who escapes from a straight jacket for tips. Then we head for the Everglades where we discover mosquitoes and alligator wrestling. After I almost cause the alligator wrestler to lose his arm we head home.*

**Chapter Sixteen: Birthday Bashes**    **169**
*My granddaughter Leila and I share a birthday. This year it's highlighted by me falling off a rope swing. Then I take Leila to Toyland for her birthday where I introduce her to educational toys such as the dribble glass and hot pepper gum.*

**Chapter Seventeen: I'll Have the Combo Please**    **176**
*I teach Leila and my grandson Charlie about the tactics of water gun fights in the swimming pool. We finish just in time for the giant birthday bouncer/slide combo, which us "adults" make dangerously faster by adding water. Finally I give Leila "her" gift of a set of golf clubs.*

**Chapter Eighteen: Writer's Eating Habits**    **184**
*I have my usual free breakfast at Trader Joe's Market. My wife calls and says she's fed up with work and I need to find a job. I decide to write a novel instead and consult with my writer friends at a local restaurant on the best way to kill charac-*

*ters. We get booted. Finally, I end up at Costco and discover it's the perfect place to retire. They have everything a guy could need!*

## Chapter Nineteen: 'Til Death Do Us Part
*While at the Santa Barbara Farmer's Market I remember that today is my anniversary. Fortunately, I find gifts among the produce. When that doesn't go over as well as I hoped, I take my wife to Santa Fe, New Mexico where we visit every museum known to mankind.*

## Chapter Twenty: From the Mob to a... Job?
*I get back to my novel and to clarify a point I call the FBI to get information about smuggling mob money over the border, only I don't make it quite understood that I'm a writer. Just as I decide maybe I will look for more gainful employment, my friend Grace calls and tells me about a real job. I decide to quickly write a bunch of stuff I can sell instead.*

## Chapter Twenty-One: Sometimes Humor Comes Crashing Down
*We head to the Carpinteria Avocado Festival so I can see how much green stuff I can eat. Later that day, I get to try out my stepson's Harley and when I tell the painful story to my readers I embellish a bit. I discover the note about the job and give them a call. They ask me to come in for an interview! Oh man!*

## Chapter Twenty-Two: From Falling to Fall
*I compare autumn in New Hampshire with leaf peepers and men looking for stout women who come with cords of hardwood, to autumn in Santa Ynez Valley with wine tasting and reflections on a recent incident at a local winery in which I almost spill a zillion gallons of wine. The next day it's off to the Halloween costume store in Santa Barbara to try unsuccessfully to find something that fits. Finally, I come up with another brainstorm to sell books, utilizing my granddaughter Leila, the cutest trick-or-treater around.*

## Chapter Twenty-Three: Our Family Thanksgivings
*I get called in for a second interview! Fortunately, it's almost Thanksgiving. Surely they wouldn't hire me now! I decide to work undercover again, this time to question shoppers on their choice of Butterball versus free-range turkey.*

## Chapter Twenty-Four: The "Fam"
*Then we're on the road to Carmel for yet another "attempt" at the perfect family photo followed by that traditional holiday game "combat Pictionary."*

## Chapter Twenty-Five: Fishing For Humor
*We go to the Monterey Bay Aquarium where I have a flashback experience while watching jelly fish.*

## Chapter Twenty-Six: A Real "Working" Writer
*Believe it or not, the company hires me! Pat's so happy, she insists the family go to Yosemite for a Christmas ski vacation. I remember less-than-successful previous ski trips, like the time I came down in a basket. But it doesn't really matter because it rains. So, we have a high stakes game of Texas Hold 'Em.*

## Chapter Twenty-Seven: What Comes Around Goes Around
*We're back on our way to Sycamore Mineral Springs. There was a slight incident involving Sam, our cat, and a vacuum cleaner. Oh well, at least I have a brand new goal to share with Pat.*

## About the Author: What More Could You Possibly Want to Know?

# Foreword

Ernie Witham is a funny guy.

It's too bad, really. In fact, it kind of ticks me off.

You see (and I tell you this in case you don't know Ernie — if you know him, you've surely figured this out on your own), there's something about Ernie that makes you want to insult him. I haven't figured out quite what it is yet, but the pull is virtually irresistible.

And of course the ultimate insult would be to tell Ernie he's not funny.

Damn it.

Now, to make matters worse, he's written this funny book. Which is particularly funny to me, as it deals with the working lives of people who make dubious livings as writers. And yes, he does speak to the whole oxy — and other — moronic aspects of the working writer concept. And he does all of this in a way that's...well...

Nope. Sorry. I've admitted it as many times as I'm going to.

So, what to say against Ernie at this critical juncture in his career? Not easy, but here goes:

I have no reason to think you will enjoy reading this book. Unless you are a writer. Or married. Or in any type of a relationship. Or have kids. Or other relatives. Or like to laugh.

Take that, Funny Boy.

**Catherine Ryan Hyde**
Author of twelve novels including *Pay It Forward, Chasing Windmills, Love in the Present Tense, Becoming Chloe* and *The Day I Killed James.*

# Introduction

When I was a photographer my wife would never let me drive. She accused me of always staring out the window composing shots. All I had to do was say something like:

"Wow, great lighting this morning huh?"

And she'd say: "Pull over. Now."

"But I'm driving just fine."

"You're looking through the viewfinder."

"Yeah, but only with one eye."

I gave up being a professional photographer because I couldn't seem to make any money at it and instead became a writer (for some reason other writers find this statement funny).

Unfortunately, my wife still won't let me drive. Now she says I'm always composing my next column.

"But I'm driving just fine."

"You have your laptop open."

"Yeah, but I'm only typing with one hand."

Truth is, there is so much going on all around us every day, it's impossible for a writer not to be distracted — especially a humor writer. I can't tell you how hard it is to go anywhere where seriousness is required...

Take church for instance: "Say, this communion wine isn't Merlot is it? 'Cause I'm not drinking any stinking Merlot!"

The symphony: "Do you suppose the triangle player actually follows along with all that music? Or whether he's back there watching 'American Idol' on his iPod until the conductor nods his way?"

Even school: "Do you think people who take all online classes to graduate ever go to class reunions?"

Today my life and my humor writing have become one. I write humor for newspapers, magazines and anthologies. Every moment that I am not writing I am thinking about humor, looking for humor,

observing people, taking notes and photos — basically living in what has become known to my family, friends and readership as Ernie's World.

What I have tried to accomplish with this book is to share a number of humorous situations and observations with you as they happened and became columns, while at the same time sharing the part of my life that comes between the actual writing — the search for the next column; the interaction with my wife, Pat, and my kids, stepkids, grandkids, friends and other people who appear in this book; and the constant drive to make a living with writing, freelance work and the occasional "actual job."

I also hope that in some small way it can be considered a primer for writing humor — especially "location" humor. I did not want to write a book on "how I write humor" and stop constantly to point out techniques. Because, quite honestly, I never know just how or where I'm going to find humor, how I will start a column or how it will end. It just seems to work out (most of the time). So I hope you can learn a few things not by me telling you, but by you being there with me in the stories included in this book.

As you read this book you will no doubt wonder if certain parts are true or exaggerated. Most humor is exaggerated, taking a thought or idea one step further is what makes things funnier. However, everything in this book is based on truth. A lot of it is exactly the way it happened. They say truth is stranger than fiction; well truth can also be way funnier than fiction.

Come on, you are bound to say. Did you really call the FBI and ask them the correct way to snuggle mob money over the Mexican border?

Yup.

Did you really fall over in your driveway on a motorcycle that wasn't even running and pull your hamstring?

Yup.

Did you really share a late-night elevator ride with a six-foot four-inch transvestite?

Yup.

Did your wife really have a close encounter with a manatee in the Florida Keys? And what about those "overly passionate" dolphins, and the skinny-dipping part?

You be the judge.

All writers live in their own little world. No matter how much they seem to be enjoying themselves in any given situation they are always working on a story. This book gives you a glimpse into my little world by presenting a typical year in my life. I can only hope you enjoy it half as much I did.

# Chapter One

## RUB, TUB & GRUB

In January, my wife contracted a severe case of stress and tension and there was a slight chance that I might have been the carrier. See, there was this incident just before Christmas...

"...Come quickly," I yelled. "I've found something unbelievable."

Pat sprinted into my office. "You found a job?" she asked excitedly. "With pay?"

"Ahh... no."

"An agent who wants your book?"

"Ahh... no."

"A producer who wants your screenplay?"

"Ahh... no."

The excitement in her voice waned. "Somebody on eBay who wants to buy your 'five decades of mismatched socks' collection?"

"Nope. None of those things."

She sighed. "What then?"

I picked up the remote control, pointed it at the small television in my office, and held it in the ready position.

"You know how you always ask me what I want for Christmas and I always say I don't know so you always get me a dress shirt but mainly I just wear sweats all day so I never really need a dress shirt

and after about six months I give the dress shirt to Goodwill and then my birthday comes and you buy me another dress shirt and I wait six months and give it to Goodwill and then it's like Christmas again and..."

"You gave away that brand new $45 shirt I just bought you for your birthday?"

"That's not really the point I was trying to make."

"I bought that especially for you to wear to important events like my boss's holiday party."

"But I still have that perfectly good shirt you gave me when we got married."

"You're going to wear an eighteen-year-old shirt to meet the Dean?"

I felt like we were drifting from the point, so I turned on the television and switched to the Golf Channel.

"See," I said. "It's called the Hammer, and the guy on the infomercial can hit his drive four hundred yards without hardly even swinging and..." I paused for effect, "...it's only one hundred dollars plus shipping and handling if you act right now."

Pat turned and marched out of my office.

"Where you going?"

"Store," she said.

"But the Hammer's not available in stores, only through this special television offer."

"I'm going to the store to buy you a new shirt," she said, "for the big party which, as I'm sure you have forgotten, is tonight!"

Tonight. Oh, man, I'd been hoping to work on my new column — while I watched the Lakers game. Guess that was out the window. And, so it seemed, was my new golf club.

Then the phone rang.

"Ernie, it's Larry. Have you seen that Hammer infomercial?"

I explained the whole scenario to him.

"But you've still got that other shirt, don't you?"

Guys like me and Larry, we just plain understand each other.

"The reason I called," Larry said, "is I bought the Hammer. Trouble is I threw my back out and can't use it. I was wondering if you wanted to borrow it."

Yes, Virginia, there is a Santa Claus. His name is Larry.

Within half-an-hour, I had gone to Larry's house, dispensed five minutes worth of heartfelt condolences, grabbed the Hammer, and headed for a driving range near the University of California at Santa Barbara (UCSB) where my wife works.

Man, I was whacking them. They weren't all going straight, but they were going far. Then... I hooked one. To you non-golfers that means I pulled it left — way left — toward the road.

I was back in my office when Pat came home with my new shirt. Bright blue to go with my dark blue suit, which I could only hope I hadn't accidentally given to Goodwill.

"Guess what? I saved you a bunch of money," I said. "Larry let me try out his Hammer and I didn't like it all that well."

Pat smiled. "Really? Why?"

"Well, see, one of my drives kinda bounced onto the road and hit a green sedan."

"Huh," she said. "The Dean has a green sedan."

"Yeah. I know."

"You don't mean..."

"I think so, but I didn't stick around to find out."

"You can't go to the party then. He might recognize you. I'll have to go by myself."

She grabbed the new blue shirt out of my hand, put it in the bag and headed back to the store. Me, I opened a beer and turned on the Lakers game — and thought about my column, of course...

~

Perhaps I should take a moment here and tell you about Pat, because as we go along I know you are going to be asking yourself: "How in the world did she end up with him?"

I moved to Santa Barbara, California to go to Brooks Institute of Photography, and after four years and thousands of dollars worth of film, photo paper, chemicals and equipment purchases, I somehow managed to graduate with a BA in Photography. The problem is that people come from all over the world to attend Brooks. On the first day they suggest that upon graduation you go back to where you came from, where you will probably be very successful. Unfortunately, Santa Barbara is just too beautiful to leave. I've heard it described as living in a postcard. The weather is near perfect. The people are friendly. There are tons of things to do every month of the year. So... most graduates never leave. This means there are approximately 400 photographers for every wedding, bar mitzvah, school and baby photo that needs to be taken. That's why many grads choose new career paths:

"You want fries with that? And how about a selective-focus, softlit, large-format family photo printed on archival canvas-finish paper?"

Shortly after graduation I was looking for a room and found one in a three-bedroom apartment. The person who had vacated the room was Pat. She remained friends with the couple who lived there and came over often to study. She was working on her Master's Degree in history. Yes, she is much smarter than me.

Anyway, we became friends and then later started dating. About the time I got my first job in publishing we decided to get married – yes, I was employed when we first met and no, I didn't quit the instant she said: "I do." It was several years at least before I decided to try a career at "freelancing." Little did I know how much "free" there was and how little "lancing."

Pat has a great sense of humor. She is understanding, encouraging, a great editor, and without her I'd probably be living on a park bench asking anyone who happened by: "Do you want to see my portfolio?" which would probably just get me slapped now that I think about it.

So considering all that Pat means to me, I may not have handled

the situation with the Dean all that well, and it could have — though not medically proven — led to the aforementioned stress that she was now experiencing.

Therefore, it seemed only fair that I should supply a cure.

"Sycamore Mineral Springs. How may I direct your call?" the young male voice asked.

"My wife needs therapy STAT," I said in my best ER voice.

"One moment please."

A different voice came on the line. "Reservations."

"Yes, I do have some doubts."

"Excuse me?" the woman said.

"Well, see, I always try to do the right thing, but sometimes — actually, quite often — it turns out to be not as right a thing to do as I thought it would be, and instead of making the situation better I sometimes — actually quite often — end up making things worse. Just recently, for instance, there was an incident that involved a golf club and a car."

"I understand."

"You do?"

"Yes. Might I suggest our deluxe rub, tub and grub package?"

"That sounds great. How much?"

The young woman quoted me a price. It was more than twice my annual writer's income.

"Do you have a pawn shop?"

The woman sighed then quoted me the cheapskate husband special. It was still rather expensive and I briefly wondered if my wife wouldn't rather have a nice set of plastic worry beads instead, but finally I said "okay" and booked a room.

~

A few days later, we took the 101 Northbound from Santa Barbara toward the Five Cities area of Central California, just south of San Luis Obispo. The first part of our drive was along one of the

last pieces of undeveloped coastline in Southern California. Pat was driving. I was watching dolphins that in turn were watching surfers zippered into their winter wet suits sitting in water that was fifty-some-odd degrees waiting for a giant swell to potentially smash them into the rocks. My son-in-law Carl is a surfer. So is my buddy Larry. They told me they see all kinds of marine life out there — sea lions, otters, whales, and of course the ever-present bottlenose dolphins. I've often wondered what dolphins really think about surfers.

"You mean they don't have to be out here?"

"Nah, they can leave anytime. Go home where it's warm and dry and watch Flipper on Nickelodeon."

"Wow. Flipper. Cool."

"What are you thinking about?" Pat asked.

"The complexities of the universe," I said. "And Larry."

Pat waited for me to tie those two thoughts together. When I didn't, she said: "Speaking of Larry, you'll be happy to know that it wasn't the Dean's car you hit with your golf ball."

"Really? Hm, bummer."

"How in the world is almost killing my boss and costing me — us — our only real job a bummer?"

"It played out better for my column if I hit the Dean's car. I'm not sure I can make the ending work if I just bounced my ball off some random stranger's car."

For some reason this last piece of conversation lead to a period of silence. Rather than ask what it was I had said, I decided to think about it. Somewhere north of Santa Maria it came to me. Either she was just as concerned as I was about the ending for my column or… it had something to do with the job reference. I decided the latter probably made more sense.

"You know, I've been thinking, if my freelance business doesn't pick up pretty soon I might just look for (I choked just slightly) a real job."

"Really?" Pat took the Avila Beach exit onto Avila Beach Drive.

"Yup. I miss some aspects of regular employment."

"Like paychecks that don't bounce?"

I was actually thinking about breaks and free coffee, but I was starting to pick up a theme here and just said: "Yes. Paychecks."

A few minutes later we pulled into the parking lot of the Sycamore Mineral Springs Resort and my wife seemed less stressed.

"This is a wonderful idea," she said. "Although, I was a bit disappointed when you told me the entire four-star restaurant had been taken over by the Pismo Beach Accordion Club."

The Gardens of Avila is one of those four-star restaurants that offers such gourmet delights as seared breast of guinea hen, Moroccan vegetable tagine and roast duck with foie gras stuffing, which I'm sure would be wonderful — if they came with a double pepperoni pizza on the side.

"Ah, yeah, that is a shame about the restaurant," I said. Then I handed her the brown paper bag. "But they say that peanut butter and jelly offers its own set of curative powers."

Our room, like all the rooms, came with its own private outdoor hot tub, which we immediately filled with steaming natural mineral water from the springs beneath us. The room also came with a television. Unfortunately, the interior designer — obviously not a guy — did not set up the room so that my poor stressed-out wife could watch ESPN, if she so desired, while in the tub. So, instead, she read me the history of Sycamore Mineral Springs from the brochure.

"Did you know that this place was discovered over a hundred years ago by two guys looking for oil, but all they found was natural mineral water? So they opened a resort, called it San Luis Hot Sulfur Springs, and famous people like W. C. Fields started coming here."

I pictured W. C. Fields naked sitting across the tub from me saying: "Go away, kid, ya bother me." Quickly, I downed half a glass of wine to erase that disturbing image.

Pat flipped through the brochure. "Wow, they have yoga classes and a labyrinth."

"You mean like a maze? Those things are cool. That one at the pumpkin patch took me an hour to find my way out of."

"A labyrinth is just a circular path, for contemplative thinking."

"Oh." I contemplated for a minute how I was going to get another drink without getting the carpet wet, then remembered that — what the hell — it wasn't my carpet. When I climbed back into the tub, Pat was still reading.

"They have a lot of treatments available. This one-hour facial sounds nice."

I glanced over her shoulder at the price. Then I put down my drink and began vigorously rubbing her temples.

"Ooh, that feels nice. How about the forehead?"

"Sure," I said. "Just let me get this out of the way so you can relax." I took the brochure from her and sank it, hoping all the ink would come off. My wife closed her eyes and smiled.

Fifteen minutes later, she opened her eyes. "I'm starting to prune, plus I think I saw something about deep tissue massages. I'll bet that's relaxing."

"Ah, yeah, but, ah, those dang accordionists are scheduled for hours. You'll just have to settle for me."

"Okay," she said.

After a little more than an hour of massaging, my fingers completely stopped working. I wouldn't even be able to operate the remote for days. But, Pat was happy. Matter of fact, she began laughing lightly.

"What?" I asked.

"Before we left home someone called to confirm our reservation. I asked her about the accordion club. She thought that was a good one."

"You mean you knew all this time that I made up the Pismo Beach Accordion Club and you're not mad?"

"Of course not. I'd much rather have you give me the treatment than some stranger. And it's worked. I feel totally stress-free."

She leaned over and gave me a kiss.

I reveled in my success. I only hoped she still felt as good when she found out I used her credit card to charge the room.

~

The next morning my wife decided a little quiet introspection would be good for me.

"Hey! Slow down you jerk! Can't you see we're heading for a relaxing spiritual experience?"

"Easy, Grasshopper," Pat said. "We're supposed to enter the labyrinth quietly and calm our minds as we walk the path."

I put down the large rock that I was about to throw at the idiot who obviously took country roads to see what he could run over. Then I ooohhhmmmed a few times, before we dashed across Avila Beach Drive and entered the Meditation Gardens of Sycamore Mineral Springs Resort.

We'd soaked the previous night pretty much until our bones melted and we went to bed smelling of sulfur and steaming like two giant white fish. I had dreams of being devoured with a nice chardonnay by cannibals with discriminating taste, but woke up in one piece, the most relaxed I'd been in years.

That's when Pat decided she wanted to center her chi before we left the resort and we had to risk our lives crossing the road to do it.

"Did you know the oldest labyrinth in the United States is in Galesteo, New Mexico and is 3,500 years old?" she said.

"Wow. It'd never last that long in California. Someone would have turned it into a condo development by now — The Mystic Circle Timeshares or something."

Turns out she was right, a labyrinth is different from a maze in that it is only made with small rocks instead of eight-foot tall hedges, so you don't ever have to freak out about spending the rest of your life wandering aimlessly and getting nowhere.

"You're heading the wrong way again," Pat said. "This is the entrance over here. Didn't you read the guidelines?"

Yes, believe it or not there are guidelines you are supposed to follow in order to maximize your meditative benefits. First you are supposed to quiet your mind and become aware of your breath.

"Mine smells a little like the crab cakes we had in Pismo Beach last night," I said.

"You're not supposed to smell your breath, but feel it. Then you can enter the first stage called Purgation where you let go of the details of your life, shedding thoughts and distractions."

Something rustled in the bushes, grabbing my attention, and I remembered reading about the increasing number of mountain lion sightings in Southern California. Great, I could just visualize the other guests who found us.

"Don't they look peaceful scattered about the labyrinth like that?"

"Yes, except for the unsightly claw marks, puncture wounds and missing extremities, they look centered."

"Are you relaxed yet, dear?" Pat asked.

"Oh yeah," I said. "By the way, you're looking tasty this morning." I yelled toward the yet-unseen mountain lion, wondering if I could outrun my wife if I had to.

Although it seems like you are going in endless circles and are never going to get there, if you follow the rock-lined path eventually you will get to the middle of the labyrinth. This is the Illumination stage. You are encouraged to stay as long as you like to meditate and, according to the guidelines, to receive what is there for you to receive.

"Here ya go," Pat said. She handed me a receipt.

"What's this for?"

"Our room," she said.

"But I used your credit card to reserve the room," I said.

"I know. That was smooth, but I gave them your card to actually pay for the room. Now I guess you'll have to write about the place so you can write it off."

I was well aware of my breath now, leaving my body in a giant sigh. My banking account has been looking a bit thin recently — actually for quite a while. Hopefully business will pick up soon or I'll win the lottery. I mentally added: "buy winning lottery tickets" to

Photo By Pat Sheppard

my to-do list.

We began the return trip out of the labyrinth known as the Union phase, where you might meet other sojourners on the path to enlightenment.

"Did you get an awakening?" a guy wearing a "Beer is the Answer" tee shirt asked.

"Oh yeah," I said, pocketing the room receipt. "A rude one."

# Chapter Two

## OLD BEGINNINGS IN AVILA BEACH, CA

"Why do you cover your crotch every single time we come here?" Pat asked.

"Ah, because, Diablo Canyon houses a nuclear power plant and everyone knows those things can make you sterile."

"Between us we have five children and three grandchildren. That isn't enough?"

"Well sure, but what if I, like, entered some kind of scientific study and they found out I had genius genes? I'd owe it to the world to make a prodigy wouldn't I?"

"Right. You do know that before a child prodigy becomes a child prodigy that it's first a tiny, little baby who needs constant feeding and changing?"

Quickly, I uncovered my crotch.

After we'd left Sycamore Mineral Springs Resort we'd headed down Avila Beach Drive to one of the most interesting dead ends I know of — Port San Luis, also home to the town of Avila Beach and the entrance to Diablo Canyon Nuclear Power Plant.

As it turns out, the power plant is some eight miles from the entrance at Port San Luis. They used to allow visitors, but 9/11 put an end to that. Probably just as well. I'm sure it's just a bunch of turbines and a group of nerdy technicians tapping gauges and say-

ing, "hmmm" and "oh my" while they eat glowing tuna sandwiches and drink enriched mineral water.

Avila Beach is an interesting spot. It used to be a funky locals' spot with biker bars, burger joints and huge oil tanks on the surrounding hills. Then, a few years ago, they removed the tanks, dug up the entire beachfront, carted it off to wherever they put oily, used beachfront towns, and a new Avila Beach was born. From what I hear, the bikers still come, but now they mostly drink lattes, eat lowfat cinnamon scones and get Omega 3 Supplifying Facials done at Coco's Body Lounge.

Not long ago, I spent a week in Avila Beach with 10 other writers on a writers retreat. We wrote all day and drank all night, just like writers are supposed to do. On the last day of the retreat I realized I had a column due, so I went out to explore the new Avila Beach to see what I could find. I wandered into a shop on Front Street called Gelato Americano that had a grand opening sign out front. I was fascinated by all the colorful and tasty looking offerings and wondered how many they would let me try. Did they have a limit? How would one beat the limit? Hmm...

"What's that one?" I asked.

"Tequila Lime. Would you like a sample?"

"Ummm." I sucked the tiny spoon dry then made a notation. "What's that one?"

"Coconut Tropicale. Would you like to sample that one?"

"Ummm." I sucked the tiny spoon dry again then recorded it in my notebook. "What's that one?"

"Dulce de Leche. Like to try that one, too?"

"Ummm." This time I balanced the spoon in my mouth, while making a notation. "What's that one?"

There was no immediate answer. I looked up. The entire staff of three was watching me. "You're from the corporate office, right?" A large guy asked.

"Ah, let's just say I'm on assignment."

He nodded knowingly. "Right. Assignment. Well, we aim to please, don't we?"

The others smiled widely. "Oh yes," they said. "The customer's always right in our shop."

"Always right. I like that." I wrote it down.

"Maybe you could go for the record," one of the women said.

"What's the record?" I asked.

"Twenty-eight tastes and four large fountain drinks."

"Wow!" I wrote this down, hesitated, then took off my *Montecito Journal* sweatshirt. "Maybe I'll just have a few more..."

The three of them quickly stuck spoons into tubs of colorful Italian ice cream and held them out.

"Papaya."

"Nice."

"Champagne."

"Tasty."

"Zambajone."

"Different."

A crowd started to gather. Spoons were thrust forward with focus. "Who's keeping track?" I asked.

"I gotcha," someone yelled as they wrote down the last few offerings. More spoons came my way.

"Limoncello."

"Tart."

"Tiramisu."

"Sweet.

"Sugar Free Raspberry."

I stopped tasting and looked at the young woman.

"I'm so sorry," she said. "No more sugar free, right?" Quickly she gave me a double dose of Passion Fruit and smiled coyly.

"Nice come-back," I said.

There was some light applause. Out on Front Street I heard a murmur. "Some guy's going for the record."

"Local?"

"No way, dude. I heard he's from the corporate office or something."

More people squeezed into the small shop.

"What do they call you," one of the servers asked.

"My friends call me Ernie."

Another round came my way.

"Mango."

"Very nice."

"Blood Orange."

"A real delight."

"Amarena."

"I like the way you say it."

A soft chant started. "Ern-ie, Ern-ie, Ern-ie…"

A hand with a napkin appeared and dabbed at the corner of my mouth. "Thanks, kid," I said. The young surfer smiled.

Someone handed me a fountain drink and I took a large sip. "Oh, that's good."

"Thirteen tastings and one fountain drink in… less than ten minutes. He's ahead of the winning pace!" someone yelled.

More applause. I glanced out the front window. The beach was practically empty now. Everyone was on Front Street, trying to get closer to the action.

"Ready?" the three counter people asked, not trying to rush me.

"Ready," I said.

Three spoons dipped and came up full.

"After Eight Mint."

"Sophisticated."

"Cappuccino Espresso."

"Lively."

"Peanut Butter."

"Smooth and chunky."

Another fountain drink came my way. I just might do it. I just might win. I just…

"Our table's ready," someone yelled. I looked up. Fellow *Mon-*

*tecito Journal* columnists Jim Alexander and Grace Rachow were standing in the doorway. They were part of the writers' retreat.

"Wow, that was quick," I said. I grabbed my sweatshirt and started to follow them out of Gelato Americano to the Custom House restaurant a few doors down.

"Wait. What? You said you were from the corporate office."

"Ah, actually, I never said that. You said that. I just said I was on assignment. See, I'm up here with some writer friends and I have a column due for the *Journal*, so I thought I'd just wander around and see if I could find anything fun to write about. This was my first stop."

The crowd parted as Jim, Grace and I headed for the door.

"But, Dude," someone said. "What about the record?"

I looked from worried face to worried face. Then I looked back at the proprietors. They stared at me for a minute then one of them held out a spoonful of rich dark chocolate.

I tossed my sweatshirt into the corner. The crowd went wild.

"Go ahead and start dinner without me," I said to Jim and Grace. "I'll try to get there in time for dessert."

Ahh, great memories often involve food don't they?

Matter of fact, now Pat and I were in The Olde Port Inn restaurant located at the end of Harford Pier about a mile or so from Avila Beach and after the labyrinth experience at Sycamore Resort I was sooo ready for lunch, but I was also still somewhat contemplative.

"Can I help you?" the waitress asked.

"Still looking," I said, pointing toward the floor.

The restaurant has these cool windows built into the tables that extend right through the floor so you can watch live fish swim by as you enjoy eating their relatives with a nice tartar sauce.

Suddenly, a sea lion swam right below us, breaking my concentration.

"Whoa. I'll bet you can make a bunch of fish tacos from one of those babies."

Before the waitress could assure us that they didn't use sea lions in any of the entrees, Pat said: "Could I have The Harpooner please?"

"Hey, I was just joking," I said, nervously.

"The Harpooner is sea scallops, large prawns and fresh fish skewered on bamboo, served on a bed of rice," the waitress said. "It's one of our specialties."

"Whew. Well, great. Bring me one of those, too."

I went back to my contemplation of the fascinating world beneath our table. "You ever wonder what it would be like to be a crustacean?" I asked Pat. "Hanging out in the same place day-after-day. Stumbling through life without much direction."

"Yes, what is it like?"

I thought I noted a bit of sarcasm in her comment, but let it slide.

"I've been involved in a lot of serious reflection lately."

"You've been reflecting about shellfish?"

"No, the new year. I've set some stringent goals for the future. I wrote them down. Here." I handed her the list.

"Number one," she said. "Write down goals."

"See, I've already made progress."

She scanned the rest of the list. "Go on the Dr. Phil show with new self-help series — *Tequila Shooters for the Writer's Soul.* Perform hilarious standup act nightly on Comedy Central. Write, direct and star in the Academy Award-winning movie, 'Ernie — the Guy, the Idol, the Icon.'"

She looked up. "These are the same goals you had last year."

"Yeah, but didn't you notice? This year I double underlined them."

"Ah," she said.

That's part of the problem with setting goals. If you set them too low — like the year I promised myself I'd lose three pounds, watch less television, and send out a resume to someone — then, when you come up short, you feel like a failure. So, now I set them really high,

and I feel much better about never achieving them.

"What's this one at the bottom?" she asked. "Institute of something? Does that have something to do with your job search?"

Wow, when had my mention of employment turned into an actual job search?

"Sort of," I said. "You know how California just voted, like, billions of dollars for stem cell research?

"Yeah..."

"Well, I'm thinking, how about an institute for humor cell research? I figure if I can find a way to grow more humor cells and implant them in world leaders, then I can save humanity and make a few billion dollars, too. I'm gonna call it Tickle U. I'll have a great office, huge salary, plasma screen televisions to watch Three Stooges movies and Seinfeld reruns, and a number of important research associates. Fellow humor columnist Jim Alexander is already on board. He's gonna bring the beer and chips."

The waitress brought us our lunch. I grabbed one of my bamboo skewers and had a little impromptu battle with Pat's lunch, severely wounding one of her prawns, before she took the skewer away from me.

Lunch was delicious and we both savored each morsel as we watched next week's menu cruise beneath us. Afterwards, as we were heading back to the car, I asked: "So, whataya think? About my humor cell goal?"

She gave it some serious thought, then said: "I think it's good enough to be on next year's list with the others..."

Wow. Things were looking up...

"Of course, you may not have as much time when you find a job."

Yikes, now I'm finding a job!

"Unless..."

"Unless what?"

"Well, what if you finished that novel you've been working on since the Reagan administration or wrote that book

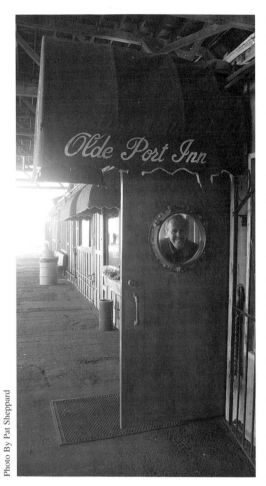

Photo By Pat Sheppard

about all your humorous adventures? What was that one called?"

"A Year in the Life of a Working Writer."

She laughed. "Well, the title is funny. I love oxymorons."

I wasn't sure whether to be insulted or say thank you. "I'm not sure that book would work anyway," I said. "Most people think of me as a serious writer."

"It's something to think about," Pat said. "Maybe even more profound than sea creatures."

The other big fear along with actual employment is actually finishing a book. It's much easier to say you are working on a book, because the minute you finish it people like agents and editors want to know what it's about. Just try to explain your life to a perfect stranger. I dare you.

"So. What's up for tonight?" I asked, quickly changing the subject.

"Prodigies."

"What?"

"We're babysitting Leila and Charlie overnight in Santa Barbara."

Grandchildren are a lot of fun, plus there is always the potential for a column or two when they're around.

# Chapter Three

## BETWEEN A ROCK AND A HARD PLACE

There are a lot of pleasant ways to wake up in the morning. A tiny barn sparrow might light upon your windowsill at eight a.m. and chirp a quiet ornithological greeting. Or your iPod clock radio might offer a low-volume version of a soft rock-n-roll classic somewhere around eight-thirty a.m. Or, perhaps your six-year-old grandson might race into your bedroom, poke you in the ribs with a finger that feels like it's made out of refrigerated steel and announce loudly: "The TV won't work!" at... 5:15 a.m.

"What? Huh? Who?"

And just to make sure you don't accidentally doze back off until some ridiculous time like, say, dawn, said grandson with the help of his seven-year-old sister might help you roll out of bed, even if your feet are tangled in the blankets.

"Ahhhhhhh." Thud.

"Come on," they said, as they dragged me across the carpet, over several fully accessorized dolls and what felt like enough Legos to open Legoland II.

"Ooo ow ooo ow ooo ow."

Part of the problem is that we recently got digital cable, which came with its own remote control. Counting the DVD player, the stereo, and the TV, we now we have four different remotes. Each

one has a hundred buttons, only one of which actually turns anything on or off.

"It might be better if you opened your eyes," said Leila. "You're pointing at the fireplace."

"I tried opening my eyes," I said. "But you guys have every light in the house on. Except for the lack of heat I feel like I'm on the sun."

My wife thought a sleepover would be fun and would allow the legally responsible and most likely still snoring parents, Carl and Christy, to sleep in for a change. Sitting on the cold hardwood floor looking for the Cartoon Network, I was thinking their well being might be a tad overrated.

"Is that drool?" asked Leila, as she pointed at my tee shirt.

I opened one eye to make sure it wasn't blood. "Sometimes I have night sweats."

"Why?"

"I don't know, fear of falling out of bed?" I pried a plastic doll purse and matching shoe out of my rib cage and continued pushing buttons. When I was growing up the only thing on television at five-fifteen a.m. was the farm report. Now there are three thousand offerings in English, Spanish, Korean and Latvian at any given moment — if you can just get the thing to come on...

"Yay!" said Charlie as the DVD player lit up and the animated Pixar logo popped up on the screen.

Great. I yawned.

"Can we have tea now?" asked Charlie.

"Tea?"

"Mo-ma told us we could have a tea party when we got up," Leila said.

"It's too early for a tea party. You couldn't even rouse the Boston colonialists against the British at this hour."

"Who?" Leila and Charlie said in unison.

"Never mind." I stumbled into the kitchen, grabbed a half-gallon of milk out of the fridge and a box of something out of the pan-

try and dumped both into a giant bowl. Then I grabbed two spoons and put breakfast down on the floor near the TV.

I turned back toward the bedroom.

"What is this?" Leila asked.

"Cereal."

"It looks like paste."

I didn't want to look, I just wanted to go back to bed, but I thought I might get in trouble if I actually fed them paste. I think you need to be a legitimate first grade teacher to give kids paste to eat.

I walked back to the kitchen and looked at the box. "It's just Bisquick," I said. "The stuff you make pancakes with. It won't hurt you. Might even be tasty. Well, good night."

"I want pancakes," said Charlie.

"And scrambled eggs," said Leila. "With toast. You can make it while the water is boiling for the tea. That's what Mo-ma always does."

Maybe it's because I was actually starting to wake up a bit, but I realized that "Mo-ma" was the one who thought sleepovers would be fun. "Mo-ma" was the one who started tea parties. And "Mo-ma" was the one still sleeping.

I wandered into our bedroom. Pat was all snuggled up. I wondered briefly, just before I grabbed both her arms, if her feet might be tangled in the covers.

~

Okay, once the initial shock of waking up while the sun was still dawning on the East Coast, and after several large mugs of very dark roasted coffee, I warmed to the idea of spending time with Leila and Charlie. To me, there is nothing more rewarding than spending a day with the grandkids and sharing the wisdom of my years.

Currently, we were exploring creative new ways of expressing the alphabet.

"Aaaaaa," Leila offered.

"Good one," I said.

"Bbbbbb," Charlie added.

"Another great effort."

"Your turn," they said.

I swallowed as much air as I could, then let loose with a loud musical belch: "Cccccccccccccccccccccccc."

"Wow!" they said.

I beamed with grandfatherly pride. "I used to be able to do the entire alphabet in one burp."

"Wow," they said again.

Leila's swallowed several times, her eyes sparkling with concentration. "Deeee-eeee-fffff," she burped.

Charlie and I applauded enthusiastically.

"What's going on?" my wife asked.

"Book!" I whispered loudly.

Leila handed me a book and she and Charlie snuggled up, just as my wife rounded the corner.

"...And that is why we don't have a Roman Empire today... Oh hi, dear. We're just reading and stuff."

She looked at the book. "You got the Fall of the Roman Empire out of *Chimps Don't Wear Glasses*?"

"Ahhhh, yeah, well..."

"Can we go to the zoo?" Charlie asked.

"Great idea," I said quickly.

Leila looked at me. "I'll bet I can burp the word zoo," she whispered.

I patted her head. I love to see them grow.

Although, it's quaint and has less creatures than say the San Diego Zoo or a weekend party in Isla Vista near the university, the thirty-acre Santa Barbara Zoo is quite unique. It was formerly known as the Child Estate, not because it was owned by one of those eight-year-old movie stars, but because it was owned by Lillian Child, a "strong-willed New England woman" according to the history page

on the zoo's website. She lived in the estate named "Vegamar" (Star of the Sea) and allowed a group of homeless Depression-era men to build a shantytown on the property. When she died the City of Santa Barbara inherited the site, relocated the last residents of "Jungleville" as the shantytown was know, and eventually built the Santa Barbara Zoological Gardens.

Today it's still a "child's estate" though many of us adults like it too, especially the popular little train that circles the entire perimeter of the zoo.

"Check this out," I said, as we pulled away from the station. "I'm not going to hold on the entire ride." I threw my hands over my head as if I were in the front car of a roller coaster at Six Flags Magic Mountain.

Unfortunately, the train has a low ceiling.

"Please no banging on the train," the teenage conductor said, then added: "Oh, it's you." She then reminded "everybody" that there was no standing, no hollering, no loud animal imitations, no leaning our heads out to see how close we could come to being decapitated by the sign at Gibbon Island. "And please don't ruin the punch lines on all my jokes this time."

Dang. I love the one about the lions spending all day "lion about."

I also really love the tunnel near the end of the ride. It has a great echo.

"Please don't 'anyone' shout out your website address when we are in the tunnel," the conductor said.

Double dang.

After the train ride, we headed for the barnyard.

"What's this?" Leila asked as I handed her a small cup.

"Food," I said. "I'll get some pictures of you feeding the sheep."

"Do they bite?"

"Naw. These are domestic sheep. Over the years they have been breed to eat just using their tongues."

A few feet away another kid held out a pellet. "Ow," she said

as a sheep took the pellet and ripped the little paper cup out of her hand.

Leila grabbed my camera. "You feed it. I'll take the photo."

The sheep smiled a toothy smile at me. "Ah, who wants a picture of a sheep anyway," I said. "Let's go see the lions."

We were in luck. One of the lions was 'lion' — I told you I love that — on a rock right near the viewing window. A group of people were just leaving, mumbling something about lions sleeping 20 hours per day and using the other four hours mainly for eating and mating. I mentally added zoo lion to one of the things I'd like to come back as in a future life.

I readied my camera. "Do something," I said to Charlie and Leila.

"What?"

"I don't know, try to look delicious or something."

They got close to the glass partition and sure enough, the lion picked its head up and ran its large tongue over its lips. "Perfect. Now, smile."

After the lions, we visited the giraffe with the kink in its neck. "I think he forgot to duck when he went into his cave," I said.

"Don't tell them that," my wife said, then she explained that the giraffe was born that way. "Some creatures just have defects," she added looking at me.

I stopped hanging my head over to one side and pulled in my tongue.

"I'm hungry," said Charlie.

"Me, too," said Leila.

We started trekking toward the parking lot. "We need marching music," I said to Leila. "I should play my underarm trumpet."

"What's an underarm trumpet?" she asked.

I started to slip my hand under my shirt, but I caught one of those wifely glances from Pat that seemed to say: "One 'ffffhh-hhttttt' and you're dead."

"Better ask your dad," I whispered.

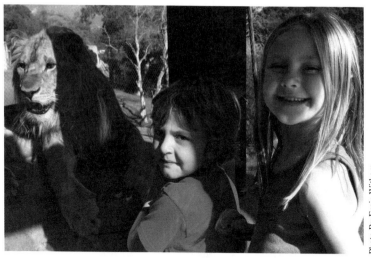

Photo By Ernie Witham

"What about Mommie?" Leila asked.

"Ah, no, I would not ask her."

"Ask who, what?" Pat asked.

"Christy, er nothing." I said.

"Hmm. Well, speaking of Christy," she said, "After lunch she needs your help. Something about a rock."

Christy is the number three child in the rank and file behind my daughter Stacey. Stacey finished high school in New Hampshire before moving to California. By then, my son Shane, who moved in with us when he was sixteen, and insisted upon having his own space, moved into the garage, hung up some posters, put on some music that scared the hell out of the cat — and me — and came in mainly for meals, had gotten his own apartment.

So Stacey took over his room in the garage, hung up some posters, put on some music that scared the hell out of the cat — and me — and came in mainly for meals.

It was through Stacey that I got a real look at the transition through the teen years. One year, when both Shane and Stacey were visiting from New Hampshire for the summer, everywhere we went Shane wore a black Metallica concert tee-shirt with the sleeves torn off, and Stacey wore a Michael Jackson tee-shirt in a pleasing pastel.

Stacey tended to walk beside me, while Shane walked several paces behind us both. A few years later, Shane was living with us and Stacey visited again. She had dumped "Michael" in his pleasing pastels for — you guessed it — Metallica and walked several paces behind me wherever we went. Shane still wore concert shirts, but he had recently asked if I wanted to take up golf. Amazing.

At our wedding, Stacey and Christy were the ones that decorated our car. Christy has always been artistic and I think she did most of the painting, which was very good, though I wish she had used a water-based paint.

"Congratulations," people would say whenever Pat and I drove somewhere. "When did you get married?"

"Three years ago," we'd say.

We donated that car to the Rescue Mission. I always wondered if they repainted it or just sold it to a newly married couple.

Anyway, the reason we were babysitting today was because Christy was once again using her artistic skills by designing and planting a new front yard for us.

"So Christy needs help with a rock, huh? Okay."

~

Actually, rocks I know about, because, as you've probably figured out by now, I grew up in New Hampshire — The Granite State. It was just about impossible to stick a shovel into the ground anywhere without hitting a rock, or worse, a ledge. The state symbol was — until a few years ago when it fell down — a huge outcropping that happened to look like an "Old Man in the Mountain." People used to come from all over the country to look at it and say:

"Wow. That's a big rock."

That's why when Christy mentioned a rock I figured she needed one removed. When she suggested buying a "decorative rock" for our new yard, I thought it was some kind of joke.

"Ha Ha," I said. "I get it. Decorative rock. It's an oxymoron,

right (oxymoron was a new term I'd recently learned from Pat when I referred to myself a "working" writer)?"

"Huh?" Christy said.

People say that to me quite often for some reason.

"You're not serious. People in California actually buy rocks?"

"Of course," she said. "At the rock store."

"Ha Ha," I said again. She was on a roll here. Can you imagine anyone going to a rock store?

"What kind of rock are you looking for?" the salesman at the rock store in Goleta asked. "We've got sandstone, granite, lava..."

"You sell lava?" I said, "Like, from a volcano?"

"Yup. Unfortunately, I'm out right now."

"Let me guess, you're expecting a new eruption any day now?" I laughed.

"Huh?" he said.

"How much is this one?" Christy asked pointing at what we used to refer to as a "back-breaking boulder."

"That one's about a hundred and fifty dollars — plus tax."

I waited for him to wink. Surely, even our cash-strapped state government didn't tax rocks. Nothing.

"Delivery's another forty-five dollars. Plus, wherever we drop it, that's where it stays."

Christy looked at me. "What do you think?" she asked.

"Christy. I love you. Really. And if you wanted me to buy you a plant, I'd buy it. If you wanted me to buy you some sod, I'd buy it. If you wanted a tree... well, I'd even buy a tree. But I can't bring myself to buy a two hundred dollar rock. Why, if anyone from New Hampshire ever found out..."

And that was that. I felt badly, of course, but not as bad as I would writing a check for a rock. "Let's see, who do I make that out to, Mother Earth? God? Big Bang Theory?"

Still, I couldn't get it out of my mind. Then, several weeks later, on a late-January Sunday afternoon, Pat and I were driving up San Marcos Pass to Cold Springs Tavern, an old stagecoach stop that

was now a rustic restaurant and bar. On Sunday afternoons blues artists, Tom Ball and Kenny Sultan, sit outside the bar and sing some old classics to an audience of bikers, ranchers from the Santa Ynez Valley, tourists from Los Angeles who stop by on their way home from wine tasting, and of course locals from nearby Santa Barbara like Pat and me.

Even from a distance, I could hear Tom and Kenny playing one of my favorites, "He's in the jailhouse now..." and I was about to start singing along with them, when all of sudden I spotted about a zillion rocks just sitting on the side of the road. Seems that every time it rains or shakes a little in California, huge sandstones tumble down the sides of the pass. At least once a winter some or all of the roads in the pass are actually closed because of landslides or, as I was beginning to think of them today, decorative rock slides.

"Early retirement here I come," I yelled, then lowered my voice, before someone else caught on. "Baby, it's time to rock, then roll. Ha ha."

"Huh?" Pat said.

"Rock, then roll... truck...load rocks...get-a-way... ahh, never mind."

We pulled over and I jumped out and threw my arms around a real beauty. It didn't budge. Hmmm. Okay, I tried a more conservative one. Still nothing. Finally, after several attempts, I found some I could handle. Sure, they weren't quite as substantial as the "store-bought ones" but if I stacked enough of them together, maybe Christy wouldn't notice. Plus, after a few more trips, I'll bet I could make some real quick money on eBay.

"Are you sure this is legal?" Pat asked.

"Legal? They're rocks." I hefted another one into the back of the Explorer. This one looked a little like John Muir, founder of the Sierra Club.

"But isn't this a national forest? I don't think you can take things from a national forest."

Guitar riff... "He's in the jailhouse now..." Harmonica solo....

"He's in the jailhouse now..."

I looked at the pieces of national forest already loaded into the back of my Ford Explorer. Then I imagined the *Santa Barbara News-Press* headline:

**Alleged Humorist Steals National Treasures**
Ernie Witham, aka The Sandstone Kid, was taken into custody today. A reporter on the scene claimed Witham just kept repeating: "I'm from New Hampshire! The Granite State!" Federal prosecutors are suggesting a complete mental evaluation.

I carefully unloaded John Muir and the other rocks then drove slowly down San Marcos Pass.

"Rock store?" Pat asked.

"Yeah. But if anyone asks, we tell them it's a meteorite. Understand?"

# Chapter Four
## NOTHING SAYS "I LOVE YOU" LIKE FLORA...

The rest of January flew by. I picked up some freelance graphic design work from a guy who actually had company checks — usually a pretty good sign. Plus I sold a couple of humor pieces to *Chicken Soup for the Soul* books. I've been in more than a dozen of those anthologies and it always makes me feel good to separate my friend Jack Canfield from a few of his many dollars.

Looked like I didn't have to actually look for a job for a few months at least. That was the good news.

The bad news was that it was now February, the worst month of the year for me. For one thing, it's my best friend's birthday.

I know what you are thinking — no big deal. Take him out to a sports bar for a couple of beers, make a bunch of age-related jokes, maybe spring for a bag of barbecued pork rinds during the game — problem solved.

The only glitch is that my best friend also happens to be my wife.

Go ahead, say it: "Ahhhh, isn't that sweet. What a lucky guy."

Lucky? Ha! Not if you are the world's worst event planner. I found out early on in life when I took a new girlfriend to a backyard keg party to celebrate her birthday that I'm clueless when it comes to being in charge.

"Who are all these people?" she asked.

"I don't know," I said. "The flyer didn't say."

"You mean none of my friends are coming to my birthday? It's just these... strangers?"

"Yes, but hey, don't worry."

That's when I smiled and handed her "her gift" — a large ceramic cup with her name on it.

"See," I reassured her. "That way you won't end up with any cigarette butts in your beer."

At that point I leaned in for a kiss. Man, it took a long time for that cup mark to disappear from my forehead.

After that I developed a plan. One of the first questions I asked when meeting a potential new girlfriend was: "When is your birthday?" That way I knew how long it was before I had to break up with her, so as not to risk further injury.

And it's not just me. I've talked to other guy friends who have problems with intuitive thinking. In fact, I'm sure that it was a guy who invented the infamous bar line — "So, what's your sign?" — not because he was in any way interested in astrology, but so that he could quickly weed out any prospects who had birthdays within the first ninety days of a relationship.

But this was Pat's birthday. So you can see my dilemma. I had to quickly come up with a thoughtful birthday plan — and we don't even have a Chuck E. Cheese in Santa Barbara!

Hastily, I went online to the "Ask Jeeves" search engine and typed in: "Need idea for wife/best friend's birthday."

The response came back: "Buy her a ceramic cup with her name on it."

Dang. I switched the television to the infomercial channel. They were advertising a huge cubic zirconium ring. Right. Like I'm going to make that mistake again. Besides, this wasn't our wedding.

I rifled through the newspaper, pausing briefly at an ad touting pain-free laser hair removal. Was that a good gift?

"Guess what dear? No more unsightly hair..."

Instinct told me to keep looking, but I circled it just in case.

I began to wonder if Pat would even want another gift. I hadn't seen her wear the plaid pantsuit I got her for Christmas yet.

That's when the phone rang. It was one of my golf buddies.

"Got an opening tomorrow for a fourth."

"Sounds great, but today's Pat's birthday, and I haven't got it figured out yet."

"Oh, man," he said. "That's how come we got an opening." Our regular guy thought his wife might like a spa treatment for her birthday, so he got her a mustache waxing or something like that. Apparently he won't be playing for a while."

"Huh." I crossed laser hair removal off my list. "Any suggestions?" I asked.

"Look, don't spread this around," he said, "but this is what I did last time." He then whispered something into the phone, which made me gasp.

"No way!" I said.

"I got to golf the next day," he said.

"Yeah, but..."

"Let me know if you're in or out." Then he hung up.

I paced in my office for a long time. Maybe Pat wouldn't remember today was her birthday. Maybe she'd like cubic zirconium earrings. Maybe divorce wouldn't be all that bad. Maybe...

Sigh. I picked up the phone and slowly dialed the Arlington Theater Box Office in Santa Barbara.

"Anniversary?" the woman asked.

"Birthday," I told her.

"Ahhh," she said, then sold me two tickets for a ballet that promised many lively dancers "performing with precision and bravura," which translates to: "men in all-too-revealing tights leaping across the stage on their toes, while skinny women in tutus spin like tops."

Oh well. She is my best friend — at least for another nine days. Which is the second reason I hate February — Valentine's Day — aka

"Don't forget the flowers you idiot" day.

~

We all felt envious of the guy with the miniature persimmon tree — even if it had been severely pruned like that.

"Got it at a garden center sale. Last one they had. They taped on a picture of what it's supposed to look like. See?" He held out the green plastic tub.

We looked at the photo of a beautiful blooming plant. The thing he was holding looked more like a garden stake. Still it was a viable offering – more than we had.

The line shifted and we moved one step closer to the Happy Moments Flower Stand, which was mobbed with anxious look-ing guys, shuffling their feet and checking their watches. From our vantage point we could see petals, stems, leaves and bits of ribbon flying outward as if a mower were being driven through a flower field in Lompoc, where they grow all the flowers for the Rose Bowl Parade. In the middle of the flurry were two frazzled young women gathering, trimming and wrapping as fast as their callused little fingers could move.

"Think they'll still have roses?" one guy asked. We looked at him like he was nuts.

Seems like just one year ago I was in this same line with these same guys and we all swore that next Valentine's Day we'd shop earlier. But here we were under a quickly darkening sky facing an uncertain future — yet again.

"I completely flaked one year," the guy behind me said. "By the time I remembered it was the day to show my undying love and devotion it was too late for flowers, so I grabbed two yards of sod from a landscaping job I was working on and raced home."

"Sod. Wow. Good one."

"Yeah, that's what I thought, until my wife reminded me we lived in a second-floor condo."

A relieved looking guy with glasses askew walked past us, holding a bouquet to his chest as if he were protecting a baby.

"What'd you get?"

"Something yellow."

"How long'd it take?"

"Hour and a half."

There was a collective groan then one guy broke rank and ran for the nearest variety store. "I can't take it. I'm going with plastic petunias," he yelled.

We gave him a round of applause for bravery.

"He's dead."

"No kidding."

"How long do you think the guy that invented Valentine's Day would last if he was thrown out of a moving van into this parking lot right now?"

"Fifteen seconds, tops."

The line moved. Ahead, I could see a lot of empty white buckets that had once held cut flowers.

"I used to do jewelry," one guy said. "Bought this necklace with a little gold heart. It was perfect — cute, sentimental, reasonably priced. Unfortunately, I bought exactly the same necklace three years in a row. Somehow it lost its cachet."

A number of us nodded, knowingly.

A murmur went through the group. Several guys left the line, then several more, then finally all of them.

"What's going on?" I asked.

"Sold out," one guy said. "Who'd a thought it?"

I approached the two young frazzled women. "You must have something!"

One of them handed me three sprigs of baby's breath and a carnation with a broken stem. "Sorry," she said.

I lowered my head and started for my car. Then I spotted something in the back of her car that looked like a specimen gathered by the Star Trek crew from a dying planet. "What the heck is that?"

"That? Oh that's a succulent," she said. "I'm redoing my yard at the trailer park. I was going to put in a flower bed, but right now I think if I never see another flower again it will still be too soon."

I took out fifty bucks. "Can you put that thing it into a nice pot?"

She mumbled something about writing a story for the flower stand industry publication one of these days, but found a pot and went to work.

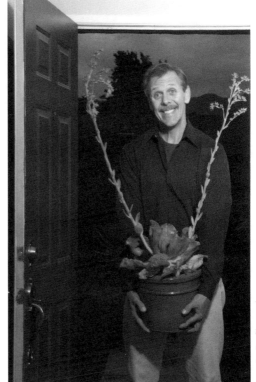

Photo By Pat Sheppard

"Good luck," she said a few minutes later, as I drove away.

I raced home, slicked back my hair, smiled, kicked open the front door held out my offering and said. "Happy Valentine's Day, dear!"

Her expression said it all.

# Chapter Five

## THE GLAMOROUS WORLD OF FREELANCING

What's it like to be a "freelancer?" Let me sum it up in one sentence:

I just might have to get that job.

The guy with the company checks I mentioned earlier? Turns out he had them but didn't like to share them. In the business world we refer to people like that as a slow-pay. I just hope he didn't turn into a no-pay.

Let me take a moment to make this statement: I have had jobs. Plenty of jobs. And I was a pretty damn good employee. Trouble was, being a humorist at heart, I couldn't always take it as seriously as I was supposed to.

For example, I was Production Manager at a publishing company in Santa Barbara and as such I had to attend meetings with the other managers. One such meeting was to pick a new masthead design for the magazine. I could tell the minute I got into the meeting that the graphic design house that did all the graphics for our publications had not put much time into the design. Probably because in the 400 meetings we had to discuss the new image, no one had really come up with anything solid, just the "feeling" we were trying to convey.

After a short presentation by the designers, the meeting coor-

dinator thought it might be a good idea to pass the new masthead design around so we could all take turns articulating just what we saw in the new image.

As it went around, a plethora of meeting-type terms came out: "I see a beacon, broadcasting our message to the masses."

"I see unification, bringing our readers and advertisers together as one."

"I see new visions."

"I see the future."

"I see stability."

When it came to me all I could think of was a Rorschach test and I blurted out: "I see a fat naked woman with a small yapping dog."

That pretty much brought the meeting to a close and, soon after, my career at that particular publishing company.

So, I started my own business. Bought some business cards, stationery, a business phone line and a great big desk. Then I waited. Nothing happened. Turns out, in case anyone is interested, that in order to have a business that brings in money you need to have clients with company checks and those clients actually have to make the checks out to you and mail them to you. And there, as they say, is the rub.

All that said, though, the great thing about being a business is that I can write off things I write about, like Sycamore Mineral Springs Resort and Pat's birthday ballet tickets.

That's right. I may not have a "job," job, but Ernie Witham Writer is licensed as a "sole proprietorship" and as such I can deduct expenses off my taxes. I also get to "be in charge" of company meetings now. My meetings often feature taco chips and beer, and the agenda focuses on timely business problems like how to get coffee stains out of my Ernest Hemingway slipper socks, and when's the best time to call for an early afternoon tee time at the Santa Barbara Golf Club. Important expenditures like Cheese Whiz and comic book subscriptions are easily approved by a majority vote of one,

and my carefully crafted retirement strategy involves the simple twice-weekly purchase of lottery tickets.

Even though I may not be listed on the Fortune 500 (or the Misfortune 500), I am considered a businessman-in-need and therefore I am privy to the many advantages associated with entrepreneurship. For instance, I get calls from the crème de la crème of recent college graduates wanting to join my operation.

"Dude, I'm, like, totally into verbs and nouns and stuff, and I designed and printed my own diploma at Kinko's. And when I'm not surfing, I have, like, a ton of ambition."

"Oh man, you had me right up until that ambition thing, but I think we have a personality conflict there."

As an up-and-coming business owner people offer me great deals on office equipment and company insurance.

"So how many copies a month do you make, Mr. Witham?"

"I dunno? Five?"

"Perfect. The new Canon Millennium will spit those out in less than a second and you can lease one for only $5000 a year, plus the mandatory service contract, because with that kind of usage it's bound to break down, of course."

"Of course."

"We also sell employee compensation packages. Has anyone been hurt recently at your office?"

"Well, Sam — my cat — fell asleep on my fax machine and was startled when a fax came in offering me a deal on neon signs and outdoor lighting, but he seems to be feeling better since he repeatedly sprayed the thing for three straight hours until he passed out from dehydration."

"Dehydration, huh? Have you considered implementing an office water cooler program? We have a small business special — seventy-five gallons a week, only two-hundred dollars, and we give you a free cup."

Having my name sold over and over to mailing list specialists means I also get a lot of calls and emails regarding advertising op-

portunities from astute salespeople.

"Mr. Witham... Good news! For less than the cost of a new car, we can help you create a thirty-minute infomercial for the food channel that will be seen by connoisseurs all over the country."

"But I'm a writer, not a cook."

"Says here you're into hummus."

"Actually, I'm into humor."

"Oh, well, heck, we don't have anyone buying that. You'd be much better off with the hummus."

Right.

As busy as all this sounds I do allow time each day to day-dream, err, that is, to reflect on short-term and long-term business plans for increased capital gain. And, while I wait for that whole humor cell research center to gel, I have identified several new, even-easier opportunities that I am actively pursuing. For instance...

I hope very soon now to go on the "Antiques Roadshow" where I expect I'll find out that my vintage black light posters are worth thousands of dollars and that the strange water pipe that mysteriously ended up in a box of my old college stuff is actually from the Ming Dynasty.

If that doesn't work out, I plan to be a contestant on "Jeopardy!" on the night that the categories include Simple Sports Questions Even a Five-Year-Old Would Know, Fictional Characters From Books I've Actually Read, Old Jokes, Corny Puns, and Potpourri for Dummies.

If none of those work out then (gulp!) I guess I'll have to either finish that novel, plan the definitive humor book or look for gainful employment.

Trouble is, looking for a job is not easy. Most employers require that you show up on a regular basis — usually in the a.m. hours — and perform some type of repetitive task even if the muse is not inspiring you. I think this may be discriminatory to writers, and I tried to rally some of my fellow scribes to the cause, but most of them spend their days at the beach, so I couldn't raise a quorum.

So, just as a preliminary gesture, and because I didn't want to tell Pat about the guy with the checks that "weren't" in the mail, I scanned the classifieds to see what was out there. I quickly dismissed all those ads that were looking for motivated people desiring a real challenge and those that required heavy lifting. I was trying to recollect if I had any experience as a dental assistant, when I spotted the ad looking for a "mystery shopper."

Excitedly, I dialed the phone. Pat would be so excited if I got this.

"I'm calling about the mystery shopper. I know mysteries. I'm reading a great Richard Barre novel right now," I told the lady who answered, "and I'm working on something that's still a mystery to me and my editor."

"I think you misunderstood," she said. "We don't want you to shop for mysteries. We want you to test the customer service skills of our grocery store staff by pretending to be an average shopper."

"Oh. Undercover operation, huh?" I hesitated for just a second, then said: "Cool. I'll take it."

"Okay. Have you been to our store recently?"

"Not since my stepson Patrick dared me to stick my tongue on the ice machine. Boy, that was a long morning. See you at the rendezvous point."

"Ice machine? Pardon me? Mr. Witham? Hello?"

Patrick is the youngest. He took over the garage suite for a while. His music scared the entire neighborhood, and he was playing it himself on his electric guitar. Now he's a waiter and *garde manger* (pantry chef) at one of Santa Barbara's top restaurants. We can't afford to eat there, but we hear it's nice. Patrick also has a great sense of humor, which I try to encourage by doing things like, well, sticking my tongue on really cold things.

~

I wanted to make a good first impression, so I went to work the

instant I got to my new job.

"Excuse me Schweethart," I said to the produce clerk in my best Humphrey Bogart. "How are your melons today?"

The young lady pointed her spray hose at my chest. "Don't make me use this, mister," she said.

I retreated to the canned meat section and made a notation in my mystery shopper's report notebook about her bad attitude and propensity to use weapons. Then, I took off my trench coat, stuffed it into my "Special Ops" knapsack, and put on one of Patrick's aprons and a chef's hat. I'm sure he won't mind.

"Can I help you with something?" an enthusiastic young man asked.

"*Oui, monsieur*. I am looking for zee restaurant-size can of Spam."

"We don't have anything like that," he said.

"*Non*? Would you say that if I was Emeril Lagasse, eh? Or how about Wolfgang Puck? Would you tell Wolfy that you couldn't fill his order, eh? I don't think so. *Au Revoir!*"

I left him shaking in his high tops and headed for soaps and detergents, making another notation in my mystery shopper's notebook: "The sardine and kippers guy seems fishy." Ooo. That was good. I'll bet they use that in their mystery shopper's newsletter.

I rummaged through my Special Ops knapsack one more time, coming up with yet another average shopper outfit, just as several important-looking store people headed my way.

"I'm looking for manly soap," I said in a deep voice, while adjusting my hard-hat, "one that smells more like a locker room and less a beauty shop."

"Mr. Witham, I presume?" the woman with the store manager badge said, as more and more store personnel entered the aisle.

"Shhh. You'll blow my cover," I said. "I already have some great material."

She took me by the elbow and walked me out the door. "Wonderful. Send it to the corporate office. This whole mystery shopper

thing was their idea. Oh, and as far as future 'undercover operations' go, don't call us, we'll call you."

"Ten-four," I said.

Then I climbed into my '99 Mercury Mystique escape vehicle and headed home to check the mailbox for the tardy check from my client and to see if I got any "Congratulations Ernie. We Want You!" calls from publishers, editors or agents.

~

And what do you know? I got one of those calls! An invitation to conduct a workshop.

The good thing about being a "working" writer is that other writers want to know how to do what you do so that they too can live the dream of financial freedom and fame as a freelancer.

So, I offer humor workshops — which is quite funny in and of itself. Did you know that more people fear public speaking than fear death? I'm not kidding. And I was one of them. But when my first book was about to be published, I knew I was going to have to speak at booksignings — or die.

So, at the suggestion of my good friend Grace Rachow, I joined Toastmasters International, a public speaking organization. The first meeting I sat all by myself in the last row and tried to look invisible, but they spotted me and they asked me stand up and introduce myself. I almost said:

"Oops, I thought Toastmasters was a cooking class, well gotta go."

But I stuck it out and a weird thing happened. After a few months I began to like speaking in public.

Then, after a few more months, a weirder thing happened. I began to "love" speaking in public. It's a "rush" to stand up there and have people hang on your every word, which makes it quite addictive.

Now I lead workshops at two Santa Barbara writers conferences

every year and have also lead them at other conferences throughout the country. So, when the husband/wife agent team of Michael Larsen and Elizabeth Pomada invited me to speak at their conference in San Francisco, I could barely contain my excitement. That's when I realized that I might have a problem. The San Francisco Writers Conference confirmed that...

...Hi. My name is Ernie and I'm a conference-aholic.

It's been two weeks since my last workshop and already I'm craving three-hour-old coffee with partially-dissolved Cremora and a sixteen-ounce sticky bun with rock-hard raisins. Any minute the Toastmasters International Rescue Van will probably show up and take me to a halfway house for recovering public speakers.

"Where are the microphones?"

"There are none."

"Podiums?"

"Nope."

"A circle of chairs? Certainly you must have a circle of chairs!"

"Not a chance."

"Ahhhhhh...."

I realized I might have a problem when I attended the first of three writing events in a row at the prestigious San Francisco Writers Conference.

The SFWC was a three-day event held at the stately Sir Francis Drake Hotel right on Union Square. As one of the perks for presenters — as if just being invited wasn't enough — the conference had a hospitality suite on the sixteenth floor with an incredible view, dozens of highly-animated, pontificating workshop leaders, and copious amounts of free wine and snacks. Plus, they gave all of us these great plastic name badges that we proudly wore around our necks like precious jewelry.

Unfortunately, I only had one session to present at the SFWC, but I had made the rounds in the hospitality suite and was now was

planning on attending several other presenter's workshops in the hope that they might call on me for sage advice about using humor in their fields. Just knowing there was the possibility for brief collaboration made me anxious to sit through sessions like "Composing Christian Gangsta Poetry," "Creating Large Print Erotica for Today's Active Seniors," and "Hands-on Guerrilla Marketing Featuring Real Guerrillas."

"Quite a grip you have there, Conga, and yes, I'd love to buy all your books, really, just let go, okay?"

Anyway, around ten p.m., lights began to blink on and off in the hospitality suite, so I emptied the remains from two bottles of wine -- one white, one red -- into my plastic cup, grabbed a half-block of jalapeño-laced goat cheese, and said good-bye to self-publishing guru, Dan Poynter, the only other person left. Then I walked down the lonely hallway and got into the elevator to begin the slow descent to my floor.

I was lost in thought about tomorrow's workshop, when the elevator stopped on the fourteenth floor and a tall, rather robust woman got in, looked at me, but did not say anything.

"Cheese?" I offered, hoping to break the deafening silence and gain one last snippet of conversation.

"No," she answered in a deep voice. "I'm watching my figure."

That's when I noticed the five o'clock shadow beneath her make-up and I remembered hearing that there was also a transvestite meeting in the Sir Francis Drake that

Photo By Cheri Molnar

weekend, including the crowning of "the king and queen."

That's right. I was in an elevator, in the middle of the night, with a six-foot-four-inch drag queen with large shoulders and well-muscled calves. My mind began racing...

What kind of workshops would transvestites have? Where to find Manolo Blahnik slingback heels in size thirteen triple E... What to do when you're having a bad breast day... How to maintain your sense of humor when another guy shows up wearing the same party dress...

Wait... sense of humor? Would they enjoy an impromptu humor workshop? I could do some fashion shtik. Maybe read my piece on going to Victoria's Secret on Valentine's Day to buy lingerie. They'd like that wouldn't they?

Incredibly, when the elevator stopped on my floor, she got out too and headed down the hall. I began to follow her. Suddenly, she stopped.

"Let me guess, workshop leader?"

"That's amazing? How did you know?"

"You mean besides the huge plastic name badge around your neck? Simple, you're the third one tonight. And no, we don't need any speakers. It's not that kind of meeting, if you get my drift."

She twirled and just like that disappeared around the corner, leaving me bewildered and emotionally spent.

Fortunately, in a few weeks I'm presenting at Millikin University in Decatur, Illinois. I get to speak three times and do a booksigning. Just me. My show. Free meals, hot coffee and a PA system.

I'm feeling better now. Thanks for listening...

# Chapter Six
## THE NAME GAME

People say with age comes wisdom. I think they base this on the fact that as you get older you nod a lot.

"Can ya turn it down a decibel or two?" my wife yelled from the other room. "The airport is going to call again and complain that people can't hear their flight announcements."

I looked at the volume control on the television. It was set at fifty-four. I pushed my chair closer to the television and turned it down to a more conservative forty-four.

"Maybe you need to have your hearing checked," Pat said, sitting down beside me.

"Oh hi, dear," I said. "You know I was just thinking... maybe I should get my hearing checked."

Before she could respond the phone rang. "It's Marco from across the street," she said. "He's having a barbecue tonight for the in-laws and his wife won't let him watch the basketball game. He's hoping that you might watch it so he can still hear the play by play."

I looked up from my favorite show, "Survivor Hollywood Edition — Who Will Sleep With the Producer This Week?" and said, "Marco's in a play? I didn't know he was an actor."

She sighed. "I'm going to make an appointment for you right now."

"Okay, and ask Marco how much the tickets are for his play."

Several days later, I was at the Santa Barbara Medical Foundation Clinic. I was worried. What if I did need some kind of hearing device? I flashed on myself sitting at lunch at Harry's Plaza Cafe with my "always-seeking-new-material" writer friends, holding one of those giant megaphone things to my ear, saying: "What are you guys laughing at?"

Hmm. Maybe I could just expand my lip-reading expertise instead.

"Mr. Witham?"

"Huh?"

"My name is Darlene and I'll be conducting your test today."

I watched her lips move, then said: "Fine thank you and yourself?"

She gave me a weird look, and then led me to a small room. "Now what makes you think you are having trouble hearing?" she asked.

She had nice lips, but dang they were hard to read. "I'm a humor writer," I said. "I'm here today because my wife thinks I'm deaf as a post."

"Ahhh," she said, and wrote this down.

Then she put a set of headphones on me and left the room, closing the thick door behind her. I hate it when they do that. It's like having an x-ray. They always tell you that it won't hurt a bit then they climb into a lead-lined bomb shelter, put on solid black safety goggles and duck just as they activate the nuclear reactor.

"Mr. Witham..." I heard in my ear.

I looked out through the protective glass. Darlene leaned forward and said into a small microphone: "Are you ready?"

I could hear her perfectly! I wonder if my writer friends would notice if I wore giant earphones all the time and made them talk into a microphone? Maybe I could cover the headphones with hair. Or...

"Mr. Witham?"

"Huh? Oh, yeah. I'm ready,"

"Okay, pick up the button, Mr. Witham, and when you hear a tone, press it."

I looked at the little handheld device. Wow. It was like I was on Jeopardy! just like in my business plan...

"Yes, Alex, I'll take 'famous movies featuring scantily-clad women' for a thousand dollars."

That's when the door opened back up and Darlene came in, pulled off my headphones and sat down directly across from me.

"That's it?" I said. "I passed?"

"Mr. Witham, I don't think that there's anything wrong with your hearing."

"Huh?"

She took my button away so I'd stop playing with it then gently lifted my chin so I was looking right at her. "I think you just have trouble paying attention."

"Really?"

"Yup. You call it the muse. We call it daydream syndrome. Most writers have it. If you just start concentrating more on the moment instead of living in your own imagination, you should be fine."

"Wait a minute," I said as this slowly began to sink in. "There's nothing wrong with me?"

"Oh, I didn't say that."

"Because, if I have to tell my wife that I just haven't been listening for the last twenty years, I'll be sleeping on the couch until the next millennium."

Darlene smiled. "How about I give you some official-looking ointment?"

I let out a deep breath. "Thanks," I said. "And I want you to know that I am going to pay closer attention beginning right now... Debbie."

"My name's Darlene," she said.

"Ah, of course it is, I was just testing you. Ha Ha."

~

Truth is, I'm terrible at remembering names, too. I think I used to be pretty good at it, but I can't remember. It's all so complicated.

Usually, when I first meet someone, I'm so busy trying to decide if this person is a regular handshake, a thumb wrestle, a tap knuckles, a sliding palm or some combination thereof, that I forget their name as soon as I hear it. Then, when I next meet the person, I'm stuck fumbling until I come up with a generic substitute.

"Hey, Dude, great to see you again."

"Most people call me Your Honor when they're in my court, young man."

"Oops. Sorry about that your judgeship. And sorry about that high-five thing, but I'll bet the swelling goes down in no time."

Oh, I've tried all those clever name-remembering tricks. Like repeating the name...

"Rob. It's nice to meet you Rob, especially on a fine day like today Rob. Don't you think so, too, Rob?"

"It's Marsha, and if you don't let go of my thumb I'll kick you."

I've even tried the association thing where you look for a prominent character trait to remember people. But that one proved dangerous, too.

"Well I'll be danged. If it isn't Nose... I mean Rose."

I guess that's why when Pat suggested, after I "passed" my hearing test, that we take a ride to Los Olivos to see the Lupines, I just assumed these were some of her friends from work and it was another one of those brunch things featuring eggs, spinach and champagne (whoever thought that combo up had a gastrointestinal tract made of steel).

But I rallied to the cause because I vaguely remember one of the Lupines being involved in the film industry, which meant they might be interested in my screenplay. I always keep a copy in the trunk. It stops the jack from rattling. And if I could sell a screenplay for just one or two million dollars, then I wouldn't have to look through the classifieds anymore. I was feeling really positive like this could be the break I had been waiting for.

It wasn't until Pat pulled over on Highway 154 near Figueroa Mountain to take a snapshot of some purple flowers that I realized my mistake.

"Don't you just love lupines?" she asked.

Not anymore, I thought, as I watched fame slip from my grasp, yet again, all because of this name problem.

Minutes later we were seated in The Sidestreet Café located — appropriately — on a side street in Los Olivos. Los Olivos is a small village in the heart of wine country featuring tasting rooms, art galleries and gourmet restaurants.

As you know from my avoiding Avila Gardens at Sycamore Mineral Springs, I'm not big on gourmet food. My idea of a gourmet meal is to dump a packet of crushed red peppers into the dipping sauce that comes with my favorite frozen pizza puffs and to use a mug for my beer instead of drinking it straight from the can. For ambiance, I like to watch nighttime baseball games on television by the soft-glowing light of a scented bug-repellent candle.

As you might expect, I don't always understand other people's gourmet offerings.

"What the heck is that?" I asked Pat.

The waiter had just walked by with two bowls of thick, iridescent magenta-colored stuff.

"That must be the Cold Beet Soup with Sour Cream and Scallions," she said. "Doesn't that sound delicious?"

I laughed then realized she was serious.

Quickly, I scanned the menu looking for anything that resembled a double cheeseburger with fries.

Oh, how I longed for "cow Sundays..."

During my transition from photographer to writer, I went to work for a publishing company that produced journals for veterinarians. I was hired as an editor and later became the production manager. One of my responsibilities was to provide photos for the various publications, including one called *Agri-Practice, Journal for the Large Animal Veterinarian.*

So I shot cows. It was a fun assignment. Pat and I used to drive all the back roads from Santa Barbara to Santa Maria on Sunday afternoons searching for cows with that certain-something-special that made them star-quality. Refined bovines. Sterling steers. The moo-vers and shakers, if you will, of California cattle.

Early spring was my favorite season to shoot because the morning light is beautiful, plus, because of the winter rains, the cows have plenty of grass to eat, so it was much easier to get them to smile.

Naturally, I had to shoot a lot of vets for the journals, too, and I always tried to capture them in their natural surroundings as well.

Like the time I photographed a doctor for an ad. I had him lean on a fence next to his open mailbox, reading the latest issue of *Agri-Practice* that had just arrived.

"Would you ever actually do this?" Pat asked him after the shoot.

"Only if I wanted to get the livestock to laugh," he said.

Then there was the time I visited a dairy in Santa Maria. I'd never been to a dairy before, but being the always-prepared-professional, I showed up with plenty of film, an extra camera body, several lenses, a handheld flash — everything I figured I'd need to capture a day at the dairy for our readers.

When the large-animal vet showed up he looked me up and down and smiled. Then he opened the back of his truck, sat on the tail gate, and put on a pair of coveralls that went up to his neck and a pair of rubber boots that went up to his knees.

"This way," he said, leading me into the barn.

A moment later, as I was standing there in my tan Dockers and white tennis shoes looking at the derrieres of forty well-fed dairy cows, I discovered the reason for the rubber boots.

"Next time," he said, "you might want to rethink the jacket, too. Leatherwear makes them nervous."

The cow closest to me then demonstrated what they did when they got nervous, and the next day I turned in a reimbursement

voucher for two rolls of film and a new pair of Nikes.

The great thing about those Sundays of yesteryear was that my wife and I would always celebrate our Ansel Adams-like successes by treating ourselves to my kind of gourmet lunch. From barbecued tri-tip sandwiches at Cold Springs Tavern to Danish smorgasbord in Solvang while watching tourists try to get out of their booths after 53 frikadellers, four pounds of mashed potato and enough tilsit cheese to support two dairies, we ate lunches to remember.

But, alas, times change.

The waitress reappeared. My wife ordered the wild mushroom raviolis and I got the steamed mussels, which I wasn't all that excited about. What I was excited about was the fact that the waitress prominently displayed her name right on her chest.

"Thank you, Heidi," I said. I extended both hands palms up. Apparently she was not hip enough for a "skin me" because she just slowly backed away and left.

"I wish everyone wore name badges like that all the time," I said to Pat.

"Name badges? You mean like at a convention?"

"Exactly. Wouldn't it be great? You could walk right up to a total stranger and call them by name. Maybe make a real clever opening, like when I meet someone named Frank I could say: 'Hey. You be Frank and I'll be Earnest.' That line always gets laughs, and I'll bet there are a lot of Franks out there who'd really appreciate it, if I just knew who they were. Whataya think?"

"I think we should schedule more tests at the clinic. Concentrate on that part between your ears."

"Seriously. Maybe I'll start wearing a name badge all the time. See if I can't start a trend."

"Why don't you just walk around in your underwear? Those have your name on them."

"I told you that was for security reasons at the gym."

"Oh yeah. I remember. In case there's an earthquake and all the gym bags fall into one great big heap.

Heidi returned to take our order. Before she could bolt again, I stood, put my arm around her shoulders, cleared my throat, and addressed the entire restaurant.

"This is Heidi, our waitress," I said loudly. "And my name is Ernie. I grew up in New Hampshire, I like to play golf, and I'm a Cancer."

The crowd stopped mid-mouthful, looked at me and then at Pat, who now had her head lowered and her hand on her forehead, shielding her face.

"I'm advocating we all wear our names, like Heidi here, all the time. Whataya say?"

I never really got an answer to my proposal, as Pat grabbed my elbow and gently lead me out of Patrick's Sidestreet Café, mumbling something about "one of these days being able to finish a lunch in peace."

# Chapter Seven
## IN THE EYE OF THE BEHOLDER...

The next weekend, my wife said she wanted to go to LACMA. I was all excited because I thought LACMA was the acronym for the Lakers Cheerleaders Modeling Agency. Turns out I brought my zoom lens for nothing.

"You mean we drove all the way to Los Angeles to see a collection of dresses?" I said, as we stood in the plaza at the Los Angeles County Museum of Art (LACMA!).

"They're not dresses, they're 20th-century opera and ballet costumes."

"Opera and ballet?"

I tried to bolt, but Pat pushed me through the door right into a tour.

"The historic past and faraway places are the sources of inspiration for the thirty costumes that designer Erté created for Madame Ganna Walska," the tour guide said. "You may better know Madame Walska for her famed Lotusland estate in Montecito."

"See," my wife, who is a docent at Lotusland, whispered. "Now aren't you more interested?"

Lotusland is an amazing estate with 37 acres of gardens that I'm damned glad I don't have to weed. I've been there a number of times, but not since the unfortunate incident behind the Bunya-Bunya tree. Word to the wise: When you first arrive and the facilitator

suggests you use the restroom before your two-hour journey, take her up on it. The organic gardens may be all natural, but they prefer their own watering system.

Another word to the wise: Don't put your Rolex watch on the lodestone just to see what happens when it gets magnetized. It killed mine. I was tempted to send it back as defective, but the Internet site that I bought it from is down until further notice.

My favorite part of Lotusland is the topiary garden. I suggested to Christy when she was designing our new front yard that she construct a giant topiary of me holding my book. Then if Oprah ever happened to drive by our place, she might stop and ask me to be on her television show.

I was about to fully share my interest level in Ganna Walska's dresses with my wife when I took a moment to scan the gallery room at LACMA and suddenly developed a real appreciation for some of the "other" incredible costumes.

"Check out that guy," I said to my stepson, Jon, who lives in Santa Monica, and had joined us at the museum. Jon is number four child in the hierarchy and works in the film industry as an art department production assistant. He has worked on such films as "Sideways" and "The Family Stone." I live vicariously through Jon. And I know as soon as he gets a little higher up the ladder, he'll find someone to buy the screenplay that I'll someday finish.

Jon and I watched as a definite non-follower of the Atkins diet waddled by wearing bright yellow shorts and a shirt that depicted the topography of the Hawaiian Islands.

Across the room was a woman who had silver lamé inserts running down the legs of her designer jeans and earrings that could have doubled for wind chimes. Beside her was a woman wrapped completely in what looked like multi-colored Saran wrap. She was standing with a man dressed in black. Probably so he wouldn't reflect badly on her.

"Welcome to L.A.," Jon said. "It gets weirder on Hollywood Boulevard."

Yet another guy walked by wearing a Lakers cap and jacket. It's good to know I wasn't the only guy duped by that LACMA thing.

That's when I realized we all wear costumes because we want people to know who we are and what we stand for. I wondered what impression I imparted.

I struck my best John Steinbeck pose. "Do I remind you of anyone famous?" I asked Pat.

"Yeah. Moe of the Three Stooges," she said.

"Wow. Cool."

I was tempted to share a few noogies with a bald guy that looked like Curly but Pat grabbed me.

"Jasper Johns is right next door," she said.

"Is that a bar? Because I could use a drink."

Jon was an art major at UC Berkeley before he got into film. He explained that Jasper Johns was a famous painter of numbers.

"You mean by-the-numbers? 'Cause I used to do that myself

— on black velvet. Now that was art."

A moment later I realized what Jon had meant. On every wall was a sketch, painting or lithograph of either a single number from one to nine or, my favorite, a collection where he painted all the numbers on top of each other.

Several people were pondering.

"It's just incredible how he's blurred the lines between the

real and the abstract," one of the ponderers said.

"My yes," another ponderer said. "The transition from the simple to the complex and back to the simple again leads one to wonder, does it not?"

"Certainly makes me wonder," I said.

The ponderers turned to me and cast an appreciative eye.

"I wonder... Do you suppose he ever woke up in the middle of the night screaming, 'I can't stop painting numbers. Ahhhhhhhh. Help me. Help me?'"

The ponderers quickly moved away and a museum guard started heading toward us, so I hid momentarily behind a statue in another room.

"Let's go upstairs," Pat said when the guard left. "They have a modern art exhibit up there."

Next thing I knew I was standing beside an eight-foot tall stack of dishes. If this was art I never should have let my roommate days get away from me. We had stacks at least that high — with food still attached.

I was beginning to think I didn't understand art when the three of us wandered into a garage. I'm not kidding. Someone had completely recreated an old wooden building with dirty, discolored, stuff taking up every available space. There was an old Dodge Dart that looked like it was in the middle of a last ditch effort of repair. There were rusty old box springs, broken toys, pill bottles, every tool you could think of, even a moose head.

"Why are you crying?" Pat asked.

I quickly wiped my eyes. "If this is art," I said. "I left a small fortune back in New Hampshire."

Jon consoled me by reminding me that I still might have a few bucks' worth in my office in Santa Barbara.

"On to the next phase of our family weekend," Pat said as we headed for the car.

"Where to?" I asked.

"Burbank."

"Burbank?" I looked at Pat. "What the heck's in Burbank?"

Some of you may remember that one of the running gags on the television show "Laugh-In" was that it was coming to you from beautiful downtown Burbank. Every time they said it everyone on the show laughed.

"Oh, I get it. They opened one of those exclusive timeshares with everything from in-room Pilates to an air-conditioned golf course, and they want us to sit through one of those no-obligation, ninety-minute presentations, right?"

"Actually, I booked us at the Holiday Inn," Pat said.

I waited for the punch line. She just kept driving. I began to get nervous.

"Clown convention?" I asked hopefully.

"Nope."

"Midget wrestling?"

"Unh, unh."

"The Miss Nude Universe Pageant?"

"Not a chance."

"Well what then?"

She smiled. "It's karaoke night."

"Karaoke?" I said flatly.

"It's a party for Michael. The whole family will be there."

Our nephew, Michael, is an actor who was moving north to re-bankroll his dream. Ironically, Jon had just recently moved south to Los Angeles to make films. I think that sums up the traffic on the Hollywood Freeway —"reelists" moving in, "realists" moving out.

Because this was Hollywood, a lot of actors and other performers have to look for creative ways to stay sharp. Michael had discovered an affinity for the karaoke circuit and performed in several different L.A. bars a week.

"I'm all for a party," I said, "especially if it involves beer and singing, but I don't have my Elvis outfit with me."

"See," my wife said to Jon. "The evening is already starting on a positive note."

According to MapQuest.com, it's 10.40 miles from LACMA in downtown Los Angeles to the Holiday Inn in Burbank. They estimate a total driving time of twenty-four minutes. Obviously, they tested this route at three a.m. when traffic actually moves. Still, we allowed ourselves extra time because karaoke bars fill up fast.

We got to the bar at the Holiday Inn just as the festivities were about to begin. I looked around for the bar because I, for one, sing much better when I'm snockered.

"No you don't," said Jon. "You just sing louder."

I looked around our table. Bob and Sally (Michael's parents), Michael, Pat and Christy were all nodding in agreement.

What do they know? I grabbed the huge song list. "Wow. Here's one of my favorites. 'Does Your Chewing Gum Lose Its Flavor on the Bedpost Overnight' by Lonnie Donegan. Remember that one?" I sang the first verse, then sang "...something, something, something... Oh, does your chewing gum lose its flavor..."

Several people glanced over at our table. My wife nudged Christy.

"How about buying me a drink?" Christy said.

I stopped singing. "But you don't drink."

"It's such a special night, I thought I'd start."

"Okay, 'Wild Thing,'" I said, then sang my way to the bar, pointing at people. "You make everything... groo-vy..."

While I was at the bar, they called Michael's name and he did a great rendition of "Play That Funky Music, White Boy." The crowd went wild with applause. Then a woman got up and sang "All That Jazz" from the movie "Chicago." These people were good. I had my work cut out for me.

I sat back down. "Hey what happened to my song slips? I have to turn those in or I won't get on the list."

"Someone came by and cleaned the table," Pat said. "Guess you'll have to start over."

I grabbed the book and started thumbing through it again, as several people got up and sang, including a drunken birthday party

group who appropriately sang "Lean on Me."

That's when I found the TV Theme Song category. "Oh, man. They got 'Rawhide.' Dum-de-da-dum-de-da-dum-de-da-dum... Rawhide... dum-de-da-dum-de-da-dum-de-da-dum..."

Pat nudged Jon. "Ouch... I mean, I could use another drink," he said. "Me, too," said Bob and Sally in unison. Even Christy held up her glass again.

The bar was now three deep with the birthday group. By the time I got served, Michael was screaming his way through "Rock and Roll" by Led Zeppelin. At the end, everyone applauded and the D.J. shut off the equipment and started packing up.

"But I never got to perform," I said.

The others looked sympathetic. "Maybe next time, dear," Pat said.

Then we all stood while someone took a "happy family" weekend photo of us and there was a big send-off for Michael from all the regulars with much back-patting and melodic congratulations. Just before we all retired to our rooms at the Holiday Inn my wife reminded me that we were going to the library in the morning. Right, the big miniature show, but that was tomorrow. I did a quick visual sweep around the bar just in case she had been wrong about that clown convention, but there were no signs of any clowns.

Oh well, I needed a column for the *Montecito Journal* anyway, so I retired to our room with LACMA on my mind. Hey, that could be a song...

# Chapter Eight

## FINDING EDUCATIONAL HUMOR

I knew the minute I bought the bag of rocks that I had become "a lifer." Purchasing the four-dollar stick just confirmed it.

"Remind me what the stick is for," my wife said as we left the Huntington Library in Pasadena and headed for the car.

"Root work," I said.

"Do you think the roots will know that they are being dug at with a professional stick, versus, say, a stick stick?"

I swapped hands, moving a plant with a gnarled root called a *portulacaria afra* with squishy green leaves that looked a prop for Star Trek to the left hand and the bag of rocks to the right. "Yes," I said with conviction.

It had all started innocently enough one day not too long ago when Pat thought I was showing signs of stress.

"The television's broken! The television's broken! Oh no! Oh no!"

She removed the remote from my hand. "This is the garage door opener."

"I wondered what that banging noise was."

"You need to get out of the house. Do something relaxing. Maybe take a class."

"A class? Like school? With homework?" I quickly grabbed

a different remote, pressed frantically, and somewhere in the house a toy Batmobile rammed into a formerly sleeping cat. "Rrrreeeeooooowwwww."

"Seriously," she said, handing me the Adult Education Schedule. "What about this?"

I put down the handful of remotes. Truth was, I had just pitched *Chicken Soup for the Soul Magazine* a piece for their back-to-school issue and the due date had really snuck up on me.

Lesson for you wannabe magazine writers: magazines work months ahead. I once had to write a Valentine's Day piece in August and a New Year's Resolution piece in June. Fortunately for that one, I still had resolutions I hadn't used yet from several years back.

I looked at the Adult Ed schedule again: "The Art of Bonsai. Quiet your mind and learn to focus while shaping miniature trees..." Wow, that did sound relaxing...

"Hi, I'm Ernie and I'm here to quiet my mind and make a tree."

"Have you ever pruned before?" the instructor asked.

"Once when I fell asleep in a hot tub."

"Funny. You should write humor."

I was tempted to tell her I already did and I was only there to make fun of her and everyone else in the class, but something told me to wait on that revelation.

I sat down next to a man who was painstakingly coiling wire around a branch on a tiny fruiting crab apple tree. "This is how we shape them," he said. "I need to move that branch an inch to the left."

"How long will that take?"

"About a year."

"And my wife thinks I'm slow to move."

There were about a dozen people in the room all hunched over a variety of tiny trees including maples, oaks, pines, and junipers. Every now and then someone who had studied their tree from all angles would reach out and snip off a quarter-inch shoot, smile, and then study the thing again. I was quickly to find out that bonsaiists

live to prune. Some of the more experienced people in the group had brought in three or four trees and after a few moments the room literally rang out with the musicality of clipping sounds. One guy named Ed liked pruning so much he brought in plants in five-gallon buckets that had more branches than Bank of America. To me they looked like they would have been a challenge for Paul Bunyan to fell in the wild.

All-in-all it was a wild and crazy bunch but I was only there to try it. I thought I could slip in, grab some material for my column when no one was looking, and get away undetected.

How many other lifers have had those same thoughts, I wonder?

"Over the next few weeks, you will trim a Bonsai, shape it with wire, create a soil mix, repot and learn the value of fertilization," the instructor said as she handed me a plant.

"Wow. That's a lot. What if you don't finish?" I asked the guy beside me.

"You take the class again."

"Does she give you a plant each time?"

"Yup. Sometimes two."

"So how long have you…"

"Five years," he said.

"It's been six for me," a woman added.

Pretty soon others joined in, volunteering their years at The Art of the Bonsai class with bravado like repeat offenders bragging about their ongoing sentences in the prison yard.

I should have bolted right then and there. Defaulted to my second column option, the merriment of macramé.

But I didn't. Instead I picked up that pair of shears, snipped a little piece of juniper and watched it fall to the table. It was a powerful moment. So I snipped again and again and again. I felt like one of those famous sculptors who chip away for months at a solid granite block until a statuesque naked woman appears. I couldn't stop. I didn't want to stop.

That was six classes and two dozen trees ago. Most of the oth-

ers I first met are still there. Very few people have come, done one or two quick terms and moved on, but I thought maybe I still had a chance to finish all my projects and hang up my branch cutters once and for all.

Then... I heard about the California Bonsai Society's annual show and sale at the Huntington Library. More than 100 bonsais on display, plus demonstrations and a bazaar. I was drawn to it like Richard Dreyfus was drawn to Devils Tower in "Close Encounters of the Third Kind."

I wasn't alone of course. They came from all over. Some of them knew each other, but even us newbies felt an undeniable bond as we shared tales of prunings past and present.

One man told a gut-wrenching story about wiring too close to the crook of a major branch and then when bending actually snapping it off. There were few dry eyes in that room.

Another man told us about stowing some tropical plants in his luggage in Florida, which by the time he reached the West Coast had begun sprouting in his underwear. Some laughed, but most of us wanted to know what brand of underwear he thought most fertile.

I felt myself being drawn in further and further. "We'd better go," I said to my wife.

"Let's check out the sale," she said. "You don't have to buy anything, just look."

Yeah. Right.

They had tools, pots, turntables, stands, accessories and of course plants small and large. I knew what buying a plant meant. Another class, which would turn into another and another. I was helpless.

A hundred bucks later, we were leaving when I spotted the decorative rocks. I wanted one for my gnarled root, but there were more than a dozen to choose from.

"You can have them all for five dollars," the vendor said. "And I'll throw in this hardwood stick for another four..."

Walking back to the car, I realized I'd run into another bonsai

quagmire. I didn't have enough space to display my trees and rocks in our backyard.

"I've got an idea," Pat said. "On the way home we can stop in Carpinteria and get a shelf."

After searching for several hours we finally found the perfect shelf in a remote corner at Island View Nursery in Carpinteria. It was wrought iron, had a nice finish, a pleasingly ornate design, and four shelves. There was only one problem.

"You're going to put this in there?" the nursery guy asked after helping me carry it to the parking lot.

I let down my end of the unit and followed his gaze into the back of our Ford Escape. "I'll just lay the back seats flat."

"They are flat."

"Oh yeah."

"We can move the front seats forward," Pat suggested.

"Great idea."

"More," we yelled from the back of the Escape. She pulled her seat even closer to the dash.

"More."

She moved it another inch. "That's it," she yelled.

Fifteen minutes and fifty yards of rope later, with our knees touching the dashboard and our faces so close to the windshield we were clouding it with our breath, we were on our way. We decided taking a back route home might be safer so we headed for Route 192 through the wilds of Montecito.

"I'm losing the feelings in my feet," Pat said. This wasn't good. She was the one driving.

"One good thing. If we get into an accident, we won't have to worry about being thrown into the dash. We're already there."

"That's a plus."

"Of course, even if we survive the crash, the air bags will most likely decapitate us."

"Swell."

"And our heads will probably fly out of the back and roll off

Photo By Pat Sheppard

192 down into a canyon and they won't be found until next spring."

"You know, sometimes it's hard to imagine that you write humor."

I started thinking about the humorous aspects of our current situation and bonsais in particular and realized that part of the art of bonsai is putting miniature trees into small pots so that they appear larger. I wondered if we appeared larger to passing motorists. Hmm, now we were the art of the bonsai'd people. Maybe I could pitch that idea to someone. People becoming plant-like.

Somehow we made it home and we walked into the house in a sitting position. Later, when we straightened out, we wrestled the shelf into the backyard and it was perfect except...

"I'm going to need more trees," I yelled out.

Pat's response, fortunately, was muffled.

# Chapter Nine

## VISUALIZING A SEA CHANGE

Approximately twelve to twenty miles off the coast of Santa
Barbara lies Channel Islands National Park. Made up of five islands
— Anacapa, Santa Cruz, Santa Rosa, San Miguel, and Santa Barbara
— they have been isolated for thousands of years, so each island has
unique animals, plants, and archeological resources found nowhere
else on Earth.

April is a great time to visit the islands — especially Anacapa,
because small flowering tress called coreopsis bloom for just a few
weeks and attract flocks of seagulls (not the singing group) who nest
on top of these trees.

Anacapa is the closest island to the mainland. It is comprised of
three small islets, East, Middle and West. Exploration is permitted
on the East islet accessed by the Landing Cove, and a small beach
on the West islet called Frenchy's Cove. The middle islet and most
of the western islet remain a wilderness area set aside for nesting
seabirds like the endangered California brown pelican. However
visitors can get up-close looks at many types of seabirds on East
Anacapa all year round.

So, after the wilds of Los Angeles, we decided to visit the island
with Bob and Sally. Now, Park Ranger Morgan was leading us
single file on a narrow path atop East Anacapa Island, pointing out

unique flora as she went along.

"That's an Indian Paintbrush," she said.

"Indian Paintbrush, pass it on," people chanted over their shoulders.

I repeated it to my brother-in-law Bob who was just behind me, and he repeated it over his shoulder.

"Indian Paintbrush... Indian Paintbrush... Indian Paintbrush..." echoed musically on the narrow path behind us. Several people readied their cameras and one guy looked it up in his botanical book and said "Ah-ha."

"Island Morning Glory," rang out a few moments later. Again, it went through the trailing line of hikers like a secret code.

"Keep your eyes open for a restroom," I whispered to my brother-in-law, "I gotta take a leak."

"Ernie has to take a leak," Bob said over his shoulder before he realized that might not have been meant for everyone.

Still, "Ernie has to take a leak... Ernie has to take a leak... Ernie has to take a leak..." resounded its way through the line and botanic guy thumbed frantically through his book, looking for an accompanying drawing. Fortunately, he didn't find one.

Our Channel Island adventure had started several hours earlier with a one-hour boat ride out of Oxnard Harbor that everyone was really enjoying until the skipper gave us important seafaring instructions.

"Remember, if you feel queasy, do not launch your lunch into the head as it will clog and overflow creating a stench that's hard to even describe. Also, do not launch into the wind, as it will spray all over everyone on deck. And, do not launch in the snack bar where, by the way, if you haven't had lunch we have a wonderful selection of deli meat sandwiches, hardboiled eggs and chunks-o'-fruit yogurt."

Once the gagging stopped he had some more good news.

"That's where we land," he said, pointing at an inlet ahead not much larger than the boat.

The so-called dock consisted of a cement block rising some twenty feet from the water, containing a rusty metal ladder that we needed to negotiate hand-over-hand while the boat was bobbing in place in order to reach the 157 steps that lead precariously up the sheer face of the cliff to the top of the lava rock island.

Did I mention that this trip was a gift from the kids? I think they bought it for us right after we gave them copies of our wills.

Apparently, we didn't lose anyone getting onto the island, but several of the crew were happy to point out that we still had to get back on the moving boat for the return trip.

In the meantime, we were following Morgan through a blooming coreopsis forest, alien-looking plants that are totally inactive almost all of the year.

"Sound familiar?" my sister-in-law Sally asked.

Bob and I were now resting on a small bench checking to see if we'd brought any beer with us. "Huh?"

A few minutes later we came to the end of the island. "This is Inspiration Point," said Morgan. "Don't get too close to the edge. The soil on the cliffs is unstable and undercut."

Photo By Ernie Witham

Instantly, everyone leaned over to get a better look. I poised my camera, but after a few minutes it was obvious no one was going over the edge. Besides, my attention was diverted by dozens of western gulls that I thought were having one-on-one wrestling matches, then I realized they were openly mating.

"Check it out," I said. "It's like seagull pornography. I wonder if there are any underground nature tabloids or pay-for-view nature channels that I could sell photos to?"

"You're not supposed to bother them," my wife said. "Says so in the book.

"She's right," said Sally.

"What're they going to do, throw me off the island?"

I laughed, then moved in closer. Suddenly a number of gulls started squawking loudly. Then more and more until it was a cacophony of angry gulls…

It was lonely sitting on the dock waiting for the boat to land, even with the two beefy rangers who had escorted me there and I hadn't even thought to grab one of the coreopsis to possibly bonsai. Still, I'd be the first one on board. And I had my heart set on one of those luncheon meat sandwiches, which, if it was rough on the way back, I was going to share with everyone on deck.

~

Bob and Sally, who live in San Jose, California, are retired. Okay, so that's one real advantage to having a job, besides that paycheck thing I mentioned earlier, and the coffee breaks. Still, eventually even unemployed — I mean sole proprietor business owners – have to retire and I wondered what it would be like and what there was to do when you retired. So when we got back to our house in Santa Barbara I asked Sally about some of the projects she's involved with now.

"I've started collecting fruit peels," she told me. "I have three jars full already."

Quickly, I closed the windows so the neighbors wouldn't hear. Then I explained to her that statements like that could earn her a one-way trip to a country estate where the music is soft and the walls are quilted.

"You don't understand," she continued, enthusiastically. "See, after I have enough fruit peels, I'm going to turn them into candy and send them out as gifts."

"Riiiggghhhttt," I said. I had an urge to put all the sharp knives on the upper shelves. Instead I just handed her an orange to keep her amused until my brother-in-law, who's also recently retired, came back.

"Where did Bob go anyway?" I asked.

"To get another book on genealogy. He wants to be the first person to trace his family roots back to the Neanderthals. Isn't that exciting?"

I thought about the word exciting. If I looked it up in my Funk and Wagnall's, would it say: "The art of collecting fruit skins for fun and profit?"

I figured this was something I should talk to my wife about, so I waited until Bob and Sally had gone to bed, then I turned off the evening news, poured us each our nightly drink, and made up a plate of anti-aging supplements.

"Is tonight the night we take gingko biloba?" I asked.

"I can't remember," she said. "Is that a Rolling Stones tee-shirt?"

"Yup. Found it in the bottom of the closet. I think it shrunk a little."

"Yeah, about three decades worth. What's this all about?"

"I think we should start preparing for an activity filled retirement. You know, take rock climbing lessons, things like that."

"Rock climbing? You don't even like to stand on a chair to replace a light bulb. Now you want to scale cliffs?"

"Okay, maybe not rock climbing. How about competitive sailing? Or scuba diving? We could dive with the dolphins and swim

with the sharks."

She tossed back a couple of vitamin E tablets. "You'd probably just bother the sharks and get kicked out of the ocean."

I ignored her reference to the mating seagulls. "I'm serious. I don't want to end up accumulating cats or becoming vice president of a bird-watchers club. I want to live life to the fullest. Explore exciting new horizons. Throw caution to the wind. Are you going to finish your herb tea?"

"No, you go ahead," she said.

I gulped it down, belched, and then ran my forearm across my lips in a manly fashion. This was a situation that called for a proactive approach. I slammed down the teacup, turned my International Wine Festival cap around so the visor was in the back, and hiked up my relaxed fit, extra-room-in-the-seat jeans.

"Where are you going?" my wife asked.

"To search the Internet until I find a fitting retirement lifestyle," I said. "Don't wait up."

The next morning I was up early studying some of the websites I had bookmarked the night before, featuring rogue horse round-ups, wilderness survival schools, and parachuting lessons, and I had just opened one on river rafting, when I heard a voice behind me.

"That's a good one," said Sally. "Especially in the spring when the rapids are really churning."

"And dangerous," said Bob. "We tipped a few times."

I turned around in surprise. "You guys have done this?"

"Sure, and next month we're going whitewater kayaking."

"But what about that fruit peel thing?"

"We like doing stuff like that, too," said Sally. "Tonight we are all heading north to Paso Robles. We want to take you to this Basque restaurant in San Miguel we heard about. It's supposed to get pretty wild."

Paso Robles is the next major California wine-growing region in between the Santa Ynez Valley and Napa Valley in the north. I've been there a few times, but I wouldn't exactly call it wild. I mean

Sally may talk a good game, but I'm betting this Basque place is a snooze.

~

I'm not sure which part was most amazing: eating something called Migas... drinking from a group bota bag... or when my "often-quite-reserved" sister-in-law Sally stood up and started belting out show tunes.

"OOOOOOOOOOOOOO — OAK — LA — HOMA, where the wind comes racing down the plain....! Come on everybody!"

Sally, who was the only one standing, smiled widely and thrust her arm out toward a guy at the end of the long table, who was warbling out his own rendition of "Oklahoma," which was in the key of Sauvignon Blanc, I think.

"Do you know her?" the young lady on the other side of me asked.

"Ahhh, no," I said. "But I think she's with that guy."

I pointed to my brother-in-law, Bob who had a wine glass in each hand and a hunk of Albacore with tarragon/butter sauce stuck in his beard from the hors d'oeuvres portion of the seven-course/seven-wine Basque dinner we were enjoying.

That's when the bota bag came to me. I hadn't used a bota bag in a while, but it turns out it's kinda like riding a bicycle — you never really forget.

"Go go go go..." the forty or so other diners chanted as I hoisted the bag, began a perfectly formed stream, and stretched my arms outward for dramatic effect, while trying hard not to get any up my nose — a mistake one only needs to make once in life.

In the background, Dallas Holt, the owner of the 10th Street Vineyard Café, wearing a red beret that matched the one on the wild boar's head hanging over the fireplace, was hitting a pot lid with a wooden spoon. He was also chanting...

"No lips on my bota. No lips on my bota..."

Photo By Sally LaMere

I stretched my arms further and opened my mouth wider.

"Know what a bota bag is made from?" I heard Bob ask my wife. He paused for effect. "Bull scrotum," he said, answering his own question. Then he and the guy on the other side of him laughed loudly and slapped each other on the back.

I stopped my stream, and quickly passed the bota on, wiping my hands vigorously on my pants.

"Well, we're definitely not in Santa Barbara anymore," my wife whispered.

Which was true. We were in San Miguel, just north of Paso Robles. An area I formerly thought qualified for the Sleepyville USA title. Matter of fact, when Bob and Sally suggested dinner in San Miguel, I figured they wanted to avoid a raucous Santa Barbara weekend of dinner salads and a movie and just share a few quiet moments together.

"NEW YORK. NEEEWWWW YOORRKKKKK," Sally finished her latest a cappella.

I looked down at her feet, nervous that she might be wearing taps and about to perform some kind of high-energy shuffle, but she just took a few bows, sat back down and reached for her glass.

"Who are these people and what have they done with Bob and Sally?" I whispered.

My wife shrugged. "I lost track of them briefly at the hotel. Maybe they got cloned or something."

"Could be simultaneous hormonal spikes," I suggested. "Or, maybe they're both doing some kind of new herbal supplement."

"Well, let's make sure we ask where they got it!" The next course was placed in front of us. It looked like a giant pasty.

"It's pulled beef," co-owner Caren Holt yelled out over the din of multiple conversations. She, too, was wearing a red beret and pounding on a pot lid with a wooden spoon. The Holts probably had some kind of Basque rock group on the side. "It's served on steamed spinach, with garlic mashed potatoes on top, all rolled up together in filo dough, which is topped with a Cabernet mushroom reduction sauce."

Everyone cheered.

"Know where they get pulled beef?" Bob asked. Before he could answer my wife shoved a piece into his mouth.

The room was getting louder by the minute. I looked at my watch. We'd been eating and drinking "Basque-style" for almost two hours.

"Cabernet Sauvignon?" asked Lisa Pretty, co-host, and owner of Pretty-Smith winery.

I hesitated.

"Anyone know 'Give My Regards to Broadway'?" the warbler yelled. I could feel Sally rising to the occasion beside me.

"What the heck," I said. "When in San Miguel, be San Miguelian."

~

The next day Bob and Sally headed north to San Jose and we

headed south to Santa Barbara.

"You know," I said to my wife, "if I do write a book about our humorous adventures, Bob and Sally have definitely got to be in it."

"No doubt about it," said Pat. She hesitated. "Am I going to be in it?"

"Oh yeah."

"Then maybe you should change my name."

"What? Everyone knows you. I can't suddenly have a wife named 'Bambi the Bombshell.'" I spaced out for a few seconds.

"What are you thinking about?" Pat asked.

"Ah, nothing."

"You're thinking about someone named Bambi, aren't you?"

"Of course not," I said trying to clear my head of Bambi the Bombshell thoughts. "How about Tish? You know, short for Patricia."

She mumbled something about coming up short in life, but I may have misunderstood.

# Chapter Ten
## FAME IS WHERE YOU FIND IT

May is the month when a young (okay, old) guy's fancy turns to sports. And, as any successful athlete will tell you, achieving greatness in any sport requires a combination of fitness, discipline and careful preparation.

"Lucky golf socks. Check. Lucky golf shorts. Check. Lucky golf underwear…"

"You have lucky golf underwear?" Pat asked.

"Well, yeah. Remember that time I got that hole in one?"

"That was five years ago at a miniature golf course."

"And your point is…"

She sighed. "Well, I hope you at least wash them once in awhile."

Wash them? I started to explain how lucky underwear works then thought better of it. Besides I still had the rest of my checklist.

"Large bag of organic nuts, seeds, grains, fruits, vegetables, berries and herbs, a synergistic combination specifically designed to support and enhance all seven body systems. Check."

My wife sniffed the bag. "Smells like a farm. This stuff better be really good for you."

"Oh it is, and extremely important to my personal well-being as well as the well-being of my game."

I grabbed the next item on my list. "Large bottle of Smart Water with electrolytes. Check."

"Smart water? What? Were they out of lucky water?" Pat asked.

"I'll have you know," I said, reading the label, "that Smart Water comes from a very special artesian spring in Connecticut. Then they vapor distill it to scrub the impurities from the water molecules and add a balance of magnesium, potassium, and calcium."

"Wow," she said, "I guess you really do take sports seriously."

"A thing worth doing is worth doing right," I said. "Besides, we athletes like to get all the health benefits out of a game that we can."

I basked momentarily in the look of admiration in my wife's eyes. Then I headed to my car. Just before I got there my cell phone rang.

"Meet you there," I said. I opened the trunk and tossed my Smart Water and organic mix into a large bag that contained half-a-dozen other fancy water bottles and numerous bags of trail mix.

A short while later I met my foursome at a sports bar and ordered the hungry golfer special, which consisted of fried eggs, fried potatoes, butter-laden toast, pancakes, bacon, ham, sausage and coffee...

"I certainly hope the coffee is organic," I said.

"Right," the waiter said.

"Great day for athleticism, huh?" I said to my friends.

"You bet," they said, digging into enough food for a small country.

"So, where was I... oh yeah, I need to buy a new lucky golf towel."

"What happened to the other one?" Rich asked.

"I set my cigar down on it when I went to putt and burned a hole right through it. Since then, it's lost its mojo."

"I know what you mean," John said. "I used my lucky cap to soak up the gin and tonic I spilled in the golf cart. I haven't broken eighty since then."

"You never broke eighty," we all said.

"No, and I never will until I get a new lucky hat."

Guess I couldn't argue with that. It's the one thing a lot of non-sports-folks don't understand about athletics – even after toning the body and sharpening the mind you still need that extra edge that something like five-year-old lucky underwear offers — even if it is a bit drafty when the wind blows up your shorts.

"We playing nine holes today or eighteen?" someone asked.

"We have to play eighteen. Otherwise I'll get home too early and have to help my wife with yard work."

"I'm with you. My wife's got a whole list of chores I'd like to avoid."

"In that case, we'd better have dessert," I suggested. There was general agreement.

~

Besides the loss of hearing and that name-remembering thing, another new term has entered my everyday vocabulary – age-related. I usually have a physical exam once a year in May and it seems like lately every time I visit the doctor for my checkup he says the same "old" thing.

"Doc, it hurts when I bend over."

"That's normal for a guy your age."

"And I'm really sensitive to cold things."

"That's normal for a guy your age."

"And I'm fidgety and have trouble relaxing."

"Yes, I noticed that, but if you'll stop complaining for just one minute we'll be done with your proctology exam."

Anyway, the good news is I'm not alone in this age-related dilemma, as was evidenced by the golf outing with Rich and two of my other golfing peers, John and Roger. Together we had enough age-related problems to fill a medical journal.

"Can you pull your seat up? Lately, my calves tend to cramp when my knees are forced into my chin."

"You mean like when you fall into a sand trap?" Rich asked as he pulled his seat forward one notch.

We thought carpooling would be a good idea so were driving from Santa Barbara to the Alisal River Course in Solvang in Rich's truck. It's one of those super cabs with a back seat big enough for two grown men, providing the men are four-foot tall and don't have

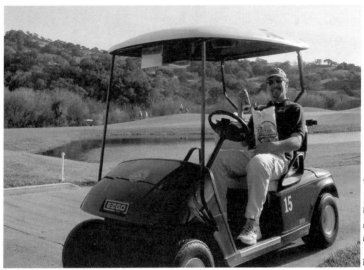

Photo By Pat Sheppard

any appendages.

"One good thing about sitting back here," John said, "is that I don't need a seat belt. If we have an accident I'll only be thrown forward about four inches."

"Of course that could be enough to throw your back out," I said. "Mine went out once just bending over to tie my shoes."

"The only way you could bend over far enough to reach your shoes is if they were on your knees," Rich said.

"Yeah, just wait until you get to be my age," I said.

"I am your age," he said.

"Right, well be careful tying your shoes that's all I'm saying."

"I knew someone who threw their back out sneezing," Roger said.

"Great. I've been having a lot of sinus problems when I golf," said John. "I've developed allergies in the last few years."

"Me too," both Roger and I said.

"That's because you guys spend so much time in the woods. It's not as bad out on the fairway."

Rich always offers to drive. That way he can say whatever he wants and doesn't have to worry about getting beat up on the way to the course.

"I used to have back problems," I said. "Now I have golfer's elbow. The doctor said it's because I have a steep swing plane and I take divots that are too large."

"You mean it's from hitting the ground instead of the ball," Rich said.

"Yeah, but in an athletic manner."

"I've got golfer's elbow and tennis elbow in both arms," Roger said. "I have to take Aleve before I play."

This comment produced a chorus that sounded like a commercial on the six-o'clock news.

"I take Aleve."

"I take Aleve."

"I take Aleve."

We all checked our watches to see if it was time for another dose.

The other expression that's now become quite common in my everyday vernacular is heredity. The first thing the doctors want to know is if your parents had something so they can say: "Probably runs in your family."

"Do you think I inherited this problem from my mother, Doc?" I asked.

"I don't know. Did she have jock itch?"

Turns out today's group had some heredity issues, also.

"I'm going to cholesterol class," said Roger. "My cholesterol is on the rise."

"Kind of like your handicap, huh?" Rich said.

We all looked at Rich and he smiled and mouthed the words.

"Careful, we're doing sixty miles per hour."

"What do they teach you in cholesterol class?" John asked.

"How to eat and drink."

"What have you learned so far?"

"That red wine is good for you."

"Wow. I've been self-medicating every night and didn't even know it," I said.

Rich pulled into the parking lot and we all got out and stretched a bit. All the creaks and groans sent a heron and two ducks to flight.

"Oh, there goes my shoulder."

"I think I felt a twinge in my neck."

"My foot fell asleep. I can't wake it up!"

We limped into the pro shop.

"You guys all together?" he asked.

"Not anymore," I said, an age-related quiver in my voice.

~

A couple hours later, we were just finishing up the front nine at the Alisal River Golf Course on a truly majestic day. The sky was cerulean blue, the fairways verdant and plush, and there was a warm valley breeze playfully riffling the flags on the greens. All around me were the poetic musings of my fellow golfers, which for some reason reminded me of Dr. Seuss.

"Not-in-the-trap. Not-in-the-trap. Crap," said John.

"Go go go. No no no!" said Rich.

"Stop stop stop." Plop. "Do I get a drop?" Roger asked.

I watched as a coot gave me a piece of its mind then scooted away to the middle of the fairway, where it would no doubt be a lot safer.

"Can you imagine? My wife wanted me to go to a flower show instead of being out here playing the game of kings. I had to remind her that, as a writer, this is where I get some of my best material."

I stopped to check the bottom of my shoe. The coot had gotten me back.

"My wife wanted me to paint the bathroom," said Rich. "Instead I just put in a lower wattage light bulb. Looks fine now."

"People who don't play don't understand," said John. "The tradition. The challenge. The honesty of a battle well fought." John took out the scorecard. "What'd you guys get on that one?"

"Ah, give me a five."

"Sounds good."

"Me too."

We headed for the next tee box.

"I'll bet Tiger Woods doesn't have to paint the bathroom or go to flower shows," I said.

I teed up my ball and took a big arcing Tiger-like swing.

"Fore!" Rich, John and Roger yelled in unison, as my ball headed toward the green, but, unfortunately, not ours.

"Of course, he has to put up with all that fame," Rich said. "That must be difficult. People recognizing you wherever you go. Wanting your autograph. Taking your photo."

"Oh yeah, that would a real drag." John said.

I hit a contingency ball, in case I couldn't find my first one.

"Fore!" Rich, John and Roger yelled again.

"Probably won't be long before a lot of people start recognizing me," I said, pulling my cap down lower on my face so that I didn't have to look at the other group of golfers that I'd almost hit — twice.

"Yeah right." John said.

"Seriously, I've had a recent brush with fame and it was right here on this golf course."

"Don't tell me you actually killed someone," said Roger.

"No, I was in a movie."

"A movie? How'd that happen?"

"Well, I was in my office busy playing that car chase game on my cell phone when it rang. It was a Hollywood casting director. He

wanted me to be in a major motion picture being filmed right here in the Santa Ynez Valley. When I asked him what my role was, he said I was going to be background."

"What do you have to do in a role like that?" asked Roger.

"You stand around in front of things like light switches and peeling paint that they don't want the camera to see when they are filming the stars."

"Did you get paid?" asked John.

"Fifty-four bucks a day and free lunch."

"Gee," said Rich, "guess you will have to file a tax return next year after all."

"You know it. Plus, being a complex role there were of course other instructions. I had to bring three different outfits, which required a quick run to the thrift store. I had to bring two forms of identification, which meant I had to bring my driver's license and one of my kids — 'Yeah, it's him, can I go now or what?' And, I had to be there by seven..."

"A.M!" said John.

"Yup. The casting director told me it was a full day of shooting."

Turned out my "full day of shooting" began with a harrowing ride up San Marcos Pass at six-fifteen in the morning in fog so thick I could barely see the hood of my car, let alone put salsa on my breakfast burrito. Then I spent three hours bonding with other aspiring backgrounders at Staging Area One — a field beside a winery that had been recently occupied by cows that did not have a problem with regularity.

Good thing I had that previous experience at the dairy and this time wore brown shoes. Too bad they were sandals.

The staging area was filled with large trucks and dozens of people with two-way radios and we were all pretty excited about being in "the biz." Unfortunately, the excitement waned when we learned that the roles of "wine tasters milling about unobtrusively" had been cut.

Fortunately, Meagan and I got reassigned as "woman driving up to winery in black car" and "man driving up to winery in brown car." Then we were redirected to another staging area beside a different winery and placed under the personal supervision of Julie, a production assistant who was now leading us on a behind-the-scenes tour.

"This is the grip truck, which is off-limits. This is the electric truck, which is off-limits. This is the prop truck, which is off-limits. And," Julie pointed at a large trailer, "this is the honeywagon, which you do have access to."

"The honeywagon? Cool. Is that where all the young starlets hang out?" I asked.

"No, it's where the bathrooms are located."

"Why do they call it a honeywagon?" Meagan asked.

"I think because the union drivers refused to pull something called a toilet truck," Julie said.

Just then another aspiring young actress named Erin joined our group. "Are you background, too?" I asked.

"No I'm a body double," Erin said. "They're going to photograph me in a wedding dress, digitally cut off my head in Photoshop, and put one of the star's heads on my body."

I looked at Erin's head for some kind of weirdness like huge ears or a third eye or something, but I couldn't find anything.

"If they're going to use just part of you do you still get the whole fifty-four bucks?" I asked.

Erin hesitated. "I think so."

I was preparing to ask Julie about that, when she talked into her neck phone for a minute, nodded and said: "Lunch."

As you can well imagine I was famished from my first half-day of shooting and lunch was incredible — mesquite-barbecued tri-tip, salmon, a complete sushi bar, deserts, coffee and more. To top it off the director came over to our table to meet us.

"Ernie Witham — background," I said loudly and proudly. Then as an afterthought I said, "I could also be a body double if you have

any older, slightly out-of-shape actors that need one." I raised my shirt up over my head in an impromptu audition.

"Ahh... yes... thank you," the director said, then grabbed Julie and scurried away. A few minutes later Julie returned.

"Good news and bad news," she said. "You're still getting paid, but we've cut your scene again."

"What about the body double thing?" I asked.

"The director said, 'we'll call you, don't call us...'"

"And they actually called you again?" asked John, as he hit a drive straight into a vineyard that borders the eighth hole at Alisal. He let out a small whine.

"Yup. They shot a bunch of scenes for the movie 'Sideways' right here at this golf course, and they used a lot of us golfers as extras. That's how people get discovered, you know."

"What was your actual role?" asked Rich.

"Guy driving by in a golf cart."

"Wow. Will you still remember us when you buy Michael Jackson's Neverland Ranch?"

I thought about that. What if I did find fame and fortune? Became a household name. A celebrity that needed to hire bodyguards and press agents? Number one in the world. Or number two or three, or even number...

"Fore!"

A golf ball landed right beside me. The guy in the next fairway yelled: "How do you like it, humor boy."

Then again, maybe recognition isn't all it's cracked up to be.

"Assuming we survive, whataya gonna do after this?" Rich asked.

I sighed. "I'm meeting my wife in Solvang Village. It's Culture Sunday..."

# Chapter Eleven
## CULTURE TO GO

I consider myself a man of international tastes. Just a few nights ago I gobbled up some kung pao chicken, washed it down with a couple of Heinekens, and watched a DVD with subtitles. Of course the DVD was actually a collection of Three Stooges movies in English, I just couldn't figure out how to shut off the Spanish subtitle feature on the remote.

Did you know that "nyuk, nyuk nyuk" is the same in Spanish as it is in English? Some things just naturally transcend cultural barriers.

Unfortunately, Pat doesn't think that I am one of those things. So she often devotes Sunday afternoons to helping me in my ongoing search for cultural awareness.

"Yeah, let me have some of them little round donut things, willya?" I said to the guy at the restaurant window.

"Aebleskivers?" he asked.

"Fine thank you and yourself?" I replied, trying to make him feel comfortable in America by letting him know that I understood his native language.

The man looked at my wife. "What's with him?"

"He doesn't get out much," she said. "He's a writer."

"Oh, right." The gentleman nodded and smiled at me

knowingly.

That's one of the many things I like about the quaint village of Solvang, which is located about forty miles from Santa Barbara and looks like a movie set for a film being shot in Denmark. I think a lot of Southern California was designed by out-of-work set directors.

The people of Solvang are nice. Probably because they originally migrated from the cold climate of Denmark (which is in the Midwest somewhere, I think) to a section of Southern California that doesn't have a beach, but does have incredible weather and spectacular views.

Judging by all the huge steins on display around the tiny town, these folks also seem to drink copious amounts of beer. I think the preponderance of beer and wine in the region may help in the "eternally happy" department.

The gentleman at the window handed me three little pancake balls covered in powdered sugar and raspberry jam. "*Velkommen til Solvang*," he said in the same polite manner.

"No, we drove here," I said, popping a pancake ball into my mouth. I extended my arms and moved them from left to right in a demonstration of the international expression for driving a car.

"He said 'welcome to Solvang' not 'did you walk to Solvang,'" Pat said.

"Huh. Well, see, Tish, I've learned something already. Now we can forego any more language lessons and just concentrate on consuming more cultural stuff at one of those all-you-can-eat joints."

"Tish?"

"Your new literary name, remember?"

"Hm, anyway, there's no way they are going to let you back into any restaurant with a smorgasbord," she said. "In the profit and loss column, you definitely represent a loss to smorgasbords. Besides, you promised we could go to the Elverhoy museum and relive the evolution of Solvang."

"Was I sober when I promised that?"

She ignored my comment and drove to the less populated part

of town — which took three minutes — and then we were standing outside a large stone building.

"Are you sure this is a museum?" I said, pointing at the hand-carved door. "That's a naked woman."

"She's one of the elf spirits," Pat said. "Elverhoy means 'elves on a hill.' It's one of Denmark's most famous folk plays."

"Really? Well if that one comes to the local theater, I'm buying."

I could have spent a little more time with the door, but Pat opened it and we entered the museum.

"*Velkommen*," the museum docent said.

I smiled. "Oh no you don't, you're not getting me on that one again," I said.

Photo By Ernie Witham

"Excuse me?"

"Don't mind him," my wife said. "He's not used to this much fresh air."

"Right, well, let me show you around."

The docent was very nice and within a few minutes we knew all about early Solvang. They even had some Viking stuff and a couple of prehistoric axes like those I'd seen on the Flintstones, so

that was cool.

"Well?" Pat asked, as we left Elverhoy. "Did you learn anything today?"

"Matter of fact, I did. While you were watching that lady sew stuff..."

"She was weaving lacework in the traditional way of the old country..."

"Whatever. While you were doing that I learned something very interesting from the docent."

"Really? What?"

"Free wine tasting today at a new winery not far from here."

I waited for the sigh of disapproval, but she said: "Great idea."

Sometimes I just never know, but I started the car quickly before she changed her mind and wanted to visit an apron museum or something, and within minutes we were bellied up to the bar with a bunch of other tasters.

"Great nose," the woman beside me said.

"Thank you," I said, tilting my head upward so that others could also enjoy my prominent proboscis. "I recently bought some ointment off the Internet, guaranteed to add several inches and increase its firmness."

The woman grabbed her glass and moved to the far end of the counter.

My wife nudged me. "Smooth move there, Jimmy Durante, but I think she was talking about the wine."

I looked around. Sure enough, there were almost a dozen people with their noses stuck into logo glasses, sniffing, pondering, nodding and smiling. It looked like something they'd make you do on "Fear Factor—The Santa Ynez Valley Edition."

"...Okay contestants, to move on, each of you must suck three ounces of Pinot Noir up your nasal cavity without choking..."

Turns out this was one of the most beautiful wineries I had ever seen. From the outside it looked like an old mission. I was a bit disappointed that the staff weren't dressed like monks. That would have

been a nice touch, and after a few drinks I thought I might mention it to the tasting room manager.

I also found out that this particular winery had once been a premier equestrian facility. I figure they probably used the horses to stomp the grapes, which would explain how they had so much wine today.

"Here we are," said the pourer as he lined up half a dozen bottles in front of me. Obviously my drinking reputation preceded me. "This your first visit to our winery?"

I looked at his name tag. "How did you guess, Franc? Wait! I know. I'll bet you heard it through the grapevine. Ha ha. Get it? Heard it through the grapevine? Marvin Gaye?"

This time Pat moved to the far end of the counter.

But Franc was not to be deterred. "Funny," he said. "You should write humor."

"I do!"

"You're kidding. Oh I get it — that's another joke. Ha ha back at you."

Before I could retrieve one of the many tear sheets of my columns that I carry around in my back pocket, he poured a taste into my glass and began his spiel.

"This is our award-winning Syrah. You should notice a jammy sweet raspberry and blackberry fruit aroma with overtones of dill and vanilla. This varietal has been called big, forward, rich, and well-rounded, with ripe red currant and blackberry fruit flavors, overtones of creamy oak, and a lingering aftertaste."

I swallowed my sample in one gulp. "Very tasty," I said. "But I don't think I got any of that dill in mine, Franc." I held my glass out for another shot.

"Hmmm. Perhaps you'll find our reserve a little more to your liking." He gave me a splash from another bottle.

A somewhat seasoned player now, I stuck my nose in as best I could and sniffed. "Wait a minute, I smell something."

"Fruit?"

"No."

"Tobacco?"

"No."

"Herbs?"

"No."

"Well, what then?"

"Smells like toast."

"Ah, very good."

"You mean it's supposed to smell like toast? I thought maybe the winemaker just dropped some of his breakfast in there when he was making it."

I was now standing completely by myself at the counter and Franc was talking through clenched teeth.

"This wine recently scored 89 points at a prestigious competition," he said.

"89? That's like a B-plus or something isn't it? Maybe it's because of the toast."

My wife approached. "This is my wife, Franc. Her name is... Tish."

My wife looked at me oddly, but just said: "I'm going to sign us up for the Winner's Circle Wine Club membership. We get discounts and special shipments."

"You mean I'm going to be in the winner's circle? Cool." I pictured myself wearing one of those giant horseshoe-shaped flower arrangements around my neck, smiling while photographers took my picture. "Does that mean that I get to make decisions around here, too? Because I'm thinking Monk Girls — you know like Laker Girls — only wearing skimpy habits and greeting people on horseback..."

That's when Franc reached across the counter and took the wine club application out of my wife's hand and tore it up.

"I'm sorry Tish, er, ma'am. Here, let me give you directions to one of our competitors."

As we walked out of the winery, my wife turned to me and said: "Do not call me Tish."

"But... why? I thought you wanted me to change your name for the book. I was trying it out."

"Franc is bound to tell other winery people about the weird guy and his wife named Tish."

"Oh, right. Hmm. Okay then should I start calling you Bambi?"

"Only if you want to die!"

# Chapter Twelve
## SECRETS OF THE UNIVERSE

As you may have noticed by now, I don't always fully understand women. But I have learned one valuable lesson. As a husband, you have to be really careful what you say because your wife might just take you to task — literally — based on nothing more than a simple statement like:

"I'm going to golf all day Saturday, then Sunday I'll do whatever you want to do, dear."

"That's what you said," Pat reminded me, handing me a hammer.

"What I meant was we could go to lunch. Grab a crab melt at Moby Dick's out on Stearn's Wharf or something. Watch tourists try to park their Hummers in those compact-car-only spots. That's always fun. Maybe someone interesting will show up — like the guy who lets the pigeons eat breadcrumbs off his head. You know he hasn't had dandruff in years? Or hair for that matter. Plus he never needs a hat because of the sunscreen effect of all that guano. Doesn't that sound like fun?"

"Sure," she said.

I smiled at my own resourcefulness.

"Right after we finish redecorating the house."

This confirms one of my many profound theories about married

life. See, I believe that if a wife only had one wall and one thing to hang on it, she'd still want to rearrange it on a regular basis. It's in the genes. This differs from most guys I know who would only take down a piece of their art to put new batteries in it so the word "cerveza" would light up again.

Matter of fact, when we guys think about the greatest mysteries of the cosmos, we're not thinking about iridium-laden asteroids or the disappearance of the dinosaurs. We're thinking about women — the most mysterious creatures of all.

Even as teenagers, we guys realized that females held the key to our universe. So we used to look for clumps of them at the soda shoppe or at teen dances. Then we would hang out as close to them as we could in hopes that we might overhear something all revealing. Sometimes, one of us could get really close without them even noticing.

"Look. Behind you. Isn't that..."

"Yes. I think you're right. It's an iridium-laden asteroid."

We never gave up, even after all these years, because we knew if we could one day just penetrate one of their camps and learn their secrets, then the universe would be ours — Mars, Venus, the whole thing.

Which is why I was so excited on a recent Saturday not too long ago. You see, Pat, like most women, still has a group of female friends that get together quite often for Ladies' Night, which we husbands know is for universal-secret-sharing. This time, it was her turn to host the evening.

"Don't you want to go to a movie with the guys? Or maybe bowling?" she asked me, just before the others arrived.

"Everyone I know is busy," I said. "Besides, I've got work to do, so I'll just stay in my office. You won't even know I'm here."

"Are those night vision goggles?"

"Huh? No, these are... er... Jedi glasses. From 'Star Wars.' May the Force be with you."

She seemed a bit skeptical, but she was no match for my prac-

ticed male look-of-sincerity. The instant she left, I made the call.

"I'm in."

"Ten-four," said Larry. "Red rooster crows at twenty-one hundred."

"Huh?"

Larry sighed. "Scott will call at nine."

"Oh yeah, ten-four."

It was hard to concentrate for the next few hours. I could hear the group of women in the next room whispering, then laughing, but I could not quite make out what they were saying, plus the water glass I was holding to the wall was starting to hurt my ear.

At exactly nine o'clock the phone rang. I let my wife answer it.

"It's someone named Rooster," she said. "Sounds like he's calling from a bar."

I wandered nonchalantly into the dining room. "My phone's not working. I'll just take it here. Evening ladies. Boy everything smells so good."

"Why don't you join us for dinner," said Jody.

"Really? Me? A guy?"

"Sure," said Karen. "We have plenty."

Sonia pulled a chair out for me. Jan pushed a plate forward.

In the background I heard Scott yell: "They're gonna let him stay. He's broken through! He's broken through!" I heard beer mugs being clinked together and a bunch of war whoops. I hung up the phone and moved into position. Suddenly, I felt ill-prepared. We should have made a script. I had no idea what to ask, where to begin.

"So." Sonia leaned forward. "Who's winning the Red Sox game?"

"Huh?" I said.

"They were up by two runs last I heard," said Jan. "Ellsbury doubled and Big Papi brough him in."

"Dodgers aren't looking too shabby either," said Pat. "Finally, they got pitching, so they're on the right track. Don't you think so, dear?"

I opened my mouth but nothing came out.

"Speaking of track, have you seen that new Harley-Davidson, the V-Rod?" asked Karen. "It used to be a track bike but now you can buy a street edition?"

"Is that the anodized aluminum one?" asked Sonia.

"Yup. It's got a 69 cubic-inch engine with a compression ratio of 11.3 to 1."

"Wow, that's a lot of compression," said Jody.

"Wait just a dang minute," I said, standing up. "Lakers? Dodgers? Compression ratios? What about girl-talk? Womanly musings? Victoria-type-secrets?"

They all looked at me. "Whatever do you, mean, Ernie?"

"I... that is... oh... never mind." I grabbed my night vision goggles and headed for the door.

"Where're you going?" my wife asked.

"Out," I said. "To a bar full of disappointed men."

Just as the door closed behind me, I heard a bunch of whispering followed by raucous laughter.

I looked up at the night sky. So close yet so far away.

~

Thus, I never did learn about woman, which is why I still make bargaining statements like offering to rearrange an entire house.

"So why am I moving this painting that looked 'perfect' over the fireplace — your word, not mine — just a few months ago?"

"Because it's almost summer and this will look much nicer up there."

"You want to put a blanket over the fireplace?"

"It's not a blanket. It's a handmade Pennsylvania Dutch quilt. It's art."

"Taxidermy is art, too. Why don't we get a moose head. We wouldn't have to move it from season-to-season, just decorate it with different hats and funny signs and stuff."

I waited for the accolades of approval. Instead she handed me a curtain rod and I began my long ascent up the stepladder.

Did I mention the fact that we have cathedral ceilings? I believe these too, were invented by wives for wives. Because no guy in his right mind, who knows he is eventually going to have to repaint his "kingdom," wants ceilings that reside in the nosebleed section.

"Higher," my wife said.

"I'm already standing on the step that says do not go above this step. What if the home repair police show up and cart me off to homeowner's jail. Then where will you be? Huh?"

"Higher," she said again.

I took another step up, cursing the existence of Pennsylvania Dutch culture on the way. "Oh look, an eagle's nest," I said.

I looked down. My wife looked like an ant.

"Perfect," she yelled.

It took about fifteen minutes to get the blanket — excuse me, art quilt — perfectly straight, then another fifteen minutes to put the painting that had been over the fireplace over the couch.

"Left. No, right. No, left. No, right."

"You know," I said. "if you ever want to try a different career, you'd have a real future leading parades."

"That's funny. You should write humor."

I thought I noted a bit of sarcasm in that statement, but before I could respond, she said: "Okay. Now all we need to do is take the two landscapes that were over the couch and put them in the dining room and take the watercolor that was in the dining room and put that in the guest room and then take the photos that were in the guest room and put them in the hall and then..."

Impossible as it must seem, I finally did get this all done. And, after a few minutes of agonizing scrutinization, my wife smiled and said: "Perfect."

I sighed in relief.

That's when the front door opened and Christy walked in.

"What's that?" Pat asked.

Christy — the artist/troublemaker — held up her brand new oil painting.

"Boats!" my wife exclaimed. "I love boats. It's going to look perfect over..."

"Don't say it," I begged.

"...the fireplace," she finished.

In my next life, I'm going to be the pigeon guy.

# Chapter Thirteen
## WHERE COLUMNS COME FROM

June got off to a not-so-great start.

"Hi dear, I hate to bother you, but can you come bail me out of jail?"

I could hear my wife on the other end of the line tell people in her garden tour group at Lotusland that it was a plumbing emergency — I guess in case they'd heard the word "bail" or something.

It was several minutes before she was at a secure location. "You're in jail," she said. "As, IN JAIL!"

I detected a note of surprise in her voice, but also something else. Inevitability maybe? Like she'd been dreading this moment since we first met?

"I thought you were going to Santa Ynez Day so you could write your column about the parade. Oh no, you didn't go to the Chumash Indian Casino and try to use that quarter-on-a-string again, did you?"

"No. Yes. I mean, I didn't go to the casino and yes I did go to the parade. It was a great small town event, too. Lots of horses, wagons, tractors, things like that. I was even in the parade myself — briefly."

"Uh-oh," she said.

"See, I noticed about halfway through the parade that the

announcer didn't have everyone written down on his notes, and when one of these late entries, as he called them, marched by he'd ask them who they were and where they were from. So, I figured it might be a good career move to be one of those late entries and introduce myself to everyone."

I hesitated. "What's that noise, dear? Sounds like pounding."

"It's just me banging my head on a Chilean Wine Palm," she said. She paused. "Are those kids I hear in the background?"

"Yup. There's about a dozen of them in here climbing all over the place. It's kind of annoying."

"You're in jail with a bunch of kids?"

"And a goat named Butch, who ate my hat."

"Look, I have people wandering all around the gardens looking for me. Can you please just tell me what happened?"

"Okay. See, when I walked in front of the stand, sure enough Ed was curious because I wasn't riding on a horse or a tractor and I wasn't exactly dressed like the other parade participants. So I told him about my column, my website, the book I was working on – you know, the one you suggested about all my humorous adventures, which this was until a few minutes ago. Plus, I told him a little bit about my early childhood growing up in a small town in New Hampshire, some anecdotes from my teen years... I even mentioned you and a couple people thought they knew you. Isn't that great?"

I hesitated again. "You know, dear, it might not be good for either you or that palm tree to keep banging your head like that."

"Jail," she said. "Tell me about the jail."

"Oh yeah. Well, Ed, he called this other guy over and the guy said he noticed I wasn't wearing a Santa Ynez Day badge and that it was part of the tradition to put anyone caught without a badge into this jail thing they pull behind a tractor until someone bailed them out."

"You're not in a real jail?"

Was that a note of relief in her voice or disappointment?

"The goat's eating my shoes," I said.

"Okay, okay. How much is the bail?" she asked.

"One dollar."

There was a moment of silence. "You called me in the middle of my garden tour to bail you out of makeshift parade jail for a dollar? Why in the world would you go to Santa Ynez Day without any money?"

Photo By Pat Sheppard

"Oh, I had plenty of money, but they had these great tri-tip sandwiches for five bucks each, so I had a few of those, then they had ice cream, and strawberries, and cookies, and beer, and I bought the straw hat that Butch the goat ate."

I heard a click. My call was disconnected. I tried calling back, but all I got was voice mail that said: "I do not now know nor have I ever heard of Ernie Witham."

"Hey mister," one of the kids said. "Are you gonna get out soon? You're taking up all the space."

"In a minute," I said. Then I opened up the phone book on my cell phone and pressed my stepdaughter's number.

"Christy? Hey, I hate to bother you, but..."

~

Fortunately, one of the parents put up my one-dollar bail and another dollar for the goat I think, which was a good thing because I thought maybe I could turn Old Santa Ynez Day into a column for the *Santa Ynez Valley Journal*, but I still needed a column for the *Montecito Journal*.

That's the thing with writing for two different papers and being a procrastinator. Sometimes I need to find two stories at the same time and I have to hang out until I find them. I'm not sure when it will happen or how it happens. Oftentimes it's a magic moment when I notice something and it all unfolds before me, like discovering the jail at Old Santa Ynez Day.

I remember once I was shopping with my wife at El Paseo, a mall in downtown Santa Barbara that's set up like a Spanish marketplace with tiled walkways, outdoor restaurants, and boutique shops, bookended with the department stores Macy's and Nordstom.

My wife wanted to go to Macy's one more time to see if she now liked the black shoes she had hated earlier better now that she couldn't find anything she liked — or something like that. I had had it, so she handed me the bags and I went to sit at this circular fountain and wait for her. As I approached the fountain I noticed there were all guys sitting there holding bags waiting for their wives. I sat down and thought: what would we all talk about if a conversation began? The obvious choice was sports, but when I wrote the story I had all the guys talking about fashion until one of the guys would yell "Wife" and then we would resume our natural guyness with "How 'bout them Dodgers, huh?" When the guy and his wife disappeared we went back to talking about fashion. I sold that piece to the *Los Angeles Times*.

Another time I was in Home Depot at the Calle Real Shopping Center in Goleta, just north of Santa Barbara, wandering around to

see what I could find and I rounded a corner and found a display of six colorful toilets lined up side-by-side. Instantly, I pictured those same guys sitting around, this time perusing the Home Depot catalog while their wives shopped. We were all grousing about how our wives would never let us buy a colored toilet like the Daydream Blue model or the Loganberry red one, telling stories about all the easy-to-install stuff that was anything but. Several readers told me after that story was published in the *Montecito Journal* that they went to Home Depot just to see if those toilets were really there. Can't you just picture group after group showing up laughing at the toilet display and then leaving? How funny is that?

Plus, and this happens a lot in this modern age of the Internet, shortly after I put my Toilet Piece up on my website, Home Depot picked it up and ran it on their site. How's that for reach?

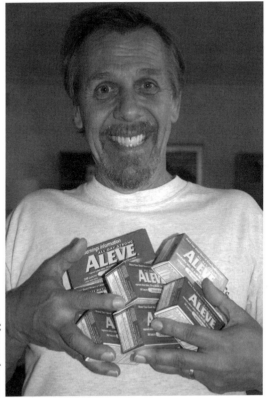

And you remember the story a few chapters back about four aging golfers complaining about their aches and pains? I titled that story "This Column Brought to You by Aleve." Within an hour of it appearing on the *Montecito Journal's* website I received an email from the PR agency for Aleve. They said they read my column,

Photo By Pat Sheppard

thought it was very funny and wanted to send me some free product. The next day I received five hundred Aleve tablets by overnight Fed-X! That was worth way more than I actually got paid for the column.

My plan for today's *Montecito Journal* column was to visit the Santa Barbara Cat Show that was going on at Earl Warren Show-grounds in Santa Barbara, so I jumped into my car and raced back down San Marcos Pass to Los Positas Road. I'd never been to a cat show before so I didn't know if there would be anything to write about or not. I walked around the entire arena several times looking for inspiration. Nothing was happening. I was about to give up when I felt my forehead get warm. Sometimes this means I'm sick but often it also means the muse is awakening.

It might have been the cigar-shaped catnip or the little bottle of Bio-Coat, a treatment for habitual scratching. Could have even been the judge pointing out the liver-like spots on one competitor's knees and elbows. But something got me to thinking:

Why don't they ever have a Santa Barbara Senior Show?

Something I could win. Ernie, a Blue Ribbon Holder in his rookie year. How cool would that be? All I'd really need is a sponsor like Acme Ear and Nose Hair Trimmer to cover a new pair of Birkenstocks and Jerry Garcia necktie.

I could see it all now... the lights... the cameras... the action...

Well, fans, here we are down to the final thrilling moments of this year's SBSS (Santa Barbara Senior Show) sponsored by Orthopedic Shoes of Oxnard and the Summerland Eyeglass Company and Wine Emporium.

There is a hush in the crowd, broken only by the occasional snore or passing of gas. We move to the main judging ring where everyone's attention is focused on the exciting finalists.

The judge is being very deliberate in her choice, moving from Barcalounger to Barcalounger where the eager competitors are resting. She chooses a fine-looking male specimen and escorts him to the judging stand, amid a chorus of polite applause.

"Here we have Mort, originally an American shorthair, now categorized as an American no-hair. Mort was sired in Brooklyn, but now frolics in Montecito. Mort no longer breeds, but he remains housebroken and is still quite playful according to his longtime wife and handler, Edith."

"Is he for sale, Edith?" a female voice shouts out.

"How much you offering?" Edith asks.

The judge quiets the crowd as Mort appears to be a bit nervous under the lights. To divert his attention the judge dangles the TV Guide in front of him. He reaches for it.

"Notice the agility and eagerness, the singular concentration. Mort is a fine specimen. I award Mort fourth place."

More light applause as the judge returns Mort to his lounger and chooses another male from the group.

"This is Cyrus. He's descended from a long line of Persians. Notice the full thick pelt." The judge lifts Cyrus' shirt to revel his back. The crowds ooohhs. "Note also the strong chin and relatively small ears. Rare in many seniors today. I award Cyrus third place."

Cyrus, in a bit of show-offs-manship, raises his shirt to revel his chest, creating quite a stir among the female groomers, then returns to his seat.

The judge walks up and down the line of seniors, finally choosing a well-groomed blonde and escorts her to the stand. The applause is a bit more raucous this time led by a group of guys wearing Minnesota Lawn Bowler's Association sweatshirts and hats with horns on the side.

"Hel-ga. Hel-ga. Hel-ga."

"Please. No chanting and stop doing that wave thing, too. Thank you. Now, may I present — as you already know — Helga, a fine Norwegian specimen. Helga was sired in the upper Midwest and like her ancestors is a follower of the Vikings. Notice the thick, muscular body..."

The raucous applause starts up again and security is called to quell the uproar. Several Minnesota lawn bowlers are asked to leave.

"I award Helga second place."

"The crowd applauds, but quickly subsides. This is the big moment. Best of Show. Who will be this year's champion? The judge walks slowly back and forth in front of the remaining competitors. It is a tense moment. Finally...

"Ladies and Gentlemen, may I present Ernie, a RagaMuffin, which is a household breed, well known for their voracious appetites and total lack of ambition."

I stand proudly, turning my chin toward the light. The crowd goes wild. Cameras flash everywhere. One woman even throws a pair of support hose into the ring. This is it. The moment I have long been waiting for. Ernie. Best of...

"Excuse me."

"Huh?"

"Sir, you are scaring the cats jumping up and down like that. This is a civilized event."

I looked around. All over Earl Warren Showgrounds cat owners were staring. I smiled apologetically, then backpedaled by the cat carriers, multi-level scratching posts and holistic cat food displays toward the exit.

Fame. So close, yet so far away. I headed home to take a catnap before I wrote down my latest experiences.

~

Speaking of writing... late June is the time for the Santa Barbara Writers Conference, my favorite week of the year. It's the one time when I can join 350 other people just like me – writers, that is.

In 1991, I attended the prestigious, weeklong Santa Barbara Writers Conference for the first time. It was a huge event that started at nine a.m. every morning and went on until the wee hours of the next morning if you attended the Pirate Workshops that started at 9:30 p.m. every night. There were more than 30 daytime workshops

to choose from, and I tried several before I finally ventured into the humor workshop to see what that was all about.

I took a spot in the corner and listened as several people read short, witty anecdotes about life and I felt a rush. These people thought like I thought. They observed everyday life like I observed it — slightly skewed. They wrote like I wanted to write. And, they weren't nearly as depressing as some of the readers in the "Poetry For Those Who Would Like to Tear the Heart Out of Their No-good, Scum-of-the-earth, Cheating Ex-lovers" workshop that I had spent the longest hour of my life in.

Like Moses (kind of) I had found my people. The humorists of Santa Barbara (and beyond) who liked to laugh and loved to make others laugh.

Those first few moments were like a flashing light going on and off telling me I had arrived.

That's when their leader, workshop instructor, Ian Bernard, former music director and writer for Laugh-In, leaned over to me and said: "Hey Bozo, you're leaning on the light switch."

Despite that initial setback, I began writing humor and attending the Santa Barbara Writers Conference every year. I took the same seat, in the same corner of the humor workshop, and slowly with the help of my friend Ian and the funny regulars who were there every year, I became one of them and developed a humor style that turned into a humor column. A few years ago when Ian retired, I became the humor workshop leader and now I get to help other budding humorists who stumble into our little off-kilter world with a dazed yet relieved look.

This year was going to be a bit tricky, though, because – wait for it — I NOW NEEDED YET ANOTHER COLUMN! Usually, I finish my column before the conference starts but I'd over-procrastinated this time. I had an idea, though…

"Good afternoon class. I thought we'd try something brand new this year. I thought we could write a humor piece together. I'll start

it with the first few sentences then the assignment is for you to write all the funny stuff. And if it comes out good enough, I'll see if I can get the *Montecito Journal* to publish it."

I raised my hands modestly in a "please, don't thank me" pose. That's when my good friend and fellow Montecito Journalist, Jim Alexander, who was sitting in on my workshop, said:

"Bull! You've got a column due and you want us to write it for you." Personally I've always thought that Jim was a bit too smart for his own good.

Fortunately, it's my workshop and they have to do what I tell them. Double fortunately, it actually worked. I turned the following column in just in time.

People are always asking me what goes on at a writer's conference. Well, besides the goat sacrifices, naked pagan dancing, and the jalapeño-tofu-hummus eating contest, it's pretty much just a bunch of successful people with real jobs who want to give it all up for a glamorous life with little or no pay.

This year, for the first time, we are at Fess Parker's DoubleTree Inn located on the beachfront in Santa Barbara, a wonderful venue for a writer's conference mainly because they have a bar and a hot tub.

"The goat peed in the hot tub."

Okay, mainly because they have a bar.

There are a few problems at our new location though. For one thing the train goes by every fifteen minutes and they blow the horn continuously to get the pagan dancers off the tracks. The humor workshop was outside one day and my opening lecture went something like this: Loud horn blowing. Mouth moving. Students straining to hear. Train finally passes.

"...and that is the one thing that will guarantee fame and fortune. Any questions?"

Some of the other hurdles that students had to overcome this year to become unemployed, er, I mean, working writers, include:

The disorientation of all the conference rooms at the DoubleTree being labeled either East or West combined with the fact that Santa Barbara actually faces south. Plus, apparently, the room layout map was printed upside down. I saw several students walking around with compasses and sextants, and one student from Florida was found three days after the conference started sitting in the men's room waiting for the "Flushing Out Our Characters" workshop to start.

Speaking of restrooms, the DoubleTree has all the latest amenities such as automatic faucets. But being Southern California laid-back faucets they don't always respond right away.

"Try putting your left foot and right elbow in the sink while wiggling your ears at the sensor and bending at the hips."

"Thanks so much. What do you teach?"

"Yoga."

As you might imagine, most writers don't get out much. That's why they smell like moles, blink a lot in sunlight, and wear things like coal miner's helmets and day-old bed linen. Of course, they're also carrying around two-thousand-dollar laptop computers. However, the real problem is that going without any sleep for an entire week at the conference requires that these writers consume copious amounts of coffee, but not all them are from Santa Barbara so they don't all like half-skim, half soy, sugar-free vanilla-laced, cinnamon swirl, chocolate-enhanced, half-caf double lattes.

"Black coffee please."

"I'm sorry no one here knows how to make that. Next."

Students are always losing things at the conference too, so there is a lost and found box. So far this year the box contains fifteen cellphones all with the text message "Where Am I?", two sets of false teeth, one of which is still attached to an agent's pantleg, a nose ring the size of a hula hoop, a Pan Am Frequent flyer card issued to Amelia Earhart, and a manuscript entitled "Why I Never Leave Home."

Another thing that's hard for new students is figuring out the system. Most workshops have signup sheets for reading your work,

which carry over from day to day but, by the time some people figure this out, it's a bit late.

"I finally finished my humor piece and put my name on the list."

"Great. You'll be first up next year."

Did I mention the weddings? There were three during the conference, which added a musicality to several of the workshops like the mystery workshop: "It was a dark and stormy night..."

"...You light up my life. Light up my life..."

And to the travel writer's workshop: "My story begins in a remote section of..."

"...Y-M-C-A. da-da-da-da-da-da-da. Y-M-C-A..."

Anyway, I hope this gives you a picture of what a writer's conference is really like. Now, if you'll excuse me, the goat's in the hot tub again.

Special thanks to humor workshop attendees: Karen, Amy, Patrick, Bradley, Jacqueline, Jade, Tracy, Jan, Mike, Tom, Sylvia, Brian, Steve, Patricia, Cat, Verna, Anita, Johan, Kim, Ellen, Beverly, Cherry, John and Jim.

Well, now that "I" pulled off another column — and worked for a week straight — I was ready for a major vacation. Someplace fun. Someplace cool...

# Chapter Fourteen

## HUMOR IS EVERYWHERE — ESPECIALLY FLORIDA

We decided that early July would be a good time to visit Florida — a state famous for its stifling summer heat and humidity — because we wanted to see and do things we'd only dreamt about — like taking close-up photos of free-roaming alligators in the Everglades, while battling swarms of mosquitoes that collect more blood in a month than the Red Cross. Snorkeling in the super-warm, shark-infested waters of the Atlantic Ocean. And visiting Key West, a place once famous for its rowdy inhabitants and strange nightlife, now famous for, well, pretty much the same thing. And man was I ready. All I had to do was pack.

My wife put down her trip checklist and said: "What in the world is that?"

"My suitcase," I said.

"No way. Do not put that thing on the dining room table…"

I put it on the dining room table. "It's just a little dusty." I took a deep breath and blew as hard as I could. For just a minute, it was like being in Pompeii during the eruption, then the soot settled and the air in the condo brightened a bit.

"See, it's actually plaid."

While Pat was choking, gasping and wheezing, I took the opportunity to open up my Travel-Rite Deluxe.

"Wow, look, my high school year book. Cool."

I sat cross-legged on the dining room floor and thumbed through it. Meanwhile my wife picked up my suitcase, held it as far away from her as possible, carried it to the front door, and tossed it out.

"Hey, be careful," I said, "I paid fifteen bucks for that..."

Too late. The minute it landed on the front lawn it disintegrated into something even a forensics expert wouldn't recognize. Bummer. I wonder if it was still under warranty?

Pat handed me my jacket. "Our connecting flight leaves for Los Angeles in a few hours. You need luggage. Hurry."

"Can I help you?" Leonard of Leonard's Luggage asked. He took off his glasses. He had huge bags under his eyes. Somehow I found that appropriate.

"Going on a trip and I need a suitcase," I said. "Do you carry Travel-Rites?"

"Ah, no. But we have the Tumi Generation 4.4 Travel Collection in a variety of color coordinates. They have ultra functioning interiors and sleek refined exteriors."

Just then a young lady holding two Trader Joe's grocery bags walked in, and we were both momentarily distracted by her sleek refined exterior.

"How about that red one?" I said returning to the task at hand. "That makes a statement."

"Ah yes, the Samsonite Silhouette with multi-directional spinner wheels." He moved the bag to the middle of the room and turned it in a complete circle. "Easy to pull. Hard to tip over."

"Wheels. Wow." I spun it like a top. "I could rinse out my underwear, put 'em in there and spin 'em dry. That way I'd only need to bring one pair."

"Right..."

I opened the Samsonite. "What's this?"

"Your tri-fold removable suiter specially made for hanging up your evening wear."

"Evening wear? You mean my sweatpants? Man, these people thought of everything."

I gave the Silhouette another hearty spin then looked at my watch. "Okay, I'll take it."

"Very good," he said. "That will be four hundred and twenty dollars, plus tax."

I waited for him to laugh. He didn't.

"Four hundred and twenty dollars! That's more than the trip is costing."

The young lady with the refined exterior walked by again. She gave me an idea.

"Whataya think?" I asked my wife as I walked toward the gate at the quaint Santa Barbara Airport.

She hesitated. "They're you," she said.

I smiled then handed my matched set of Trader Joe's grocery bags to security. "Careful," I said. "They're new."

~

Traveling can be a bit stressful (he understated), and our stress level began to rise the moment our flight from Santa Barbara ar-

rived at the gate in Los Angeles and we had to secure our boarding passes for the next flight. Being experienced travelers, we planned a two-hour layover in case they needed to strip search us again (for fun I was wearing my "Home of the Lochness Monster" briefs), and also so that we could beat the rush to the International Cafe for the coagulated beef stroganoff daily special. You just can't get food like that anywhere else. I figure it's made by people who dropped out of chef school early on, then worked briefly in high school cafeterias so they already had an ample supply of hairnets that they didn't want to waste.

Our gate representative was Maureen. She took our tickets, gave us the required big toothy smile, and then looked us up on the computer.

"Oh! Now this is an interesting routing pattern," she said.

"Is there a problem?" my wife asked.

"Oh, no," she said. "Matter of fact your hourly rate for flying just went down dramatically." She handed us each a pillow. "Have some nice flights."

We were a bit apprehensive as we joined the rest of the herd of travelers standing in front of the chute that lead into the plane, but hey we were on vacation, so what if it "took a little longer" to get there. It would be worth it. I'm sure these are the same words Admiral Byrd kept repeating to himself as he tried to get the feeling back into his butt cheeks on his way to the North Pole.

One thing I think is clever is how the airlines have made summer traveling more fun by combining flying with that popular elementary school game, musical chairs. You know, the game where there are more participants than seats and the goal is not to be left standing or you lose.

"I'm sorry, the flight is overbooked," a brave young man standing a safe distance away yelled. "Would anyone like to switch planes and wait for a later flight?"

Some of us — who were near the front of the line — laughed.

"We'll give you a twenty-five dollar voucher and free head-

phones for life."

More laughter.

He took a deep breath and went for the big guns.

"And we'll throw in five thousand frequent flyer miles."

The laughter subsided.

Frequent flyer miles are the S&H Green Stamps of the new millennium. Used to be if you shopped around the clock you could earn enough Green Stamps to get a free set of stainless steel backyard barbecue tongs. Now if you fly until you actually start to look like a bag of complimentary honey roasted peanuts, you can get a free flight and fly some more. A dream come true.

A few people gave up their spots and a few new people quickly took them. Finally the herd of passengers started mooing, er moving, and within a few minutes I found our row and was about to squeeze into seat assignment G7 when I spotted the red handle. Immediately I signaled for a flight attendant.

"Yes?"

"What's this?" I pointed to the words "Emergency Only" written on the wall beside me.

"That's our emergency wing-access evacuation door," she said. "As a G7 you will be in charge of opening it and helping other passengers out onto the wing in case of some unforeseen problem, like another one of those annoying water landings." She smiled. "Can I get you a pillow?"

"How about a parachute in case I accidentally bump the thing and get sucked out into the jet stream?"

"Oh a parachute wouldn't do you much good," she said. "We fly much too high. Besides, you'd most likely hit the tail and be split in half anyway. Would you like a blanket?"

"No. I don't think I'll be sleeping."

"Well then, just call me if I can be of any further assistance. Oh, and as a G7, these are yours. Our compliments." She pinned a set of plastic wings onto my shirt pocket, saluted me, and left. Printed on the wings was the airline's clever catch phrase: "We'll get you there

in one piece — or charge you proportionately."

"Ah, that's nice, huh?" my wife said. Then she excused herself and headed for the tiny torturous aluminum bathroom.

I hate those things. I try never to use them. For one thing, to get there, you have to squeeze up the aisle around the always-present beverage cart, excusing yourself each time you step on someone's outstretched foot and bang into their elbow. Now, everyone knows where you are going and, if you are carrying a magazine along, what you are about to do. You know damn well they are timing you. It's a lot of pressure. Plus, it seems like the minute my little buddy is unencumbered and performing his bladder-emptying duty, we hit turbulence and then I'm stuck spending the next five minutes wiping down everything from the mirror to the floor. And how about the sign in those bathrooms about proper disposing of used razor blades? Right. Who the hell is going to shave in there? The webmaster of Masochism Today.com?

I moved as far away from the ominous red handle as I could and was settling back to read the airline's in-flight magazine, *Winging It*, when the plane began shaking side-to-side. I glanced up, just in time to observe a 400-pound man wedge himself into the seat across the aisle. Then another one joined him, and two more sat behind those two, then two more came down the aisle...

I signaled for the flight attendant.

"Yes?"

I pointed at the behemoths.

"Aren't they something?" she asked. "Headed for the International Sumo Wrestlers Conference in Sarasota, I heard."

"But all that extra weight... on one side of the plane... won't we just keep banking to the left and going in circles until we run out of fuel?"

"No. Of course not," she reassured me. "This plane's too old to sustain banking for that long. We'd lose engine power long before we ran out of fuel. Besides, their weight will be offset by the drill team."

"Drill team?"

Suddenly, I heard a cacophony of sounds — huge drums being rolled along the floor, batons bouncing off the ceiling, heads being bonked by tubas, then a whistle followed by a woman's voice...

"Ahhh-ten-shun! Now. I want percussion one and two in these seats, large brass right behind them, followed by the acrobatics team... Brenda... please stop doing flips until the seat belt warning light is turned off... and remember everyone, watch where you sit. We don't need another one of those medical mishaps with a piccolo..."

The flight attendant sighed. "Don't you just love a band? Well, guess I should get everyone seated for our flight to Albuquerque."

"Albuquerque? I though we were going to Florida."

"Well sure, but first we have to stop in Albuquerque for the Southwestern Chili Bake-Off judges. Can you imagine? They've been eating nothing but chili for three straight days! Then it's on to Boise, Peoria, Chattanooga — that's where we pick up the yodelers — and, then before you know it, Tampa Bay, where you switch planes one final time for your flight to Miami. Isn't flying a marvelous way to travel?"

Before I could respond a skinny teenager whizzed by my head and struck the seatback in front of me. He quickly jumped up and dove over me onto a much bigger teen.

"Sorry about that," a deep voice said.

I looked up and saw a man in shorts, knee-high socks, and a tee-shirt that read, "Camp Second Chance: a Better Choice Than Jail."

"They're just a little excited about getting out of maximum security." He yelled over his shoulder: "All right. Who's smoking? You know the rules, no smoking, drinking or body piercing while on the plane." He turned back to me and smiled. "Say is this seat beside you taken?"

"Actually, my wife..."

"Great. Tank, you sit here."

The young man sat down, put his massive tattooed forearm onto

my armrest, grunted once, looked me in the eye, and said:

"You gonna be wantin' your dessert?"

Without answering, I jumped up, grabbed my carry-on from the overhead, and headed for the door.

"Where're you going, G7?" the flight attendant asked.

"Home," I said, cautiously stepping over a young woman who was sitting in the middle of the floor, blowing spittle out of her clarinet. "We're gonna drive to Florida."

"Drive?" my wife said. "Don't be silly. That would take days."

She sat down in seat G-7 beside Tank. "Young man, we've survived five teenagers," she said. "I've got techniques I'd rather not use unless I have to."

Tank smiled sheepishly then moved to another seat.

I thought about days in the car with my wife reminding me that we'd be there by now if we'd flown, then I signaled the flight attendant to see if I could get early alcoholic beverages, pulled the set of plastic wings off my shirt, and tossed them to my wife.

"Don't bump the handle," I said.

~

Just about the time I ran out of cash and found out that flight attendants are not allowed to run bar tabs or take personal checks for alcoholic beverages, we arrived in Humidity, er, Miami, rented a car, cranked the air conditioning, and headed for South Beach — SoBe to those in the know — the Art Deco capital of the world.

I made Pat take one little detour first.

"He's never, ever going to hear you."

I ignored her, stuck my head out the window and yelled at the huge *Miami Herald* building again: "Hey Carl. Over here. It's Ernie Witham. I sent you my book. It had a green cover. And my manuscript. I've also called. And emailed. And written. And faxed. Hey Carl."

I knew, of course, there was a good chance columnist and

humor novelist, Carl Hiaasen, was not even in the building. He probably had a home office with a built-in spa. And even if he was actually at an annual office meeting or something and did spot me, he might not remember me — I'm sure he's filed restraining orders on lots of other humor writers.

"Let's go around one more time," I said. "I think I saw someone at the window."

"Did he look like a security guard?"

"Ah, kinda, yeah."

We — meaning my wife — decided that maybe we should forget about annoying Carl any further right now and instead go check into our room at the Beachcomber Hotel, which wasn't actually on the beach of course. Ever notice how many places that don't have a view are called Ocean View or Wavecrest and those with no beach front are called the Sandyman Inn or Tides Hotel?

The Beachcomber, built in 1937, is in the middle of the famous Art Deco District, which has been everything imaginable since its inception in the 1930s, including one of Al Capone's hangouts — the gangster offered illegal gambling at his casino in what is now the Clay Hotel.

Over the years, the Art Deco District has survived slumlords, drug dealers, and annoying, pale, winter tourists from New York. Then, in the 1980s, people with vision — very colorful vision — began restoring the place. Now when you visit it's like being on the Hollywood set of the Dick Tracy movie. In fact, I felt like I should be pulling up to the Beachcomber in a 1940s black Lincoln with my moll.

"What did you call me?"

"Nothing, Dollface. Now hand me my shooter, willya?"

Pat handed me the camera. I let loose with a burst of clicks.

"Nice job, Mumbles, only you left the lens cap on again."

So that's why all my photos are coming out so dark. Huh.

I followed her into the lobby, which had a green and white linoleum floor, a green 1960s couch that looked remarkably uncomfort-

able, and light green walls. I expected the guy at the desk to introduce himself as Mr. Green but he didn't. He just quietly processed us.

Being a wordsmith, I, of course, tried to start a little witty banter.

"Hot enough for ya?" I asked.

"Actually," he said, "I don't like being this far north. The winters can be rough."

"Compared to what?" I asked. Having grown up in New Hampshire, it always kills me what other people call "rough weather."

"I prefer South America," he said "That's warmth you can depend on."

He lead us upstairs to what I now knew would be a non-air-conditioned room. I figure this is a guy who will end up in hell and complain about inconsistent flames or something.

Our room itself was billed as being "spare with modern influences." How's that for marketing spin? I was hoping the modern influences included sheets and indoor plumbing. The room also came with a great view of another two-story Art Deco hotel directly across the street. There was a guy standing on the second story porch, holding a piece of pizza in one hand and a beer in the other.

"What color's yours?" I yelled.

"Turquoise and yellow," he yelled back.

"Green and white over here."

He grunted, skillfully shoved the entire piece of pizza into his mouth, and went back inside. It was gross, but it also made me hungry, so I grabbed my wife and we made the one-block trek to Ocean Avenue, where the more famous — and hugely more expensive — Art Deco hotels are located.

There are a ton of outdoor eating establishments on Ocean Avenue in SoBe, but I knew from the guidebook that there was only one place to go — The News Cafe, a cafe/restaurant, newsstand and bookstore. It had been described as "the" South Beach Miami watering hole for the simply fabulous. A place where everyone tries

to look like somebody as they look for somebody who really is somebody.

"Hey, that guy looks real familiar. Is that Don Johnson?"

"Where?" My wife's head swiveled.

"Right there." I nodded toward the guy.

"No," she said. "That's our waiter."

Huh. No wonder he looked familiar. He walked over to our table.

"Can I take your order?"

"What does Carl Hiaasen order when he comes in?" I asked.

"Who?" the waiter asked.

Instantly, I doubled his tip.

~

After a vigorous afternoon of watching extremely buff, scantily-clad men and women playing volleyball on the beach, rollerblading up and down the sidewalk, and just generally "hanging out" in SoBe, I was a little spent, but my wife was just getting her second wind.

"On to the Bayside Marketplace," she said.

"What do we need at a marketplace?" For some reason all I could picture was hard buns and ripe melons.

"Culture."

I frowned.

"And fruity alcoholic drinks," she added.

This is a woman who knows me well.

The Bayside Marketplace is located on the shores of Biscayne Bay at Biscayne Boulevard and N.E. Fourth Street. It is a popular tourist attraction due to the variety of shopping, dining, and entertainment offerings found within it. There are something like a hundred and twenty-four shops and dozens of restaurants. Everything from Hooters and the Mambo Cafe to the Bubba Gump Shrimp Company. There was a harbor full of incredible boats surrounding

the marketplace. I even saw a sign advertising a pirate ship tour, but business seemed slow. Probably because of today's "reality-oriented" thrill-seekers. Maybe if they offered a drug runner's powerboat tour, complete with live ammo being fired over the bow they'd do better.

After walking around the marketplace for a while, I figured I should buy a souvenir and had narrowed my choices down to a cigar kiosk offering hand-rolled cigars the size of a kosher salami, and a shop called Art by God (you know the economy's bad when God has to work the malls). That's when another Miami hotspot caught my eye — a large open bar called "Let's Make a Daiquiri."

Cool. I grabbed three ice cubes that someone had spilled onto the counter and began juggling while flashing my best Tom Cruise smile from the movie "Cocktail." Then I found out that the sign did not literally mean that I got to climb behind the bar and play with all the ingredients. Probably a union thing. I was disappointed but the real bartenders did make a mean rumrunner... and a mean planter's punch... and a mean margarita...

At sunset, the culture part started in the form of a Cuban band, which climbed up onto the stage just a few feet away and began performing. Within minutes there were dozens of people on the dance floor, skillfully moving to the pulsating music. The female singer had a voice like Gloria Estefan and the band played a great salsa beat. I listened and watched for a few minutes until I got a feel for it then I grabbed my wife and began performing my patented hip-thrusting, arm-flailing, white man overbite — always a crowd-pleaser.

"Half of Miami is laughing at you," said Pat.

I smiled. Did you hear that, Carl?

The band slowed things down a bit, but my wife didn't want to slow dance because she was wearing open toe sandals and the bruises from the last time we slow-danced had barely gone away. Plus, of course, we were still suffering a bit from jet lag (and frozen-drink-itis). So we headed back to the Beachcomber for a night of

1930s Dick Tracy-type passion.

"Where we headin' next, Breathless Mahoney?" I asked.

"Pennekamp."

"Penny Camp? Are we broke already?"

"Pennekamp is a state park," she told me. "In the Keys."

~

The Florida Keys are a group of 800 islets (some are pretty dang small) that stretch 124 miles from Mainland Florida to the last key, Key West. To me, it looks like someone painted Florida and hung it up on the wall before it was quite dry and it ran. This made a long, skinny, curving drip at the bottom.

We were now on Key Largo, the first part of the drip, located just south of Miami. Already we were far removed from big city lights and anything that looked remotely like Art Deco, though many of the small restaurants and hotels were "weathered," another one of those great marketing terms that tourists love, along with "quaint," "rustic" and "barren."

"Wow. This looks nice," my wife said, as we pulled off Highway 1 onto a narrow dirt driveway at a blue sign, featuring a large pelican with an open mouth.

Over the years, I've learned to avoid hotels with the names of animals in them like Skunk Creek Inn, Night Frog Motel, The Aggressive Chipmunk — to name a few. That's why I was a bit nervous as we pulled into the Hungry Pelican Motel.

"I wonder when the last time the pelicans ate?" I asked.

I sniffed my hands. They smelled like fish. Actually not fish — conch (konk). We'd stopped for lunch at Key Largo Crack'd Conch — a two-for-one, both weathered and quaint — and eaten their famous conch fritters, which were kind of like chewy fish sticks.

Conchs are the perfect tourist seafood. They're an acquired taste, which gives them cachet, plus the beautiful shells, which sell for a small fortune, add the perfect touch to your tooth-paste-

smeared bathroom counter. In fact, they are so perfect that people have pretty much collected and eaten all of the conchs in Florida. According to my wife, the fritters we had were most likely produced on a conch farm.

"And on his farm he had a conch. Ee-I-Ee-I-Oh."

"Please stop singing that," Pat said. "It wasn't all that funny the first twenty times."

And you thought it was easy being a humorist.

The Hungry Pelican is a rectangle of sand, palm trees and tiki huts, wedged in among a number of other rectangles of similar size containing other homey "Mom & Pop" motels and eateries along Route 1. Unfortunately for everyone, except those people whose idea of roughing it is room service that ends at eleven p.m., there are a number of mammoth resorts that have sprung up in the Keys — especially the middle Keys. Why people think they can experience something unique from a cookie-cutter gated community is beyond me, but I suppose they vary the size and shape of the facial spas to keep it interesting. Throughout our entire trip, we tried to avoid staying anywhere too large or too chi-chi. We like our culture natural (and cheap).

At the Hungry Pelican there were just nineteen cabin-like rooms and two trailers for rent, and the hosts, Dave and Rosemary, lived in a small private residence in front of one of the two docks, where the pelicans hung out waiting for fish (or small unattended pets?). Some of the rooms had great names like Captain's Quarters, Angel Fish, Sea Horse, Conch Shell and Minnow Suite, and were comfortable, clean and tropical. Oddly, we got another green shaded room. Ours came with two double beds and was romantically called "Room D."

It was about seven-thirty and a bottle and-a-half of wine later when we ventured out of our comfortable, tropically themed room and headed for the dock to watch the sunset. There was a white egret waiting...

"Probably came for the early bird special," I said.

My wife sat back in a chaise lounge, closed her eyes and let out

a relaxed sigh.

"Early bird special. Get it? It's a bird... It's not yet sunset... It's here for the feeding..."

Pat opened one eye. "Did the egret laugh?"

I looked at the bird. The bird looked at me. "Didn't even crack a smile."

"I heard they were intelligent." She closed her eyes again.

I thought about that then realized that the problem was the egret was probably a slow processor. Later, when it was back at its nest it would most likely break out into uncontrollable egret guffaws and then share the joke with all its other plumed friends. Probably even take credit for it. Use it at egret gatherings all up and down the Keys. Maybe even post it on its own little egret Internet...

I felt my own eyelids getting heavy. Next thing I knew my wife was shaking me. The sun was down. The egret was gone. Most of our fellow travelers had retired to their rooms. And if any pelicans had stopped by they hadn't bothered to wake us to introduce themselves.

We walked back to our homey little duplex cabin. The C's were out. Probably went with the A's and B's. Throughout history it's always been the ABC's. The D's always get left behind. I thought there might be a joke in there somewhere, but decided not to share it just yet. After all, we had a full day ahead us tomorrow and my wife prefers my jokes in small tasty batches — like conch fritters.

~

Every now and then I get to see something so amazing that I know it is a once-in-a-lifetime experience. This one happened at John Pennekamp Coral Reef State Park at Mile Marker 102.5 on Key Largo mid-morning the next day.

John Pennekamp was the first undersea park in the United States, established in 1963. Combined with the adjacent Florida Keys National Marine Sanctuary, we're talking 178 nautical square

miles of coral reefs, seagrass beds and mangrove swamps saved from humankind for humankind. Don't panic if you're a developer, though, because there is still plenty of swampland for sale in Florida.

It was eleven o'clock. We had been to the Visitor's Center and learned all about Florida's coral reefs, which took 5,000 to 7,000 years to develop (bet a lot of restaurants went out of business waiting for that tourist attraction to come to fruition) and are basically made of polyps...

Interesting we humans have to have polyps removed during colonoscopies — I wonder if that's so we don't develop reefs where reefs aren't supposed to be. Another great thought worth mulling over.

Seriously, though, the Florida reef is the only living coral reef in the continental United States and we were scheduled to go out on the noontime snorkeling boat for a close-up look and an hour-and-a-half of swimming with the fishes, but that wasn't quite enough for my wife.

"Let's check out Canon Beach," she said, pointing at the little cove just beyond the Visitor's Center. "I want to try out the snorkeling equipment before we go out on the boat."

"You want to get all wet before the boat ride? You could catch a cold or something."

"It's ninety degrees with ninety percent humidity. Come on."

"What about all our stuff?" I asked. "Someone has to keep an eye on things."

"Wimp," she said.

"Excuse me? I'm being the responsible one here for once."

"Er-nie's a wimmmpp... Er-nie's a wimmmpp..."

I was still formulating a comeback, when she slipped on her facemask, threw me a playful kiss, whispered "Er-nie's a wimmmpp" one last time. Then she went down to the water's edge and slipped on her flippers. I thought about chasing after her, but something told me to wait, so I just sat back and watched as she headed

straight into the eighty-five-degree water and just kept going until she was neck deep, a little further out, I might add, than any of the other swimmers.

Ready for that amazing thing?

As I was watching, my wife stuck her snorkeled face into the water to see what she could see. Just as she ducked under, this huge — I mean humungously huge — gray thing surfaced right in front of her. It looked kind of like a cross between a submarine with a tail fin and an elephant without a trunk. That was odd. I couldn't remember seeing anything about native trunkless elephants in the highlights section of the John Pennekamp Coral Reef State Park brochure.

I wondered briefly if Pat had noticed it.

That's when she pulled her head out of the water, stood straight up, and began walking backwards as fast as her flippered feet would allow, which was incredibly fast. I can't ever remember seeing anyone in flippers move that fast before or since.

In fact, she was striding backwards at such a pace that she was creating a small wake, and she went from neck deep to waist deep so quickly that several kids had to scramble out of the way or get run over.

But she didn't stop at waist deep. She didn't stop at thigh deep, knee deep or even ankle deep. She just kept on striding backwards right out of the water, onto the beach, and through the sand until she got to the picnic table under the shady palm tree where I was dutifully guarding our stuff.

"Did you see that?" I asked.

She looked at me like I was nuts.

"Yeah, I thought you must have. It was pretty big, huh?"

"Our house is big," she said. "That thing was from a Japanese horror film. I expected to see Godzilla surface next it and begin a battle to the death."

"According to this," I held up our guidebook, "the 'thing' you just had a close encounter with was a manatee. Says here they're docile and have doleful eyes."

"It touched me," she said.

"Probably just lonely. Some people find them endearing. Maybe you should have pet it, let it know you were a friend of the sea."

Again, she looked at me like I was nuts.

"By the way, the Guinness people called, you've set some kind of water-to-land speed record."

Pat's look changed from staring at me like I was nuts to actually looking a bit crazed herself, so I thought I should let it go for now.

A few hours later, though, as we were about to jump into the Atlantic Ocean and observe schools of Parrot, Angel and Butterfly Fish, the captain reminded us that there was a nine-foot-high "Christ of the Deep" statue submerged several hundred yards away from the coral reef that we could swim to if we so wanted. It's supposed to be quite amazing, attracting divers from all over the world.

"Whataya think?" I asked. "Maybe we'll see your manatee friend."

"No freaking way," she said.

I smiled. "Pa-aatt's a Wimmmpp... Pa-aatt's a Wimmmpp..."

It took the rest of the afternoon for the mark on my chest — made by my wife's right flipper — to go away. But believe me, it was worth it.

~

The next morning we went to a breakfast joint that had Mom and Pop written all over it. Weathered red wood, a parking lot made of crushed white shells, large screened-in seating area in the front, this place had character, characters and generous omelets made from fresh local eggs. You could even get conch fritters for breakfast. Seeing as conchs were now farmed, I wondered if the same farmer supplied both the eggs and conchs.

After breakfast we meandered over and through some spectacular Keys including Plantation Key, Upper and Lower Matecumbe Keys and Long Key to get to Grassy Key — Flipper's place.

Well, not the real Flipper of course. He's (actually there were several different "finned actors") long since passed and gone on to his great reward. Which I figure, because he was such a good dolphin with good karma and all, means he gets to come back and spend more time rescuing young, bikini-clad beauties from the perils of the sea.

"Are you staring at that woman in the bikini?" my wife whispered.

"Huh? No. Of course not," I said, looking away from the amply endowed woman who was about to climb into a large pool full of excited dolphins.

We were now at Mile Marker 59 at the Dolphin Research Center (DRC), a not-for-profit education and research facility, home to a family of Atlantic bottlenose dolphins and California sea lions. In their brochure the DRC states their goals are to promote peaceful coexistence, cooperation and communication between marine mammals, humans and the environment through research and education.

We were getting a tour of the watery digs.

"Over half of our family was born at the Center," a young woman was telling us, "while other family members either have come to us from other facilities or were collected long ago by previous management."

I was concerned that maybe she'd been at the Dolphin Center a bit too long, calling these big sea mammals family, but then I realized all of the staff did that. It was part of the dolphin/human encounter philosophy that makes this place so unique. Matter of fact, the DRC lets regular folks like us climb right into the pool to play with the dolphins.

"Excuse me, you can't go into the pool," the guide informed me.

"The blonde with the rose tattoo on her shoulder is in," I said.

"I knew you were checking her out," Pat said.

"Merely trying to avoid confusion as to whom I was talking about," I whispered.

"Yeah right."

Turns out to "have an encounter" costs extra, plus you have to take a training session first that lasts three to four hours. Then you get twenty minutes in the main pool with various members of the pod (which currently numbers sixteen). You can also invest a little more and spend an entire day as a trainer or — for the price of a used car — even spend an entire week at the facility. We had decided to just pay the basic admission fee and check it out first and were now passing three members of the pod who shall remain nameless because, well, I can't remember their names. And, I hate to admit this, but they all looked alike.

As we were passing this smaller tank with the three dolphins a strange thing happened. Our guide got red-faced and stammered:

"Oh my, I'm sorry. Perhaps we should leave them alone."

Then she quickly tried to lead us away to another small pool.

Pat and I looked at each other, then at the three nameless dolphins who seemed like they were just frolicking like all the others, though there was a bit more bumping and splashing, bumping and splashing, then, churning and bumping and splashing, churning and bumping and splashing, then the splashing turned to thrashing and it looked like the three of them were caught in a high-speed wash cycle.

"Dolphin sex," Pat whispered.

"Cool." I took a photo to show all my perverted writer friends back home, then said: "You know, I hope our next hotel comes with a hot tub."

Pat winked and then pinched me, which only seemed to make our guide more embarrassed, so I tried to ease her discomfort.

"Looks like you're gonna be an Auntie again," I said. "Maybe twice. Congrats."

I found out later that female dolphins purposely (porpoisely?) "do the deed" with all the male dolphins, so that none of them know who the father is. That way there is no jealousy and no one kills the pup. Also, they all have to contribute child support and the female, after a few flings can retire to, well, the Florida Keys, I guess.

I didn't find this out from our guide, because she quickly changed the subject away from sex and began telling us the history of the DRC, which opened in 1958 and now sponsored cutting edge research such as studying signature whistling unique to each dolphin and synchronicity between mothers and calves. Interesting stuff, but not nearly as interesting as the x-rated pool. So, as she was spieling, I snuck back to the small pool, which was now calm. I expected to see smoke wafting up from a couple of dolphin cigarettes, but there was nothing.

"I don't know about you," I said to Pat. "but I'm not sure I want to climb into the pool with any of these creatures. I'm wearing aftershave."

Another time she might have poo-poo'd my nervousness, but she still had that manatee adventure in the back of her mind.

"Let's go get lunch," she said. Four of my favorite vacation words.

~

To stay in the spirit of our recent adventure, we had dolphin sandwiches for lunch at an island tiki bar restaurant aptly called The Island Tiki Bar Restaurant. Good food, incredible view. You almost start to take these things for granted in the Keys, so I recommend you hit a Denny's or Pizza Hut or something every once in a while to ground yourself.

Okay, we didn't actually have dolphin, we had dolphin fish. Dolphin fish sandwiches are called mahi-mahi sandwiches in California, but probably these local mahi-mahi were trying to increase their odds of survival by hinting they might be related to the beloved mammals — which they're not.

After lunch we headed to one of the sights I'd been really looking forward to, Seven Mile Bridge. I know, I know, a bridge, whoopee, does this guy have a life? But Seven Mile Bridge is said to be the world's longest segmental bridge in the world. Still yawning?

Well, how about it's been in a bunch of movies? Remember the helicopter-limo chase scene in "True Lies" with Arnold Schwarzenegger and Jamie Lee Curtis with Jamie Lee being pulled out of the sunroof by Arnold who's hanging from a helicopter, just as the limo goes off the blown-up section? Great scene. Seven Mile Bridge was also seen in "2 Fast, 2 Furious," the James Bond film "License To Kill," and in "Up Close And Personal" with Robert Redford and Michelle Pfeiffer. That's more work than a lot of other strong, steely silent-type actors are getting.

I know all this, of course, because my wife, the historian, had studied up on all the historic things we might see and do. She had already shared with me the fact that the original Seven Mile Bridge had been built on top of the railroad tracks that used to be the only way, other than boat, to get through the Keys. The new Seven Mile Bridge runs parallel to the old one.

"Speaking of movies, here's a funny scenario," I said, just as we passed the exit to Pigeon Key — the last exit. "What if a husband and wife had gone to a filling station, and she went to, oh let's say, the ladies' room, while he decided to check out the speedy mart to see if they had anything unusual like conch gum or dolphin jerky that he could buy as a souvenir? And — ha ha — neither one of them ever actually put any gas into the car thinking surely the other must have thought of it."

Pat looked at the gas gauge, which was dangerously close to empty.

"You didn't put any gas in while I used the ladies' room?"

"When I came out you were cleaning the windshield, so I assumed you had pumped the gas."

"But I would have had to come inside to pay. You would have seen me."

"Yeah, I thought about that."

"When?"

"About a minute ago."

I knew she was about to add a further comment or two, so I pre-

empted her.

"If you were, say, writing this scenario, and as so it happened, this couple — who were both, I think, equally at fault — actually ran out of gas at exactly the halfway point on Seven Mile Bridge, would you a) suggest we start walking back this way, or b) suggest we start walking the other way?"

"You forgot 'c,'" she said.

"Is that the one where one partner tries to throw the other partner-slash-love-of-her-life into the Gulf of Florida?"

"Bingo," she said.

There was a moment of silence.

"Incredible view, though. You have to admit that?"

Fortunately, my wife has a great sense of humor. And fortunately, we didn't have to test it, as the car easily made it over the bridge, where, I quickly filled up the tank, so we would have plenty of time to visit some of the greatest beaches in the world at Bahia Honda State Park, which is right under the bridge and offers access to both the Atlantic Ocean and Florida Bay.

It's the kind of place where tension dissolves.

"You know," I said, as we were sitting neck deep in water that was almost exactly the same 90-degree temperature as the air, "I checked the odometer. The Seven Mile bridge is only 6.8 miles long."

"You checked the odometer, but not the gas gauge?"

"Well, yeah."

"Are all guys like you?"

"Well, yeah."

She shook her head and laughed.

"Man, this feels just like a hot tub," I said.

"I know," my wife said, then leaned in close and whispered: "Hold this, willya?"

She handed me her bathing suit.

I forgot about mileage and gas gauges and conchs and everything else. I did a quick glance around to see if anyone was near us,

then slipped out of my suit.

What a feeling! We were naked, in public, in the Tropics, in water so clear you could see all the way to the bottom — both of our bottoms — and not a care in the world. We were living on the edge!

We both noticed the kids about the same time — a pair of twelve-year-old boys, wading right toward us.

Here's a little hint you won't find in the guidebooks, but I'll share it with you now, so that you can file it away for your next carefree trip. Bathing suits are a lot easier to take off while sitting in the water than they are to put back on. Also, our struggles were hampered by the fact that we were now thrashing around and laughing so hard we couldn't catch our breath.

The boys stopped before they got to us and headed back to the beach. The way I figure it, they'd probably been to the Dolphin Research Center and learned all about the birds, bees and mammals.

"Tourist sex," one of them probably said.

"Yuck," the other one probably added.

# Chapter Fifteen
## RISKING LIFE AND LIMB FOR A STORY OR TWO

By now, my wife and I had become "well-seasoned" Florida Keys travelers, and as such were making an effort to capture the flavor of our newest exotic location and its most famous inhabitants.

"Can I help you?" the tan young woman asked.

"Yes. I'd like the Ernest Hemingway sandwich."

"Of course. Do you want the Harry Truman fries with that or the Jimmy Buffet soup?"

Thus began another lunch of historic proportions in Cayo Hueso (Island of Bones) better known as Key West.

Key West is a mysterious island community filled with artists, writers, musicians and other people who drink a lot. It is the Southernmost point in the Continental United States, as is illustrated by signs at the end of Duval Street indicating the Southernmost House, the Southernmost Hotel, and Bob, the Southernmost Panhandler.

Ironically, even though Key West was far removed from so-called civilization in the 1800s, it became the richest town in the nation because it had two things going for it. One, a lot of Spanish, French and Dutch treasure-laden ships sailed by Key West on the way to someplace else. And two, a lot of those ships hit the hidden coral reef and sank. Every time this happened the "wreckers" as they became known, jumped into their own boats, and salvaged the trea-

sure — and occasionally, a few surviving sailors. It's rumored that during the slow wrecking season, some of these early entrepreneurs

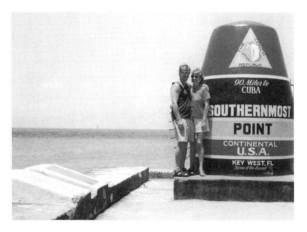

even hung out lanterns to lure ships to the reef.

I'll bet there are some locals today that would like to try this technique out on the plethora of huge cruise ships that stop by during the prime tourist season — December to May — when the place is over-run with loud, obnoxious people from weird places like California.

Which was why we were here in the off-season in early July, when the temperature outside your body is about the same as the temperature inside your body. Still, we were not about to lie around by a shaded pool all day. What kind of a vacation would that be?

"What's next on the itinerary?" my wife asked after lunch, as I floated on a rubber raft in the shaded pool of the Travelers Palm Inn and Guesthouse — a great hideaway on Catherine Street, just far enough from noise and crowds of Duval Street, yet close to everything.

"Well, we haven't seen the world's largest turtle shell yet or the place the islanders used to hold the cock fights. Says in the guide book it's now a KFC."

"Naw. I want to do something adventurous this afternoon," she said.

I felt a little twinge. A couple days ago when she said that we ended up six miles out in the Atlantic Ocean at the Looe Key National Marine Sanctuary for our second and most memorable

snorkeling experience.

"Here we are," the captain had informed us after a 45-minute boat ride that reduced the land behind us to a mere memory. "Snorkel up. And be careful of your footing. We've had more accidents this summer from people slipping than from shark bites."

"How many more?" I'd asked him. But he never answered. He'd been too busy chumming the water with fish food and pointing out several shiny barracuda — the fish, not the cars — that constantly circled the boat.

Fortunately, we'd survived two hours of floating about at Looe Key, but I don't like to tempt fate.

"The ocean looks rough today," I cautioned Pat. "They're predicting four-inch swells and visibility less than fifty feet."

"That's okay, I don't want to go out on the ocean today."

I smiled.

"I want to ride the Conch Train."

I unsmiled.

The Conch (aptly pronounced konk, like the shellfish) Train looks like something from Toon Town at Disneyland. Only instead of inching its way through throngs of little kids, this train winds its way through narrow streets in the heart of the tourist district full of large delivery trucks and cars being driven by overly excited people looking through digital video cameras.

"You're sure about that turtle shell? I hear it's breathtaking."

Pat threw me a towel, handed me my ticket, and twenty minutes later we climbed aboard the train behind a guy wearing a microphone and an Evel Knievel hat.

"Welcome aboard," the guy said. "I'm Ace, and I'll be your driver today." He stomped on the gas pedal, forcing two bicyclists into a hedge. "Please, no screaming or leaping from the train."

I stopped screaming and sat back down.

"Key West has an interesting history," he began. "For instance, it was a day just like today when a fire raced right up this very street destroying everything in its path in mere seconds."

We took a corner on 18 wheels, all on the left side of the train.

"Of course, that's nothing compared to all the savage hurricanes of the last few years."

I thought I felt a sprinkle.

"Did I mention that we are only 90 miles from Cuba? They say we could be the first city destroyed during a nuclear attack."

The Conch Train stopped suddenly near Little Bahama to let an old woman holding two chickens cross the street.

"That's Crazy Shirley," Ace whispered. "She hates tourists. And they say she practices voodoo."

Shirley looked right at me and I realized I was holding fourteen brochures, three bags of souvenirs and two cameras. I grabbed Pat and climbed off the train.

"Where are we going?" she asked.

"I think we just passed Hemingway's house," I said.

Pat smiled. "Great. I wanted to see the polydactyls anyway."

Polydactyls? All I could picture were some kind of prehistoric birds — predecessors to the voracious seagulls in Key West, with twelve-foot wingspans and sharp pointy beaks.

"Hope the hell they don't find out how 'well-seasoned' we are," I said.

Turns out polydactyls are just cats with more toes than cats normally have. Ernest Hemingway had a number of six-toed cats and through careful breeding techniques — like not spaying them and buying them little cat lingerie — the original line has continued. There are about sixty cats at Hemingway House, half of which are polydactyls.

As you might imagine, that's a lot of cats to keep hydrated, so Hemingway had a special drinking fountain built for them. The top of the fountain is an old Spanish olive jar that was brought from Cuba. The trough at the base of the olive jar came from one of Key's West's most famous saloons, Sloppy Joe's, named for the first owner, a guy named Joe who was sloppy. (See, all history lessons don't have to be complicated.)

"Hmm, that looks familiar," I said, leaning over the base and turning my head to the side. We had eaten Sloppy Joes at Sloppy Joe's just the previous day, and consumed a number of their drink specialties.

"It was actually one of the bar's urinals," our guide told us. "Hemingway's wife, Pauline, added decorative tiles to it to disguise it."

"She also took out the little blue deodorizing cake," I said, showing off my observation skills to our tour group, many of whom were probably writers.

Someone in the group — besides my wife — groaned. Probably an editor. They have no sense of humor.

The house was interesting. Yellow. Square. Lots of old furniture. Photos of Papa Hemingway being a kid, then a young adult, then someone who fished a lot. Tons of art including a cat statue made by Picasso. And, chandeliers that the guide kept pointing to excitedly, which looked to me like, well, chandeliers.

One thing I liked was a wrought iron Spanish bottle safe called a Tantalus. It was used by wealthy Spaniards to keep the servants from drinking the good stuff while the family was away — kind of a chastity belt for old wine. There was also a cupboard that was one of Hemingway's manuscript chests where he kept the stories on which he was working. I have the same thing in my office. I call it the floor.

My favorite thing, of course, was Big E's writing room, which he had built over the carriage house and at first was only accessible via a precarious catwalk from the second story of the house across an open expanse about sixty feet wide, according to our guide.

"Probably why he did most of his writing in the morning," I said. "Because after a few drinks for lunch crossing it could have meant *Death in the Afternoon*."

I heard several groans this time. Must have been a number of editors in our group. I know they travel a lot. That's why they're never there when you call.

There are stairs now that lead to Hemingway's writing room and you can peer in at his old Royal typewriter and the very chair he sat in while pondering the adventurous *Snows of Kilimanjaro.* Someday, when I'm famous and dead, people will be able to look at my Macintosh computer and early twenty-first century ergo dynamically designed chair where I pondered over an adventurous afternoon at Home Depot for one of my stories.

Speaking of pondering (note the clever transition there, I think a bit of the other Ernie may have rubbed off on me), after the Hemingway House we found a great open-air saloon called the Green Parrot Bar, known as: "A sunny place for shady people." Listed as the first and last bar on Highway 1, it's been there since 1890. Looked like some of the patrons had been there almost as long. The blues was playing on the jukebox, there was cold beer on tap, and some very bizarre things hanging on the wall.

"Now that's good writing," I said, pointing to a sign with the clever caption: "If you're walking on thin ice you might as well dance."

"I like the one that says, 'No Sniveling,'" Pat said. "I'd like to hang that one on my office door at work."

The Green Parrot had a real homey, familiar feel about it, which says a lot about my life-to-date, and I could have stayed a long time, but there is just too much to do in Key West during the day to just hang around drinking beer.

For instance, you can visit the above ground cemetery and read some of the clever epitaphs, like: "I told you I was sick," on the crypt of B.P. Roberts, and "a good citizen for 65 of his 108 years," marking the grave of Thomas Romer.

You natural types can sunbathe at the clothing optional Garden of Eden Bar on Duval Street. Or perhaps you'd like to take the Gay and Lesbian Trolley tour. Or, visit the Audubon House and Tropical Gardens or the Truman Whitehouse.

For your nighttime enjoyment, you might want to consider the Hog's Breath Saloon, where they occasionally host a pig roast and

"bobbin' for booze" contest. Or, the Margaritaville Cafe, Jimmy Buffet's place. Or, maybe you'd like the Red Garter, a raw bar that doesn't serve food (think about it).

We did a number of these things (you guess which ones), but the one thing that we, and it seems everyone else, did every day at sunset was to visit Mallory Square where all kinds of entertainers gather each afternoon to perform for tips. So we jumped on the trolley and a few minutes later we were drinking something called a mudslide and standing around the mini arena of one of Key West's most famous attractions.

"No way is he going through that hoop," I said to my wife.

A second later the cat (yes, cat!) jumped through a hoop of fire.

Somehow, Dominique LeFort has trained house cats — Oscar, Cossette, Sharky, Sara, Chopin, George and Mandarin — to perform all kinds of tricks, including walking on tightropes and jumping repeatedly through hoops. I thought about my cat, Sam. The only trick he'd mastered in his eighteen years was to fall asleep standing up beside his bowl waiting for din-din.

There are also full-grown tightrope walkers like Will Soto, who's been performing in Mallory Square for 20 years. Fire and sword swallowers. People juggling while riding around on giant bicycles. People who can hold completely still for long periods of time who have painted themselves silver and pose as statues.

And my favorite, a guy named the Great Rondini, who lets the crowd put him into a strait jacket, wrap him in heavy chains with the kind of locks they shoot bullets at in those television commercials. Then they hang him upside down by his feet from a large tripod, which he proceeds to escape from twice nightly.

"I'll bet this show would go over big at mental institutions," I said. "Now! Disappearing nightly, hundreds of inmates..."

"Shhhh," Pat said.

"Does make you wonder, though, where he got that strait jacket in the first place, doesn't it?"

The Great Rondini twisted around and looked at me, then he

began squirming frantically, and I realized that in a few moments, he was going to be "loose" again.

I tossed a couple bucks into his collection bucket. "Maybe, we should move on."

"Good idea," Pat said. "Big day tomorrow."

"The giant turtle shell?"

"Nope. The Everglades."

~

Traveling a hundred and twenty-four miles on California freeways takes about an hour-and-a-half (unless you are in Los Angeles, then it takes a day-and-a-half). But the Keys are not meant to be rushed. Matter of fact, Ace, the Conch Train driver, told us about one time they evacuated Key West because of an approaching hurricane.

"We all jumped into our cars, causing a huge bumper-to-bumper gridlock, and inched up the Keys at about one mile-per-hour. By the time we made it to Marathon Key, the hurricane was over and we all turned around and drove back at about the same speed."

We didn't have a hurricane to worry about. Matter of fact, there wasn't a cloud in the sky. Plus, we got an early start. Still it took us four hours to go up the Keys, which put us in Everglades National Park at about noon when even the laziest mosquitoes are hovering about scratching their little mosquito butts, while staring into the great refrigerator of life looking for leftover tourists.

"More?" I turned the aerosol can toward Pat.

"No." A mosquito so large that it should have been required to file a flight plan landed on her leg and began drinking. "Yes," she said, then went back to holding her breath.

It's not easy to spray yourself while sitting inside your rental car. Probably not all that healthy either. But we'd tried doing it out in the open — once.

Freshly poisoned, we opened our respective doors, jumped out

and closed them as quickly as we could to prevent mosquito hitch-hikers. We exhaled. The swarm checked us out, but didn't land on us. I felt like singing the praises of Diethyl-m-toluomide.

"What the heck are you singing?" Pat asked.

"Uh, just an old Beatles song."

Another car entered the parking lot at the Royal Palm Visitor Center, stopped, and all four doors flew open. There was a moment of gleeful tourist squeals, then the swarm dive-bombed them. It was like watching a low-budget horror film. The car was shaking back and forth as the occupants tried to kill the invaders, then the doors slammed shut, the windows fogged with aerosol and everything got real still.

Times like that I wished I had a digital movie camera.

The Royal Palm Visitors Center is located just four miles from the Everglades National Park's southern entrance near Florida City. It offers two half-mile loops, including the Anhinga Trail, which goes through a saw grass marsh.

"Why do they call it saw gra... ow, damn." I watched the blood trickle down my finger. "You know if the mosquitoes ever figure out how to use this stuff, they'll bleed us all dry."

Most of the Anhinga Trail consists of raised wooden paths that meander through the swamp and allows people to safely share a bit of territory with alligators, turtles and all kinds of birds. There are also more than a dozen different grasses and plants, including swamp lilies, pickerel weed and apple trees with apples that they say taste like turpentine (probably some house painter confirmed this).

Interestingly, to get to the trail, you walk on a roadway along the bank of a slow-moving river that also contains wildlife. There was nothing to prevent any of this wildlife, including the alligators, from crawling out of the river and joining us on the roadway that lead to the paths.

"If you encounter an alligator on the path," they told us in the Visitor Center, "do not try to feed it or pet it."

Damn, I brought a bucket of raw meat for nothing.

"Stay back at least fifteen feet because alligators are really fast," was another standard warning. "They can outrun you."

When I heard this, I grabbed my wife and we quickly caught up with some older people that looked like — in an emergency — would be slower than us.

"Also be careful of your footing," they said. "We've had more accidents this year from people slipping than from alligator bites." (Okay, I made that last one up, but I'll bet if the captain of the *Komono Cat* from Looe Key were here, he would have said it.)

The second trail, the Gumbo Limbo Trail, goes through a dense hammock full of wild orchids and gumbo limbo trees. The Calusa Indians used to use the resin-like gum from the gumbo limbo trees to make glue.

"Do not touch that resin stuff," my wife said.

I retracted my hand. "Well, duh, whataya think I am, dumb?"

"You once epoxied your forehead to a kitchen cabinet."

"The door swung shut on me. That could have happened to anyone."

Another husband that was walking in front of us, turned and nodded to Pat.

"See."

It took about an hour to finish both loops, which is also about how long bug spray is effective, so a number of us headed back to the parking lot, as another wave of tourists were arriving to take our place.

"Yeah we're here! Ahhh! Quick! Where's the Diethyl-m-toluomide?" could be heard all through the parking lot.

Being in the Everglades was great, but I wish we could have seen alligators with a little more spunk. The ones we saw looked like logs with eyes.

"You been to the Miccosukee Indian Village yet?" a guy we meet on the Gumbo Limbo Trail asked. "They got a guy there that does alligator wrestling. Almost got bit a couple of times when we were watching."

"Cool," I said, then I frowned. "I'm not sure my wife would go for that. Animal cruelty and all."

"They got a cultural center and a museum, too."

I high-fived my new friend then climbed into the car.

"You ever heard of the Miccosukee Indians," I asked my wife.

"They're in the guide book. The Miccosukee Indian Village is about fifty miles from here."

"I heard they have a great cultural center and a museum. Seems like we should end our vacation on an educational note, don't you think?"

"Wow. Maybe there's hope for you yet," she said.

Fast-forward two hours.

"You're hopeless," Pat said.

"What? This is cultural."

There was a guy sitting on an alligator's back. He was leaning forward and holding the top of the alligator's open mouth with his chin. He had his arms out to the side in a ta-da position. I took a flash photo.

"Please no flashes," someone said. "That's how we lost the last wrestler."

I waited for the laugh. There wasn't one.

Photo By Ernie Witham

"How'd you like to recruit for that job," I whispered to my wife, who supervises national searches for university professionals. "Wanted, guy with strong chin and weak mind."

Photo By Ernie Witham

The audience clapped as the wrestler walked around to the front of the huge beast, tapped him on the snout, so he'd open his mouth as wide as possible then began to reach his hand forward.

"Whoa, I gotta get this." I shut off the flash, moved closer, bent over so I could get a really dramatic shot.

"The trick is not to touch the alligator's mouth," the wrestler said. "Watch."

He took off his hat, put it a little ways into the gaping mouth, and then quickly touched it to the roof of the alligator's mouth.

"Whap!" The jaws snapped shut, just missing the cap.

"Please get ready," he said. "And no yelling. We don't want to break the alligator's concentration."

Several more people lined up around the fenced in arena and aimed their cameras. I didn't want to get the fence in my photo, so I poked my camera lens through one of the diamond shaped openings. Several other guys followed my lead.

The wrestler tapped the alligator on the snout again. It opened its jaws wide. He moved his hand forward. I focused. Then, just as the guy put his hand inside the alligator's mouth, my lens cap fell out of my shirt pocket into the arena, rolled across the cement and fell over, doing one of those woogaty-woogaty-woogaty things.

The alligator looked at it, looked at the crowd, looked at the guy in front of him. Then the alligator thought: Hey there's a hand in my mouth.

He snapped his huge jaws shut with a resounding "Whap."

The audience gasped, the alligator wrestler yelled "Ow."

Then the alligator wrestler stood and held up his hand — still intact. The crowd applauded. The guy took a bow. I felt like I should get a little credit for the drama, but my wife thought it might be better if we just moved on — quickly.

"What about my lens cap?"

"No one knows yet who dropped the lens cap. When they figure it out, they may return it to some portion of your person that you'd rather not have a lens cap returned to, if you know what I mean. Besides, seeing that alligator reminded me that we have to pack our bags for tomorrow's flight."

We did a quick tour of the museum, which had traditional Miccosukee clothing, paintings and other tribal artifacts. It also had a wall of photos featuring tribal members from past generations.

"Makes you wonder, doesn't it, how many former tribal alligator wrestlers, had to learn to eat with their left hands. That's a cultural lesson for sure."

"Right," Pat said.

We bought a few post cards at the gift shop and we headed back out the Tamiami Trail to civilization.

"I can't wait to get back to Santa Barbara," I said.

"Why?"

"Well, I didn't want to mention this earlier, but I may have the computer on in my office. And the lights. And the television. And the stereo."

Pat sighed. It was going to be another long flight.

"Plus, of course, I have a column due and I think I might write something about Florida."

"Well whatever you do, don't tell your readers about getting naked in broad daylight at Bahia Honda State Park. I have friends at the university who read your columns."

"Ah, okay, sure," I said, as the muse began to snicker in my ear like a teenage boy.

# Chapter Sixteen
## BIRTHDAY BASHES

A few days later we were back in Santa Barbara for the big annual birthday bash. My granddaughter Leila's birthday is the day after my birthday, so we always celebrate them together. This has been the story of my life for years. See my son, Shane, was born the day before my birthday, so when he was a kid, we always had a double birthday party, at which he got the majority of the gifts and attention. Now, there's Leila, who also gets a majority of the gifts and attention.

The combo birthday was tomorrow, but today we were supposed to do something just for my birthday and I wanted to feel young again, so I was washing the "Be Twenty-Something Again" hair color solution out of my mustache when Pat came into the bathroom holding her cellphone to her ear.

"The kids want to know want you want to do for your birthday," she said.

"Umthim woo woo," I said.

"Excuse me?"

I pulled the teeth bleaching apparatus out of my mouth.

"Something youthful," I repeated. "I'm feeling sprightly."

"Right," she said.

As soon as she left, I fired up my battery-powered ear and nose

169

hair trimmer, did a bit of pruning then smiled into the mirror. Not bad. And by the time I finished shaving my back, filling in my laugh lines with face putty, and slathering on a coat of "Hollywood Casting Call" instant-tanning lotion, I'd look downright boyish.

Life was good.

My wife came back into the bathroom just as I sprinkled the last of the foot fungicide powder in-between my toes and stood up.

"Whataya think?" I asked, hiking up my choners and giving her a quick butt flex. "Remind you of that rascal you married?"

"Actually, yes," she said.

"Really?"

"Oh yeah, because that guy, he wouldn't have read the section on the tanning bottle that talked about applying the lotion evenly either."

I looked in the mirror. The guy staring back at me looked like he'd lost a paintball fight.

"That reminds me," she said. "I need to buy some vanilla and chocolate ice cream for the party."

A short while later, we pulled up to the historic, red wooden Ballard Schoolhouse in Ballard, California, which was built in 1882 and is still in use today.

"This was the most youthful thing I could think of," said Pat. "Besides, Leila and Charlie love it here."

Indeed, the grandkids were running all around the huge lawn — even though it was ninety degrees. I overheated just watching them.

"How come you're wearing a long-sleeve shirt and long pants?" Christy asked, as she fastened a birthday hat onto my head.

"Yeah, aren't you baking?" my son-in-law Carl asked.

"He has a bit of an issue with his new tan," my wife whispered.

Before I could respond, Leila and Charlie grabbed me.

"Let's go on the rope swing," Leila said.

Ballard School has a thick rope that hangs from a huge old sycamore tree. For twenty minutes, I pushed and the kids swung and

Photo By Pat Sheppard

twisted, laughing all the way.

Then Leila said: "Your turn."

I looked at the dangling rope with the giant knot on the bottom, wondered briefly about the maximum suggested load capacity, then said: "What the heck."

I grabbed as high up as I could, pulled myself up, and sat on the knot. Leila and Charlie gave me a great big push.

Wow. This was great. I hadn't been on a rope swing since that time I...

"Mommy! Ernie fell," Leila and Charlie yelled.

"You okay?" asked Christy.

"No," I would have said, had there been any air in my lungs. I gasped a few times, which reminded me of something — my ribs.

"That was fun," I eeked out. "Now, I think I'd like to lie in the grass and watch the clouds."

An hour or so later, the food was gone, the wine, most of which I had used medicinally, was gone, and the cars were packed up. Carl, Christy, Leila and Charlie were headed to Solvang to look for another gift. See, tomorrow was Leila's birthday.

"I thought we'd stop by the Maverick Saloon," my wife said. "Do a little dancing before we join up with the kids in Solvang. That is, unless you are too pooped out."

"Just getting started," I said in my most youthful voice.

The Maverick Saloon is located in the small western town of Santa Ynez, where Old Santa Ynez Day is held each June, which as you know features a parade with a jail that Pat wouldn't bail me out of. The Maverick is a favorite of Valley ranchers and cowhands, Santa Barbara bikers, and country and western dancers. Today the place was packed. My wife aimed me toward the bar, then danced her way to the ladies' room.

The bartender watched me hobble in holding my side while picking at the loose chunks of face putty and, no doubt, noticed my ripped shirt, which revealed my blotchy skin. He pointed at the Happy Birthday hat sitting atop my thinning, now-unstyled hair.

"Good news and bad news," he said. "The good news is, because it's your birthday, the first beer's on me. The bad news is, we don't offer senior discounts on food or anything."

I was tempted to drop my trousers and give him a quick flex of the old gluteous maximus, but I knew that would hurt too much.

"Light beer," I said instead. "I still have another birthday party to go to."

"You city folks sure are a strange breed," he said.

~

Occasionally, I feel the need to share the wisdom of my years and bestow upon a new generation those things that played such an integral part of my own early childhood development.

"And this," I said to Leila, "is a dribble glass."

We were at one of the great life-lesson-learning centers of the Santa Ynez Valley — Toyland in Solvang, California — and I was determined to buy Leila a birthday gift to remember.

"You fill this thing up with water and when the person takes a

drink they get it all over themselves. Is that great or what?"

"Why?" Leila asked.

Hmm. Maybe she was a tad too young to appreciate the humorous possibilities of a dribble glass.

We continued our search for wisdom.

"Oh man, hot pepper gum! This gets a laugh every time." Hot pepper gum and a dribble glass seemed like the perfect combination. But for some reason it made me think of high school detention. Leila was only in first grade. They probably didn't even have detention. Still, maybe a better gift would be...

... a whoopee cushion! Of course.

I began pawing through racks of squirt cameras and plastic ice cubes with flies in them, pausing once to blow really hard into an auto exhaust whistle. Man, that was loud. Cool. I was about to blow it again when Leila poked me in the leg.

"Whata these?" she asked.

I read the box. "Mood Toe Rings," I said. "Wow. I didn't even know they made mood rings for your toes."

I quickly took off my shoe and sock and forced one into place.

"These babies contain some kind of crystal thingie that's sensitive to your emotions or something," I said scientifically.

"Why?" she asked.

"Ah, just because."

I watched the toe ring for a minute. "See. It's turning dark blue. That means I'm happy."

Leila squatted down for a closer look. "You have an owie," she said loudly.

My toe was also turning dark blue.

"Hmmm. My foot must have swelled a little." I bent down and tugged for several minutes. The ring was stuck.

Several other patrons came over to have a look at my toe, which was now throbbing.

"Looks like it's gonna burst," a guy behind me said. He squatted down for a closer look.

"Someone ought to call 9-1-1," a woman said.

"I'm sure it's nothing," I said, trying to curl one of my other toes over the blue one before someone pulled out a pocketknife and tried to cut the thing off.

"My brother-in-law lost a toe once," said another patron. "Now he walks with a limp."

I looked at the mood ring, which was getting darker by the second, as was my toe.

Leila touched it.

"Eeewww," several people said.

"It's just discolored!" I said. "I'm sure it'll be fine in a minute."

"Rightttt," they said.

I needed a diversion, so I grabbed a Captain Laughing Feather Sword off the shelf and started waving it around until they moved along.

I felt a presence behind me.

"*En garde*," I said, poking the young lady. The sword giggled, then began laughing hysterically. Now this was an educational toy.

"I thought you looked familiar," the woman said.

Ah, yet another fan.

"Yes," I said. "I am Ernie Witham. The writer. I suppose you'd like an autograph."

She looked at my sockless, mood-ring-adorned swollen foot and at the still-slightly-wet auto exhaust whistle in one hand and the Captain Laughing Feather Sword in the other.

"I'm Lisa," she said. "The store owner. And you're the guy who put Quack & Flaps inside all my hand puppets a few weeks ago, aren't you?"

I tried to feign indignation, but the Captain Laughing Feather Sword started giggling again, which made me smile.

"Can I get this?" Leila asked. She held up a large box containing a plastic horse.

"That's what you want?" I asked. "Out of all this — intellectual stuff?"

"It's a horsie for Cinderella," she said. "I'm gonna call her Honey."

"About that autograph," Lisa said.

I handed Lisa my credit card, then I tucked my new sword into my belt, put my whistle into my shirt pocket, slipped my sock and shoe over my new toe ring and grabbed the plastic horse from Leila.

"Not easy sharing wisdom," I said.

Lisa nodded. "Nope. Your granddaughter certainly has her work cut out for her."

# Chapter Seventeen
## I'LL HAVE THE COMBO PLEASE

As you probably have learned by now, I take my grandparenting responsibilities very seriously. The morning of the big combo birthday, before all the guests arrived, I was giving my grandson Charlie an important life lesson about swimming pool survival.

"Now!" I yelled.

He hesitated and missed. Unfortunately, Leila didn't, and we took a direct hit. Charlie and I coughed, sputtered and spit out water. I also quickly rubbed my wounded left eye.

"Now," I yelled again.

My granddaughter Leila dove. Then Charlie yelled "now" and fired at nothing.

Two seconds later, Leila came up firing again and nailed us. More coughing, sputtering, spitting and left eye rubbing.

I took the squirt bomb away from Charlie, held it under the water for a minute to refill it, and said profoundly: "Timing is one of the most important things in life. Not counting beer and pizza, of course."

"Apple juice," Charlie said, "and peanut butter toast."

"Right. Pizza, beer, apple juice, peanut butter toast, hamburgers and French fries."

"I want French fries," Charlie said.

"Later. Right now we are learning about tactics."

"What's tapics?"

"Tactics. Ah, well, it's like when Wallace and Gromit are trying to save the town's vegetables by catching all the rabbits in that movie 'Curse of the Were Rabbit' and they use the giant sucking machine. Remember?"

"We don't have a giant sucking machine."

"Yeah, I know."

"And Leila's not a rabbit."

"Yeah, I know that, too. That's not the point. The point is... Well, the point is when I say 'now' I mean right now, got it?"

"Like this!" Leila yelled. She squirted both of us, then disappeared to the watery depths of the swimming pool as Charlie fired again at the spot where she had been.

I grabbed Charlie and we retreated behind the large plastic dolphin raft to regroup.

"Dude, we are losing badly here and I'm not sure I'll ever see out of my left eye again. What would Wallace do?"

"He'd have cheese."

"Right, but what would he do besides that?"

"Nothing. Gromit would do everything."

That was a good point. Gromit was always saving Wallace. He was one smart puppy. I grabbed Charlie's shoulders, turned him toward me. "I want you to be more Gromit-like." Charlie smiled and nodded.

I caught a glint of sunlight bouncing off goggles as Leila surfaced right behind us. "Ha-ha," she said and let loose with an entire water bomb's worth of chlorinated ammunition.

"Fire, Gromit!" I yelled. "Fire, fire, fiubblubblbbly...." The last command was muted as I got a mouthful of pool water. I choked then said. "Dude? Why didn't you shoot?"

"You didn't say 'now.'"

"Fire means the same thing." I grabbed his shoulders again. "So when I say fire, fire, fire I mean now, now, now."

Charlie panicked and shot straight ahead hitting me right between the eyes, evening out my water blindness.

"Now," he yelled after his water bomb was empty.

That's the thing with the transferal of worldly grandfatherly advice; it can be downright dangerous at times. Still I wasn't ready to admit defeat, though I was seeing every color in the rainbow. I scanned the pool's surface as best I could, but Leila has learned to stay down an amazingly long time for someone who weighs fifty pounds — soaking wet. I got an idea.

"Wait here," I said to Charlie. Then I whispered into his ear. "I'm going to cannonball Leila just when she surfaces. Maybe the wake will dislodge her water bomb and we can disarm her. Watch how carefully I time my attack. Okay?"

"Okay," Charlie said.

I quickly climbed out of the pool, stood at the edge, waited, waited, waited, and then yelled. "Here comes the big one!" and jumped high in the air.

Just before I hit the water, Leila shoved the giant plastic dolphin raft right into my path. So instead of a splash, there was the creaky, squeaky sound of a six-foot tall, one hundred and ninety-pound man landing on a piece of inflated plastic meant to hold a fifty-pound kid.

I heard Leila say to Charlie. "That's tactics." To which Charlie replied: "Leila, can I be on your team now?"

Then the dolphin exploded and sank taking me with it, proud at least that today's life lesson had been learned.

That's when my wife came out with towels and said: "It's time to get ready for the party. The bouncer guys just arrived."

"Good, because this pool thing is dangerous," I said. "I'm ready for some gentle bouncing."

"Yay!" Leila and Charlie yelled.

~

Christy was the one who thought of calling the bouncer compa-

ny. Leila's friends were coming for the combo Leila-Ernie bash and she thought it would be perfect for a bunch of six-year-olds.

But come on. Fess up. How many of you adults (especially guys) have always wanted to climb into one of those giant blowup bouncers like the ones they have at local festivals and bounce around and fall down and say things like: "Whee, what fun." Or: "I feel young again." Or: "Hey, whose kid is this jumping on my face? And is that a fresh diaper?"

And if said bouncer has one of those giant blowup slides attached to it, what red-blooded adult hasn't wanted to fly down that thing yelling: "Look out below." Or: "Incoming." Or: "Wait. How do I stoppppppppp…"

Well, today's combo birthday party included one of those blowup bouncers with one of those aforementioned humongous attached slides.

And there were lots of people. Besides all Leila's friends and their parents, a bunch of my friends came and together we all had a great barbecue. I, of course, like to meet new people so I singled out some of the parents.

"Hi, my name is Ernie. It's my birthday, too. You probably want to know all about me, so let me start at the beginning. I think it was my seventh birthday or maybe it was my eighth… no seventh…"

"Ah, great. Ernie is it? We'll be right back. You wait here."

We also had some glitter painting for the kids, some backyard golf for the adults, tons of great gifts, even more splash time in the swimming pool, though this time I made sure there were no rafts in the way:

"Incoming!"

"Does Ernie yell and jump like that all the time?"

"Yes," my wife said.

"Even at bedtime?"

"Yes," Pat said.

It was after the pool, the cake and the gifts that our attention turned once again to the twenty-foot tall, forty-foot long red, blue

and yellow monster bouncer with the two giant blowers constantly breathing life into it.

"I've got an idea," Jon said. "How we can make the slide faster."

The bouncer's slide hadn't been very fast earlier in the day. Heck, most of us couldn't even get all the way to the bottom. But now that the majority of the non-adult-type kids had gone home, Jon, Patrick and Carl, all of whom were under the influence of reckless confidence and some of whom were also under the influence of beer, which is similar to reckless confidence, suggested that hosing it down might give it a new thrill.

"That's a great idea," I said.

"Okay, then, birthday boy," Patrick said. "You get to go first."

So, I put down my beer, scurried up the plastic ladder, held my arms over my head in sheer bravado imagining the theme from the movie "Rocky," and yelled: "Incoming!"

It's odd how many feelings go through your head in the matter of three and one-quarter seconds. Things like: "Ewww, the water's cold." And: "Wow it really is faster." And: "Gee I never noticed before that the bottom of the slide is actually two feet off the ground."

Speaking of theme songs like "Rocky," you music lovers probably remember that other perennial favorite: "The leg bone's connected to the hipbone. The hipbone's connected to the tailbone. The tailbone's connected to the solar system..."

"Are you all right?" my wife asked.

"Are there really stars out?" I asked back.

"No, it's still daytime."

"Then I guess 'no' would be the answer to your question."

The good news is that I have a birthday every year. So my wife is always prepared. "Ice!" she yelled. "And Ibuprofen – the large bottle."

Jon, Patrick and Carl watched as I limped off with the assistance of my wife and my stepdaughter Christy.

"Do guys ever grow up?" Christy asked her Mom.

As if in response, behind us Carl said: "Dude, we need way more water to make it go faster," to which Jon and Patrick said: "Definitely, Dude, definitely."

"Maybe I'll try it again later," I said. "After I get Leila's special gift."

"You got her another gift besides the plastic horse?" Christy asked.

"Yup. Something more stimulating and athletic."

Buying a birthday gift for your six-year-old granddaughter can be a challenge. It has to be thoughtful yet selfless. However, if it happens to be beneficial for you too, well that just makes it perfect. Right?

"You bought Leila golf clubs?" my wife said, as I put the huge box on the table.

"Too cool, huh? I also got her a subscription to Golf Magazine. Check out this article on power putting. Tell me she's not going to be excited about that."

Christy looked beyond the magazine to another large package standing near the door. "What's that one?" she asked.

"Oh, that. Ah, that's a Cobra 454 titanium driver with a 10.5 degree loft and a 55 gram mid-kick graphite shaft."

"Looks a little big for Leila."

"See, the thing is I knew Leila with her new clubs wouldn't want to go to the golf course with someone who has an old dinged-up driver."

"Tell me you didn't buy Leila clubs just so you could justify golf magazines and a new driver," Pat said.

"Don't be silly," I said. "But you know how kids are. It's all about image with them."

Before she could formulate any more of those thoughts, I tucked in my John Daly signature golf shirt, put on my Greg Norman anti-arthritic magnetic bracelet, slipped on my Jack Nicklaus Cabretta Leather All-Weather Golf Glove, and my Arnold Palmer long-bill, fast-dry logo cap and headed for backyard again.

Leila opened the huge package. She and her friend Darya took turns trying to lift the big box, all the time giggling like, well, little girls. Then they abandoned it and went to play with a makeup set and some new clothes some other parents had given Leila for her birthday.

"Did you keep the receipt?" my wife whispered.

"Won't need it," I whispered back. "She just needs to learn a bit more about the game that's all."

I waited until all the guests had gone. Then Leila and I went into the house and turned on the television to women's golf, which I knew she would like.

"That's Paula Creamer," I said. "And Natalie Gulbis and Lorena Ochoa and Morgan Pressel. Some of the newest stars on the LPGA."

"They're pretty," said Leila.

"Some of them are also models," I said.

"I like their little outfits."

"Me too," I said.

"Whose little outfits?" my wife asked. "What are you watching?"

"Ah, we're watching golf. Big tournament. Leila's learning a lot."

I quickly switched to men's golf. "That's Tiger," I said. "He's the best in the world."

Charlie came in to see what was going on. "Where's the tiger?"

"He's Tiger. That's his name. Look, he just got a birdie."

"The tiger ate a birdie?" Leila asked.

"No, see a birdie means one under par. An eagle is even better than a birdie."

"Do tigers eat eagles, too?" asked Charlie.

"What in the heck are you teaching these kids?" my wife asked. She grabbed the remote and turned off the television.

"This was so you could justify a new driver — and justify watching more golf on TV, too, is that it?"

I was shocked. "Of course not. This is all for Leila. Matter of

Photo By Pat Sheppard

fact, I plan on spending a lot of time with her at the golf course. We'll probably have to go two, three, maybe four times a week when she gets the hang of it."

My wife's eyes narrowed.

That's when Patrick came in. "Leila and Charlie are playing with her new golf clubs out near the pool," he said.

"See," I told my wife. We all headed out back, arriving just in time to see Charlie and Leila engaged in a very serious game of… sword fighting. Charlie was wielding a nine iron and Leila had the driver.

"What are you doing?" I asked.

"Charlie's the birdie and I'm the tiger," Leila said. "Grrrrr."

"Did you keep the receipt?" Pat asked for the second time that day.

# Chapter Eighteen
## WRITER'S EATING HABITS

Well, I survived yet another birthday, now it's time to get back to work. Of course, being a "working" writer you do have to keep your energy up. That's why I love the Trader Joe's Market on upper De La Vina Street in Santa Barbara. Trader Joe's started out as a small chain of convenience stores in 1958 called Pronto Markets. In 1967, the founder, the original Trader Joe, changed the name and the way they do business forever. In the 60s, that was referred to as getting groovy. They decked the walls with cedar planks, put the crew in Hawaiian shirts and started shopping all over the world for "interesting" products.

They also have a great philosophy: The customer should get to try stuff.

That makes it one of my favorite free breakfast hangouts. But today I was late getting to the sample booth because of an incident at their upper De La Vina parking lot, which I think was originally designed by engineering students at the Hobbit Institute to handle the occasional donkey cart delivery but which now sees a steady stream of cars, trucks, mini vans and SUVs the size of blue whales. Not to mention all the tractor-trailer rigs with their loads of flavored vitamin water and Charles Shaw dollar-ninety-nine wine referred to as "two-buck-chuck."

Among other design highlights the parking lot allows people to enter from either end, so when the lot is full, which it always is, they bunch up in the middle. Today, there was one spot open and two guys with graying beards in original VW vans both tried to enter it at the same time then they climbed out of their VWs and started to talk about it.

"Hey man, you take it."

"No brother, I insist, you go."

"That's righteous, man, but I'm working on my Karma."

"I can dig that. Peace to you, man."

That's when a tiny woman in a full-sized crew cab that was jacked up so high she must have had a view of the ocean yelled: "I'm completely out of acidophilus milk!" and tried to fit between them, closely followed by half a dozen other behemoths. They didn't quite make it. The roaring engines and squealing brake noises caused both VWs to cough, sputter and die a symbiotic death creating gridlock that spilled out onto De La Vina Street, backing traffic up to State Street and beyond. A cacophony of worrisome shouts could be heard from all directions.

"I need vegetable tapenade. Now!"

"My water crackers have no goat cheese!"

"My kingdom for some organic arrugula."

I had to park three blocks away and jog to my free breakfast with half a dozen other regulars, arriving at the rear of the store en masse.

"Thought you weren't going to make it today," the free samples server said.

"What? And miss out on… what are we having today anyway?" I asked.

The server smiled. "Today we are sampling fair trade soybean cakes topped with a lovely tofu mousse and soy milk drizzle."

I waited for her say "Just kidding. Gotcha!" But she didn't.

"We risked life and limb for soybeans? What happened to the chicken pot pie or the mini burritos or that cheesecake flambé you

had yesterday?"

She looked around then whispered. "Management says soybean cakes aren't moving."

"There's a surprise."

"You know what I think the soybean problem is?" one regular asked.

"Besides the lack of any discernible flavor, you mean?"

"Yeah, besides that. I think the soybean is wrong to try to make it on its own. It should team up with something. You know, like baked beans. They teamed up with ham."

"Or franks," I added, an auto response from a New Englander.

"Exactly."

"And kidney beans teamed up those other beans to form the three-bean salad," someone else added. "Now they're a holiday staple."

"And where was the lima bean?" I asked. "Before it joined forces with corn kernels to form succotash? Can you imagine lima bean cakes with a soy milk drizzle?"

No one could.

The doors opened at the front of the store revealing a series of beeps, shouts and an optimistic chorus of "We shall overcome."

"You know, when that mess gets sorted out all those famished people will be ready to eat anything, even soybean cakes. So maybe you can stow those underneath and break out something for us regulars."

The server looked from anxious face to anxious face, then finally nodded. "I've got some 'Beat the Winter Blues Mojito Chicken Cha Cha' that I was going to serve tomorrow. I suppose I could heat it up if you're willing to wait a few minutes."

We looked at the display of soybean cakes. They practically spelled out the word boring.

"We'll wait," we said in unison.

I checked the free beverage section. "What's the drink for today?"

"Unfiltered, antioxidant carrot and beet juice…" she said, then quickly changed her mind. "I mean, French roast coffee, as much as you want."

Like I said, I love Trader Joe's. It's a great way to start a productive day.

~

Upon arriving back at my home office, I discovered a not-so-great way to continue a productive day when I pressed the message button on my telephone. There were two messages. One from my writing group reminding me today was the first Friday of the month, time for our writers' lunch, and the second from my main client, the one who provided the majority of my freelance income.

"Never mind that brochure we talked about last month, hope you haven't started it." I had just finished it. "And don't bother stopping by the office, we are having a slight cash flow problem and probably won't need you for, oh I don't know, six months or so, if then."

Oh man, what about the money they owed me. I wondered. "Oh, and about the money we owe you, don't call us, we'll call you."

I picked up the phone and instantly called them. The line was busy. I'm guessing I wasn't the only freelancer to receive this message.

Quickly, I opened up the California Lottery website and checked my ticket against the latest winning numbers. The only thing that matched was the date.

It took a minute for my deductive skills to kick in. When they finally did, I deduced that this was not good.

That's when the phone rang. It was my wife.

"I'm tired of working," she said. "I want to retire."

"*No Habla,*" I wanted to say and then hang up, but I wasn't sure if *no habla* was the correct Spanish for I don't speak English or whether it was *no hablamos* and I also realized that even if I got the

right usage, Pat would probably recognize my voice or at least check and find out that she did indeed call the right number...

"Hello? Did you hear me?" she asked.

"Yes."

"What do you think?"

"Well I just checked and we didn't win the lottery."

"All I'm saying is that you may want to finish that humor book or that novel or that screenplay or... get that job you've been talking about."

Would now be a good time to mention that my client flaked on me I wondered briefly? Or that I had worked temporarily as a mystery shopper, though we hadn't actually discussed any payment for that either? Instead, I just said: "Okay."

"Thanks, dear," she said. "I feel better now. Oh and please run out to Costco and buy some wine." Then she hung up.

I sat there for a minute then realized it was almost noon. I needed help. I needed my support group.

~

Every month a bunch of us get together for a writers' lunch. Turns out they taste just like chicken.

Okay, okay, we don't actually eat writers — though we do relish the lifestyle — instead we get together in hopes of unleashing an avalanche of unabridged creativity, which will make us all rich and famous, which is exactly what I needed now.

Unfortunately non-writing lunch patrons don't always appreciate our unbridled enthusiasm. Matter of fact, we've been kicked out of so many restaurants over the years that we don't even use our real names anymore.

Today we were at the newest spot for our monthly gathering, a nice family type place that we hoped to call home for a long time, and I instantly started a conversation about the literary problem that I was having with the novel that I had been working on for so long

that the first draft was composed on a typewriter (you younger readers will have to look that term up on Wikipedia).

"I think I need to brutally murder someone," I said. "So that I can get an agent."

"Wow, I thought they just wanted a fifteen percent commission," Boo Boo said.

Roc laughed. Unfortunately he was mid-sip and began spraying coffee from both nostrils. We cleared a safety zone and waited politely to see if he was going to choke to death. When he didn't we signaled the waiter that Roc needed a refill.

"What's the big deal?" Doc asked. "Most of us have killed before or at least maimed a shady character or two."

There was a general nodding of agreement. The people at the next table looked up then quickly turned away.

"Oh I can kill the guy," I said. "No problem. But this time I'd like to do it with flair."

"A blowtorch would be better than a flare," Hopper said.

"Good point."

People left from the table behind us without even finishing their lunch, so MacDaddy reached over, grabbed a plateful of fries and passed them around.

"Is he a surfer?" asked Dish, "cause you could trick him into surfing near a toxic waste dump. Toxic deaths are very visual."

"That sounds a bit slow," I said. "Not that I'm personally opposed to long painful murders with graphic discoloration and oozing wounds, you understand. But that's been done to death — so to speak."

Three older women entered and exited without even sitting down.

"How about botulism?" Cricket asked. "There's a lot of that going around these days. It's practically not safe to eat anywhere."

I heard the scraping of chairs as yet another group abandoned their table.

"I'm not good with food prep," I said. "Besides, I'd like to really baffle the police."

"You could make a knife out of an icicle," said Mush Momma. "Stab him in the chest like this..." she gave a nice demonstration, including hanging her tongue out of the corner of her mouth. "The weapon melts and takes care of itself."

"I don't know. All that blood sounds a bit messy and dangerously slippery."

I noticed a large guy leave his sandwich at his girl friend's urgent request and angrily head our way. Just before he got there, Sparky yelled out: "Viagra user!"

The guy wilted and headed back to his table.

"Perfect," Ralph added. "He's already got the weapon, all you have to do is stimulate an overdose."

"I like it!" I said. "It's contemporary, and should appeal to a lot of female readers, too."

"Plus it's got great character arc," added Sky. "He's up one minute, down the next."

We high-fived with our drinks then held them up for more refills.

"But what if I need to get rid of the body?" I asked.

"Well, in the movie 'Fried Green Tomatoes' they barbecued the dead guy and served him to the investigator for lunch," said Mac-Daddy.

"Wow, what a tasteful ending," Roc said.

A guy in a chef's apron stormed out onto the patio, looked at all the uneaten food and said: "I quit." Then the manager approached our table. We all knew only too well what that meant.

"I heard about a new restaurant opening up on Coast Village Road in Montecito next month," said Doc.

"What name shall we use for the reservations this time?" Hopper asked.

"How about we tell them we're a stamp collecting group from Ventura?" Skooby suggested.

"'Until we meet again," Roc said. Then we quickly exited the now empty restaurant.

~

Though I was really anxious to get home and murder my character — maybe all my characters, I remembered about Costco and jumped onto Hollister and headed north toward the Calle Real Shopping Center. It wasn't the first time my wife had talked about retiring. But somehow this time she sounded a bit more, what's the word? — ready! Wine and lottery tickets, I thought. Lots of lottery tickets.

The thing with Costco is that no matter how fast I get there or how carefully focused I am the minute I walk in I start wandering aimlessly and grabbing stuff randomly. They count on this. That's why the shopping carts are the size of a Volkswagen.

I was shifting the load in my cart, so that the eight-pound jar of "Renewsit Face Spackle" nighttime wrinkle filler didn't put a crease into my 12-pack of "Stretch As You Go" choners, the perfect undergarment for today's active male, when I rounded a corner and saw one of the sexiest sights I'd ever seen.

"Oh, man. Oh, man. Oh man."

"She's a beauty, huh?" another guy said.

"She" was a 52-inch, high-definition, bizillion-pixel, plasma television, which was on special for a mere $2499.99 plus tax. She was showing a major NASCAR race in full Technicolor with surround sound.

"Erotica," I said.

"Tell me about it." He was up to his elbow in the extended-family-size box of Cheese Nips. He pulled out his orange forearm and offered them my way. I took a big handful, just as two cars bumped each other at two-hundred-plus miles per hour sending one of the cars right toward us. We ducked.

"Whoa, that was close," another guy behind us said.

I sniffed my shirt. "No kidding. I think I smell burning oil."

"Awesome," we all said.

We moved over so the new guy could see better. He pushed aside a box of Metamucil capsules big enough to control the regularity of Idaho, reached into his shopping cart and pulled three bottles of water out of one of the six cases he had and passed them around.

A young salesman approached to see if we needed any help.

"You sell many of these babies?" I asked.

"A few."

"Oh yeah, I could see my wife's expression if I brought one of these home," said the water guy.

The salesguy leaned in close. "You just need a plan."

We offered him Cheese Nips and water then formed a human shield so management didn't spot him.

"One guy," he whispered, "had me put in a foreign movie DVD with subtitles just as his wife came looking for him. She loved it."

He took another handful of Cheese Nips. "Another guy had me switch to PBS for a special on Amish quilts. His wife bought it on the spot."

"Brilliant," we said in unison.

"But the best so far was a guy named Bob, who supposedly threw his back out lifting one of these things off the shelf for an older gentleman who was here by himself. They took Bob out on a gurney."

"Bummer."

"Yup. Thing is, Bob was here with his wife, who was off buying a 'Whiter Wetter Water' reverse osmosis unit that he was going to have to install."

"Ouch. Plumbing."

"Yeah. Anyway, when she heard how it happened, she felt bad for good old noble Bob. So she forgot about the osmosis unit, bought him one of these plasmas, and even hired someone to deliver it and set it up."

"What about that elderly gentleman?" I asked.

He smiled. "My friend Manny. He works in accounting."

"Cool," we all said.

"Let me know if I can help you further," he said. Then he wandered over to a couple of other guys who had been playing computer games on a display laptop computer and were now about to walk away. The salesguy was pulling out a special game disc on the way.

"Bet he does okay with commissions," water guy said.

Cheese Nips nodded. "No kidding."

We were all silent for a minute. "So?" I finally said.

"I don't know, man, somehow I don't see my wife falling for that PBS thing," said the water guy.

"Yeah, and I don't wanna have to lay around smelling like Ben Gay for two weeks, though I did see that they had it on special — buy one gross, get the second gross at half price."

The other two guys wandered away. I sighed and started thinking about retirement again, which isn't hard because as babyboomers my wife and I are inundated every day with attractive offers for the perfect retirement location:

"It's Baja for Blue Hair, Bingo and Beans."

"Rise Again in Phoenix's New Viagra Timeshares."

"Retire in Witness Protection Program, Arizona. We Have Great Sicilian Food."

"Arkansas: Trailers Welcome."

I rounded a corner and a salesman grabbed me by the elbow.

"Welcome to Costco, I have an opening right here in the middle."

"Thank you," I said to the salesguy. Then I eased myself down into a Galaxy D3000 Acupuncture Point Deluxe Air Massage Chair.

"Remote?" I asked.

"You bet." The salesguy handed me the throttle to decadence. I fired it up. A groan of ecstasy instantly escaped my now vibrating torso.

"Yeah, you got that right," the guy beside me said. It was one of the guys from the plasma television section. He was fully reclined in

an Eclipse D4000 with built-in MP3 player.

"Nice slipper socks," I said. "Get them here?"

"Of course," he said. "I spotted them when I was looking for the forklift guy, see if I could get that television moved closer in time for the game."

He pointed at an even more humongous plasma TV, which now featured a commercial advertising something that required a close-up of more-than-ample cleavage.

"Ever do any rappelling?" I asked.

"No and I've always regretted it. Maybe when I retire."

"My wife wants to retire right now," I said. "Only I'm not sure we – she – can afford it."

"I know what you mean," another guy chimed in. "My wife wants to travel when we retire, which is not only expensive, but always screws up my digestive system, too."

"I can relate to that," someone said.

Two new guys moved into the chairs to my left. When they got the speed set properly, they passed around a pillow-sized bag of pretzel nuggets and a cheese block the size of a microwave oven.

I was thinking about retirement and the odds of getting a massage chair. My wife's not big on furniture that requires extension cords. I found that out early in our relationship when I tried to pass off a refrigerated wet bar as a coffee table.

"You know," the guy beside me said, "it's too bad we couldn't just retire here."

"What? You mean in Costco?"

"Sure. Think about it. This place has everything." We were interrupted by a saleslady passing out free barbecued mesquite chicken wings. "See?" the guy said.

Another guy agreed. "There's enough beer and wine here for the entire baseball season, plus they must have three-hundred pounds of tri-tip steaks. Not to mention desserts up the wazoo."

"We could take turns cooking. They got a gas grill over there could easily hold enough for a dozen of us at once."

"I do a mean charbroiled fish," one of the new guys said. "And they just brought in truckload of tiger prawns."

I reversed the kneading function on my Galaxy D3000 and turned up the back heat. "What about recreation?" I asked.

"They got a twenty-foot inflatable water slide that looks like a lot of fun, plus we could clear a few aisles and easily set up a tennis court."

"Or put down a couple hundred throw rugs and make a fairway."

"Plus, we could set up a couple of tents and sit around one of those tables with the fire pit in the middle and play poker."

"The wife says you're supposed to get cultural stimulation when you retire," one guy said.

A group of purple-haired teenagers walked by followed by an Asian couple, a family of Pakistanis and two large women speaking Russian.

"No problem."

"Maybe we could buy, like, timeshares."

"Wow!" we all said.

"We should pitch this idea right now," I said. "See if we can get a group rate."

We called the chair salesguy over and told him our plan and he immediately left to talk with management. We began planning.

"First we should set up a computer so we can download all the sports schedules, then get some beer and start in on some rotisserie chickens. Maybe drag in some patio heaters for when it cools down later."

The salesguy returned. "The manager loved the idea of you wanting to spend more time here," he said. "So he gave me these."

He handed us all job applications.

There was a huge sound of deflation, as if the air was being let out of the Goodyear blimp.

"You know," one guy said, "I've heard good things about Baja."

"And Arkansas," another guy said as he shut off his Galaxy

D4000.

I looked at the application. Was this a sign? Get a job at Costco? Watch plasma televisions all day? I shoved the application in my pocket and headed home.

Maybe I'd think about it over the weekend. It seemed like there was something else going on this weekend, but I couldn't for the life of me remember what it was.

# Chapter Nineteen
## 'TIL DEATH DO US PART

Question: Why do so many husbands follow football?
Answer: So we can learn how to scramble when life is about to tackle us.

"Ah, yeah, let me try the organic jalapeño goat cheese again. Maybe you could slather it on this all-natural cracker sample I got from the hummus booth over there."

Pat was out shopping, so I ventured down to the Santa Barbara Farmer's Market, the healthiest — and cheapest — Saturday morning breakfast spot in town. (Yes, I have different free breakfast spots for every day.) So far, along with the cheese, I'd consumed twenty-seven peach slices, half a watermelon, four cups of unfiltered cider, and a spoonful of a magic curative called royal jelly, which was collected from the pharyngeal glands of nursing bees, probably by ex-dairy farmers with extremely small hands.

Now I was about to head over to the Solvang Pie Company booth for some dessert samples, then home to a toothpick and the couch in time for the big game, proud that I helped support a great local industry.

"You gonna be here next week?" I asked the pistachio guy, grabbing a few of the hot and spicies on my way by.

"Oh yeah," he said. "We've been coming for a long time. Matter

of fact, we're about to celebrate our Farmer's Market anniversary."

I practically dropped my yogurt-covered almond balls.

I looked at the date setting on my watch. Oh man. Today was Pat's, er, our anniversary. Number eighteen... or nineteen... or something in the teens, I think. That must be why she went shopping. For a gift. For me. In return she'd no doubt be expecting a gift. For her. From me.

I checked the time. Less than thirty minutes left in what could easily be the final game of my marital career.

I did a few head rolls, a couple of squat thrusts, then tightened the laces on my running shoes and ran up one aisle and down the other looking for inspiration.

Fresh arrugula? Baby lima beans? Kumquat preserves? I'm pretty sure she likes all those things, but I'm not sure they say: "Honey, you are the love of my life." Nor was I sure they'd lead to a celebratory evening of amorous adventure.

I ran faster. Bags of Valencias turned into orange sneers. Zucchinis seemed to be pointing at me in disgust. Strawberries seemed to be giving me the raspberry.

I stopped to catch my breath, tripping over a large pot.

"Sorry," I said. "Hope I didn't hurt your flowers..."

Flowers! Oh man! Who knew they had flowers at a farmer's market? I always just came for the brunch.

"I need something special, quick." I said to the lady. "But I don't know which ones to get."

"What's the occasion?"

"Anniversary. Fifteen minutes and counting."

"Gee, too bad I don't have forget-me-nots." She looked around "How about roses? One for each year of your marriage."

"Perfect. Give me, ah, twenty. I'm sure that covers it."

I was feeling better, but still a little under prepared.

"Jojoba oil?" A voice said.

"Excuse me?" I spun around.

The guy held up a small fancy bottle of golden liquid that

looked like something the Wise Men might have carried to Bethlehem.

"I don't know, man. It's pretty and all, but the last time I gave my wife oil as a gift she threw a slice of birthday cake at me. Okay, actually, it was a coupon for an oil change, but it included a free tire rotation."

"Riiigggttt," the guy said. "But women love jojoba oil. It's probably in your wife's favorite shampoo."

Shampoo? Is that a good gift? I wondered.

"Most woman, however, love the feel of jojoba on their skin." He leaned forward and whispered: "As in a slow, sensual massage."

I knew how to do that now, thanks to Sycamore Mineral Springs Resort. Score! I high-fived the guy, bought a small bottle (turns out it sells for like $600 a gallon, more than high octane gas in Santa Barbara), then I raced home and waited for my wife.

"Happy Anniversary!" I yelled, handing her the roses, jojoba oil, and a package of coconut-covered date bars I purchased as the *pièce de résistance.*

"Wow," she said. "This is even better than the golf hat and divot tool from last year. Maybe next year you'll actually be at a jewelry store when you remember."

I smiled. Marriage is always a close game.

~

Occasionally, the muse takes a nap and the left or reality side of my brain kicks in and I make a decision based on what might be best for someone other than me and my readers. So, even though I thought the jojoba oil was pretty damn special anniversary gift, after careful consideration I thought maybe I should do something more special this year, So, I charged a couple plane tickets to Santa Fe, New Mexico, charged a room, and charged two dozen lottery tickets to hopefully pay for it all. My wife was really grateful.

"Come on. Once more. You can do it. It's our anniversary."

I looked into Pat's pleading eyes, took a deep breath, wiped the sweat from my brow, and then slugged back the last four ounces of my Golden Gecko margarita.

"Okay," I said. "Once more. I'm ready."

She smiled, grabbed my hand, and led me out of the cantina, across the plaza, toward our fourth museum of the day.

Yes. Fourth.

"Gee, I sure hope this museum has pottery," I said.

I was perfectly happy to historically research the vast array of Mexican tequilas and specialty chile dishes at pueblo-styled restaurants throughout the downtown area, but my wife wanted to bring home more than heartburn from our trip so I was soaking up more Southwestern culture and history than seems humanly possible. But, after all, it was her anniversary, too.

"Isn't it amazing," Pat said as we walked up Palace Avenue toward the Institute of American Indian Arts Museum where, according to someone we'd met in the rooftop hot tub of the Eldorado Hotel, they had an "arresting display of stacked-up blankets that conceptualized a contemporary interpretation of the use and importance that they serve in Native American culture and history." I'm not kidding. Stacked blankets. Which proves that I've always been ahead of my time, because as a bachelor, I had huge stacks of really old bedding. Goodwill's gain, the art community's loss, I guess.

"I said: 'Isn't it amazing?'" she repeated.

"What?" I asked.

"That we've made it all these years and are still happily married."

"Ah, yeah," I said. "Yeah, it sure is. Amazing. All these years. Wow. Who would have guessed it?"

My wife stopped and looked at me.

Dang. I knew what was coming next. A quiz. I tried to think, but my brief foray into that left side of my brain where I store valuable information like the names of the kids, their approximate ages and birthdays, and the number of actual anniversaries we have cel-

ebrated was over. I was now comfortably back on the right side of my brain, where I live in my own little creative fog. I strained and a number did start to form. I had no idea if it was a number related to marital bliss or my checking account pin number, but I was about to go with it anyway, when she said:

"Oh look! A walking tour. Let's see if we can join up."

I'd never been so glad to see knobby-kneed tourists in cargo shorts and floppy safari hats in my life.

I settled in beside a young woman wearing a shirt that said: "Never underestimate the power of stupid people in large groups."

"Does this tour visit any restaurants?" I whispered to her.

"I wish," she whispered back. "So far, the highlight has been a place called Donkey Alley that used to be lined with saloons and gambling parlors."

Shoot. I felt like an ass missing that one.

"This is Saint Francis Cathedral," our tour guide said, as we stopped in front of a large church. "It houses La Conquistadora, Our Lady of Peace, a 380-year-old virgin..."

"Wow. I guess she didn't get out much."

"Shhh," my wife said.

"...The country's oldest Madonna was carried here all the way from Spain on a large pole," the guide continued.

I wondered briefly about the person who originally made this statue that lasted 400 years. Still in business? Not with that kind of turnover. Things weren't made to last more than...

"Eighteen!" I blurted out.

Several safari hats turned my way.

"Ah, sorry. It's just that we're celebrating our anniversary. Eighteen wonderful years."

I looked at Pat. Held my breath. Waited. Finally... she smiled, then slipped her arm through mine and kissed me on the cheek.

Whew. For just a second I thought I'd told everyone my pin number.

"Next, we are going to visit Loretto Chapel," the guide said.

"Home of the Miraculous Staircase. It makes two complete turns of 360 degrees and has no center support. No one can explain how the thing stands up and bears weight. Some people think it was built by Saint Joseph the carpenter himself..."

"Isn't history fun?" Pat asked.

It may have been the spirituality and romance of the place. It may have been pure luck. But I said: "Yes, especially our history."

Then we quickly left the tour and headed back to the hotel.

# Chapter Twenty
## FROM THE MOB TO A... JOB?

As you have just witnessed, somewhere deep in the recesses of my vastly unorganized writer mind, a constant struggle takes place between two opposing forces: The protagonist — or thinking part of my brain — versus the antagonist — the part that does most of the talking. That trend continued upon our return to Santa Barbara, when I decided to make an important phone call.

"FBI. San Diego Bureau," the friendly voice on the other end of the phone said.

"Yes. Hi. I was just wondering, if a person was trying to smuggle five million dollars in cash over the border into Tijuana, Mexico, would the FBI follow them or would they have to let them go because of jurisdiction problems?"

I heard a series of clicks on the line, followed by an eerie silence.

Then I heard the thinking part of my brain say, "Uh-oh."

A new "deep voice" came on the line. "Mr. Witham?"

Funny? I didn't remember giving them my name.

"Still at the current address in Santa Barbara?"

"Ah..."

"Ford Escape, silver, two-thousand-seven. Mercury Mystique, champagne, ninety-nine?"

"Ah..."

"Wife, two kids, three stepkids, three grandkids and a cat named Sam?"

I glanced at Sam, who was sleeping in the corner. He opened one eye as if to say keep me out of this you big jerk or I'll pee on your leg until you rust.

"Listen," I said quickly. "I don't actually have five million dollars in cash. Ha ha. That's silly. It's really mob money."

"Excuse me, Mr. Witham?"

"Oh... my... god!" the thinking part of my brain screamed.

At this point, two words came to mind: Shelly Lowenkopf.

See, Shelly's a professional editor, teacher and fellow workshop leader at the Santa Barbara Writers Conference. After I murdered off several of my characters, he read the latest version of my decade-old novel and suggested I get clarification on a few points.

"But I can't just call the FBI, can I?" I asked him.

"Sure, why not?" Shelly said.

Did I mention that Shelly also has a great — albeit somewhat sinister — sense of humor?

"Mr. Witham?"

"I, er, that is... Shelly. Shelly told me to call."

"Shelly? Shelly Eyebrows?"

"No. Well, yeah, he does have some wompin' eyebrows now that you mention it."

"And you are connected to him how?"

"Eyebrows, I mean Shelly, is helping me get ready for the next big West Coast meeting."

"Big meeting huh? This meeting got a name?"

"It's called the Santa Barbara Writers Conference."

"Writers? With five million dollars? Clever. No one would ever expect that. Who's in charge of this big meeting?"

"My friend Marcia."

A second of silence, then Deep Voice returned.

"One husband, one daughter. Just off the 101 in Santa Barbara?

Easy access day or night?"

"That's it. I'm outa here," said what was left of the thinking part of my brain.

I wasn't quite sure what to do next. I mean, as you've witnessed, I've worked without the thinking part of my brain before, plenty of times, but this didn't seem to be going all that well.

I glanced down and saw an offer from a travel company for last-minute discount trips to the Caribbean sitting in my trash basket. I pulled it out and laid it on my desk right near the door.

"Perhaps I should start over," I said. "Then maybe you can help me."

"Sounds like you might be beyond help," Deep Voice said.

Weird, that's the same thing Pat's always saying.

"I'm working on a novel. It's about money laundering. With mob people. They're the ones with the five million dollars. And they're going to kill people if they can't get over the border. It's a comedy."

Silence.

Was that a knock on my front door? Nah. Couldn't be.

Sam the Cat slipped out of my office and headed for parts unknown.

"I'm just a humor writer. Honest. Check out my website. I haven't even stolen anything since I was a kid..."

This was usually the point where the thinking part of the brain — or the thinking part of my relationship, Pat — told me to just shut up, but neither one was here right now.

"Mr. Witham."

I heard the theme song from "Dead Man Walking." "Yes?"

"I just pulled up your website. I see that you are indeed a writer."

"Humor writer."

"Let's not push it."

"Okay. So... what about my question?"

"I'm afraid I'm not the right person. You need to call back to-

morrow and explain what you need to a different agent in our media department."

"Right."

I hung up, unplugged my phone, and locked the front door. It was times like this that I thought maybe I should have given that photography thing more time. Or maybe I should have tried harder in those company meetings.

My cellphone rang. Oh man, I forgot about that one.

"I'm giving up a life of crime writing," I blurted out. "I'm going straight I tell you. I'll write meaningful essays. Poetic verse. Greeting cards with bunny themes. I'm gonna get a job, too, with paychecks and stuff."

"Really? That's incredible," the voice on the other end of the line said.

"This isn't the FBI?"

"Nope, this is Grace."

Grace is one of my longtime writing friends, fellow humor columnist at the *Montecito Journal* and an editor. I was suddenly weary of editors. Also, I realized I'd just told her I was going to write bunny themes. If that got out it could do damage to what was left of my dwindling career.

"I just thought you'd like to know that there is an opening coming up at the company where Ron works."

"You mean like a job?

"Yes."

"Part-time?" I asked hopefully.

"Nope full time. You should call if you really do want a job."

"What if I don't want a job, but need a job?"

"You should call. See ya."

This was an interesting turn of events. I'll bet the FBI goes easier on guys that are employed — or at least guys that are seeking employment. I mean there was a real good chance I wouldn't get the job, right? Somehow the thought that I might not even get the job made me feel better. I wrote myself a note. "Call about job. Some-

time. Soon." Whew. Accomplishment is a tiring thing but it's also addictive.

Maybe I should do some more writing stuff. Then I wouldn't need this job that I wasn't going to get anyhow. I could send out some query letters to magazine editors, and probably get some great paying assignments. Then, I could finish my screenplay and send it to some eager Hollywood producers.

Yup. Now that I think about it, it's a perfect day for getting stuff done. So, nose to the grindstone, ear to the wheel, butt in the chair, stomach how do you feel?..

Hmmm. The thought of all that upcoming work has made me a little hungry.

I'm not about to lose momentum, though, so in the spirit of the moment, I'm going to multi-task by not only having an energy-inducing snack, but also by eating all the formerly-healthy low-fat food products in my pantry so that I can replace them with the new live-longer-look-better-and-take-up-less-room-on-the-couch low-carb products.

After all, a healthy writer is a happy writer and a happy writer is a successful writer who doesn't need a job.

Whoa. Another idea coming in — always happens when my muse is over activated like this. What if I leap-frogged ahead of the current trend and started personally advocating low-protein products right now? That's got to be coming back around, right? We've had low-fat, now low-carb... low-protein is definitely due.

Wait! I could write a self-help pamphlet. "The Anti-Protein Diet" by Dr. Ernie.

Ou-weee. Anti and pro right there in the title. Great conflict. A metaphor of life itself. I'll subtitle it: "One man's struggle to free himself from the bonds of the food chain."

Can you say instant bestseller?

They'll probably want me to go on an international speaking tour, too.

"Ladies and gentlemen, introducing, Ernie — the lean, mean,

(and extremely wealthy) low-protein machine." (Insert cheers here.)

I'd better start preparing a thirty-minute after-dinner speech so I'll be ready. Wonder if it will be a formal dinner with all those forks? I can never keep those straight. I'll buy a copy of a dining magazine to brush up on etiquette. Huh. Maybe I could write for a dining magazine: "Preparing for the after-dinner speech" by Ernie Suave-a. Wonder how much food magazines pay?

I quickly dry swallowed half the dozen salt-free saltines and four ounces of low-fat peanut butter I'd been working on. Then I grabbed the one-percent-fat milk carton out of the fridge and took a big hit. Huh. Not even organic. I'd better finish it off and get some organic stuff. That's what everyone's drinking now.

Maybe I could work organic into the low-protein thing. Was there any such thing as high-organic low-protein? Seems I heard about a television show on organic foods. Maybe I should call them and set up an interview: "Ernie Goes Organic." Nice. 'Course, I'll need some new clothes. I wonder if Macy's is having a sale. I could check that in the paper.

Wait. What's this note on the refrigerator: "Don't forget to call the heating repairman."

Oh yeah. The furnace stopped working just before spring. Now we were heading into fall and needed to get it fixed. I was going to write my column about the broken furnace: "Cold-Calling Editors." Wow. I'd forgotten what a great idea that was. I'm going to make a note of that right now.

Oh look. Here's that magazine that lists all those websites. Here's a cool site: doityourself.com. Heck, I'll fix my own furnace. Save all that money. Then I can buy those new clothes. Wait. What did I need the new clothes for anyway? Television. Something about television.

I'd better make some coffee. Need some caffeine. Hm. Caffeine... protein... magazine. Maybe I can do an entire bit on eins. "Making it During the 'Ein' Years." Wow. I am on a roll...

The front door opened.

"What're doing home so early?" I asked Pat.

"Early? It's five o'clock."

I looked at the clock. Impossible!

"Did you get the furnace fixed?" she asked.

I hesitated. "No. I was way too busy writing."

"Did you find a new client?"

"Ah, no."

"Get some work from your old client?"

"Ah, no."

"Work on the humor book?"

"Ah, no."

My wife's face began to cloud over, kind of like one of those thunderheads that I used to watch as a kid in New Hampshire building over Lake Winnepesaukee just before an earth-shaking deluge of a summer storm. I didn't want to get all wet, so I blurted out: "I... I may have a lead on a job."

The storm dissipated. "Really? How, what, when, where who?"

I felt like I was married to a journalist. "The details are still sketchy," I said. "And I'd rather not discuss it and jinx it, you know?"

She hugged me and I felt a tad guilty. Now I was probably going to have to make the call — well not right now, of course, but... eventually.

# Chapter Twenty-One
## HUMOR SOMETIMES COMES CRASHING DOWN

"Shouldn't I be leading?" I asked my wife, as the band belted out an ambitious rendition of the Fats Domino classic: "I Found My Thrill on Blueberry Hill."

"Fuhgeddaboutit," she said, spinning me around several times, and then dancing us through a gap to the far side of the temporary parquet floor.

We were in front of the Guac 'n' Roll stage at the Annual Avocado Festival in Carpinteria, California, a beach town fifteen miles south of Santa Barbara. My wife had decided maybe a little exercise was called for after I consumed six helpings from the world's largest vat of guacamole. Each year the Carpinteria High School cheerleaders try to see how many avocados they can mash into a huge dip that they sell to raise money for cheerleading events. This year they mashed something like five thousand of the things.

Five thousand! That's a lot of mashing!

I figure they probably use the same technique that early Napa Valley grape squashers used, but I couldn't prove it because they were inside a giant tent and I couldn't see if they all had green feet or not.

"They don't use their feet," Pat said, as she spun me around several times and danced us to the left.

"How do you know?" I asked. "And, how come I can't lead, anyway?"

"Because you don't understand leading," she said, as she skillfully dipped me and brought me back up, this time moving us to the right through another gap in the crowd. "It's not supposed to be a contest to see if you can constantly fool everyone, including me, into guessing which way you are going to go next."

"It's more fun that way. Besides, that other couple wasn't really hurt. I'll bet anything they were both limping before they even got here."

"Right."

The song ended. Pat dipped me one last time and the crowd applauded our performance, so I took a bow, then we sat down in a couple of floor side chairs.

"Well, that sure made me hungry," I said. "How about you?"

"You've had three tacos, two ears of corn, half a dozen churros and a Greek gyro. What's left?"

"Good question." I took out my official welcome guide and turned to the "It's All About the Food" page.

"Aha!" I jumped up. "Guacamole ice cream and fried Twinkies. Coming?"

"No. I think I'll just wait here."

To say it was crowded on Linden Avenue would be an understatement. The Avocado Festival gets bigger each year and this year the attendance was supposed to top one hundred thousand. The Festival offers three different entertainment stages, an everything-you-could-possibly-want-to-know-about-avocados-and-then-some tent, plus dozens of food and activity booths. They even had avocado miniature golfing, but I always look foolish enough trying to get something round to roll straight so I didn't try it.

Add to that the fact that many avid guacamole lovers — like me — tend to be somewhat overweight to the point of actually looking like an avocado in some cases. Plus, most people are busy reading all the food signs instead of watching where they are going, which

creates a potentially dangerous situation.

"Ahhh, Umphf."

I righted myself, then grabbed the white-gloved hand and pulled.

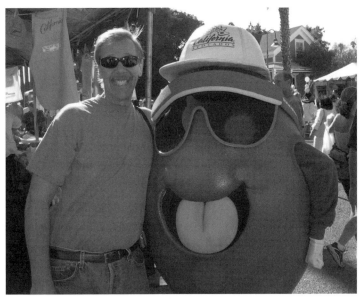

Photo By Pat Sheppard

"Sorry," I said.

Mr. Avocado rolled to a standing position, straightened his huge sunglasses and yellow cap, brushed off his dimpled green skin, and held up three fingers.

"Third time someone's knocked you down today?" I asked.

He nodded.

Then he pinched me and held up eight fingers, slapped me in the butt and held up ten fingers.

He looked around, then he whispered: "You don't even want to know how many times some kid has pulled on my tongue and tried to shove their hand down my throat."

I peered into the giant smiling mouth. I was a bit tempted to see who was really in there myself. "Wow. Do you even get to eat?" I asked.

He shook his head sadly.

I wanted to run right over and buy him an avocado shrimp cocktail or a sticky funnel cake or something, but before I could offer, several kids came up to him and started poking and prodding my round, green friend, so I headed back to Guac 'n' Roll stage.

"What's up next?" I asked Pat.

"A blues band," she said.

"Blues! Cool, I love the blues." I started dancing a bit to show her my moves.

She took out her wallet and gave me ten bucks. "Try the taquitos," she said. "You're going to need your strength if you plan on riding on Patrick's motorcycle."

Wow. I'd totally forgotten about that. Patrick had just inherited a Harley and he had left me the key. I hadn't been on a motorcycle in quite some time. Should be a lot of fun.

~

Please don't panic, but I thought you should know... I've had a motorcycle accident. I'm not seriously injured — pulled hamstring, some bruises, a few scrapes. I guess Lady Luck was looking out for me...

"Do you need any more ibuprofen, dear?"

"No, thank you. I'm too busy to worry about the pain right now."

"Are you sure? I'll crush them up for you again so they'll be easier to swallow."

"I'm fine."

"Okay, just holler if you need me."

Yup, it was quite an accident. See I was doing about 95 miles-per-hour on a rain-slicked highway in the fading light of day trying to catch this outlaw biker gang for a case I was working on for the FBI...

"Here, dear, I brought you a frozen juice bar. It's kiwi-straw-

berry. What are you writing anyway?"

"Just telling my readers about the motorcycle accident."

"You mean the one that happened in the driveway?"

"Shhhh. Jeez!"

As you might imagine my wife is not privy to my clandestine operations. She doesn't even know about the cold, calculating assignments that I'm often asked to perform for the secret service. In the business we refer to it as wet work...

"You're getting your desk chair soaked you know. If you are going to sit on an icepack you should at least put a towel down first."

"Excuse me. I'm talking to my readers here, huh? They're probably concerned about me not making any public appearances in the last few days and I want them to know that I'm all right considering everything that's happened."

I'm not sure how long I was actually working this case. A man can lose track of time when he's deep undercover, but one thing's for sure, I'd been outed now...

"Well can I at least get you a pair of sweat pants or something? The grandkids are coming over and if they see you sitting there in your Captain America underwear, they may get embarrassed."

"If it will make *you* feel better then yes, please bring me some sweat pants."

"Some more cookies, too?"

Cookies? Can you believe that? One minute I was a step from death's door and the next I'm being offered treats. Life in the fast lane is an e-ticket roller coaster ride, my friends. Up then down, then up then down...

"Oh yeah, Patrick called. He said thank you for not scratching his bike when you fell over. He said not to worry he'll put it back in the garage when he gets home."

"Is there anything... anything at all that you have to do in a room other than my office?"

"Okay, okay, Mr. Grouchy Pants... I mean Mr. Grouchy No Pants. Next time maybe I won't help you pick up the motorcycle.

Maybe next time I'll leave you lying there in the driveway for all the neighbors to gawk at. Maybe…"

"You know, on second thought, dear, some cookies would be great."

"Really?"

"Yes, only not those store bought ones. Remember when you used to make cookies. Wow. We were so young then and crazy in love…"

"I think I have all the ingredients, I'll make some cookies for you."

"Thanks so much…"

Now, what was I saying? Oh yeah, I was traveling about 115 miles-per-hour in a pounding hailstorm chasing heavily-armed fugitives wanted in half-a-dozen states…

"What cha doing?"

"Oh hi Leila. I'm writing to my loyal readership about my motorcycle accident."

"Oh."

I was supposed to wait for the SWAT team of course, but I couldn't risk letting these ruthless killers get away, so…"

"Know what?"

"What?"

"Charlie has underwear just like that."

Dang. "You know, I'll bet Mo-ma needs some help with those cookies…"

"She told me to come out here."

"I'll bet. But I'm really busy…"

"Oh look! Here's the key."

"What?"

"The key to the motorcycle. Mo-ma said you were all dressed up in your helmet and leather jacket, but you forgot the key and when you got off the bike the kickstand wasn't down anymore and it fell over and you hurt your leg. Is that what you are writing?"

"If I say yes, will you go help Mo-ma?"

"Okay."

"Yes."

Kids. So, I was doing about 125 miles-per-hour when the earthquake hit and opened up a three-foot wide gap in the road in front of me and…

Leila shut the door to my office and the wind caused a piece of paper to fall in my lap. "Call about job. Sometime. Soon," it said.

Man. I'd forgotten all about that. I finished off my undercover agent Harley story and emailed it to the *Montecito Journal.* Then I steeled myself, picked up the phone and called someone named Joan.

"Hi, my name is Ernie and I'm calling about the Production Technician job you have open in the Design Department that Ron's wife Grace who is a writer friend of mine told me about and I fully understand if you have already filled the position or if you think I might be too old or not right for the job and I'm sorry to have bothered you goodbye."

"Oh hi. Ron said you might call. When can you come in for an interview?"

An interview! Oh man! Never, I thought. "How's next month?" I said.

"How about next Monday," she said.

She seemed a bit pushy, but I said okay. Then I hung up, limped out of my office and into the bedroom to put on pants. Suddenly I was cold all over.

# Chapter Twenty-Two
## FROM FALLING TO FALL

Speaking of cold, as you know, I'm originally from New Hampshire. This comes up occasionally when I cut someone off in traffic and they ask: "Where ja learn ta drive, you jerk?" And I say, "New Hampshire." And they say, "Ah," as if that somehow explains it.

That may be because one of the few times New Hampshire is ever in the spotlight is during the Presidential Primary. So California drivers probably figure that I grew up constantly darting in and out of an unending procession of television trucks, political limousines, and disoriented cows wearing 'Vote Early, Vote Often' signs.

But there's much more to New Hampshire than cow pies and politicians. So I thought I'd take a few minutes today to tell you about New Hampshire in autumn or, as the locals like to call it, Fall.

"Careful patchin' that roof, Tom."

"Ahhhhhhh." Thud.

"Ayup. Fall's here."

Yes, Fall is here. And in New Hampshire that means the Fall foliage spectacular when 'leaf peepers' (I didn't make that up, that's what they really call them) travel from all over the world to ask that age-old question:

"Excuse me, where are the rest rooms?"

Leaf peeping in New Hampshire is a major tourist attraction.

You've probably seen travel brochures depicting happy tourists bundled up in brand new L.L. Bean flannel shirts and Redwing mountain boots — a necessity to make sure they don't slip walking up the stairs to the souvenir shop — standing on the Kancamagus Highway staring in awe at 50,000 trees, waiting for the leaves to die.

"Could we move to another spot, honey? My cappuccino's gone cold."

"Not yet, dear. I still have two hours of video left to shoot and I think that leaf over there is about to go."

Of course, one thing tourists may not realize is that when a zillion trees all over the state drop their leaves, it makes for one big mess. Which leads to one of the great oddities in New Hampshire, local folks — get this — rake up the fallen leaves. By hand. Can you imagine?

I think there should be a pilgrimage of professional California leaf blowers that travel to New Hampshire in October. They could start at the coast, and with giant tanker trucks following them for refueling purposes they could blow their way slowly westward in a cloud of blue smoke, until New Hampshire is as clean as a mall parking lot. Unfortunately, that might drive some of the tourists elsewhere.

"Grab the mini cam, Stella. We're goin' to Vermont to get some footage of that giant leaf pile."

Hopefully, though, people would still travel to New Hampshire, even if it was clean, because Fall isn't just popular with leaf-peepers. For the locals, Fall is prime "tourist-peeping" season.

"Here comes some now, Jeb, wow, they sure are colorful."

"Ayup. Really big this year, too."

Dead trees and large tourists aside, Fall in New Hampshire is important for other reasons. For instance, the falling leaves and cooling temperatures indicate that it's the season to gather food for winter through the centuries-old traditional hunt.

"Dangit, Wilber! You nearly shot Earl again this year."

"'Taint my fault. The man needs ta wear a shirt or shave his

back durin' bear huntin' season."

Speaking of hibernation, Fall denotes the beginning of coupling season as well, which has become more complicated since the price of fuel oil began rising almost as fast as the number of wealthy oil company executives needed to count all that money. On a recent October trip to my hometown I saw a guy on the corner of Main Street with a sign that said: Woman wanted, must have warm heart, warm feet, and access to five cords of hardwood.

Finally, Fall in New Hampshire signifies a change is in the air — a change of about 50-60 degrees by January. So once the trees are bare and the tourists have gone, New Hampshireites head inside to stoke the fires and turn their satellite dishes toward the West.

"Look at that freeway Edna, wonder where tha heck those fools learned ta drive."

~

Fall in Santa Barbara's Wine Country means harvest parties and tons of samplings. Sometimes it's so cold, though, that you have to wear socks with your shorts and sandals.

I was perusing the menu at the Hitching Post, a popular Buellton restaurant, featured prominently in the movie "Sideways." My wife decided to treat me to a special dinner after I mumbled out the big news:

"I ah, I got a job interview on Monday."

It was the first time since I'd know her that I ever saw her do a complete back flip. I didn't even know she was a gymnast.

"I still might not get the job," I said. "There are probably dozens of recent UCSB grads that want to be production technicians at a trade magazine publishing company. Maybe hundreds."

"I'll keep my fingers crossed for you."

"Thanks, but don't go out of your way or anything."

Anyway, she was so happy she got tickets to a special wine tasting and made reservations at the restaurant.

I looked at the menu again and I was trying to decide between the roasted duck breast, the grilled quail or the ostrich steak, when a colorful bird flew by the window and landed in the parking lot. I thought I heard a screen door in the back of the restaurant quickly open and close. Then the waitress asked someone at the next table:

"Would you like to hear about tonight's special?"

"Wow. That's what I call fresh," I said.

My wife kicked me under the table. Though she was thrilled about the interview, she was still a little upset about the incident at Sanford Winery.

Turns out it was an exclusive release party for wine club members only. Free tasting. Free music. Free cheese.

"I don't think you are supposed to take an entire wedge," the guy behind me said. "That's why they have those little slicers."

"Oh. I thought they were souvenirs." I took the slicer out of my pocket and put it on back on the table. Then I broke the wedge in half and wandered back to the tasting table for a refill.

"I think I know you," said one of the pourers.

Quickly I tried to calculate how many "tastes" I'd had. We'd only been there ten minutes, so it couldn't have been more than fifteen or twenty. I can usually get away with twice that many at a large tasting before they ask me to leave.

"There's a guy here who looks a lot like me..." I looked at her name badge. "...Rhonda. Big drinker. Look, there he goes now."

I pointed to the left then made a dash to the right, where I bumped into the winemaker, who was answering questions about the unique facility.

"The walls of the winery, which are some thirty inches thick and keep the cellar at 55-65 degrees without any heating or air conditioning, are constructed of more than 180,000 adobe blocks, which were handmade on site by Sanford employees."

"I bet I know how they phrased that in the job description," I whispered to the group. "Learn about wineries from the ground up in this unique hands-on position. People with strong backs and their

own steel-toed boots preferred."

"What's that?" the winemaker who was not all that small a guy, asked.

"Er, nothing, I was just saying what a boot, er, beaut-iful job you guys did."

He stared for a minute then pointed up at the rafters and continued his spiel. "All the lumber, including those huge beams, were recycled from a turn-of-the-century building originally located in Washington State," he said. "We reused more than 500,000 board feet of first growth Douglas fir."

Fortunately, he was also pouring while he talked, so I held out two glasses — both mine — and he said: "La Rinconada Pinot Noir. From estate grapes grown right here."

As interesting as all that was, something else caught my eye.

"Is that some kind of winery thrill ride?"

"No," the winemaker said. "That's a gravity racking system. Those four 3600 gallon wine tanks are positioned on hydraulic lifts, so the winery crew can move the wine below ground for storage or..." He put a key into the control box and raised one of the huge tanks to eye-level. "...they can gently move the wine to other tanks or barrels by gravity without agitating the wine by pumping."

Some large woman asked a question about bruising grapes and the winemaker turned his attention away. I was intrigued by the tank. It was so big and cool to the touch. And with that great big valve, why I could refill my own wine glasses in no time.

"Don't touch that," someone yelled. "Or we'll all drown."

I stood with my hand on the valve of the 3600 gallon tank and smiled sheepishly.

"Now, I remember," said Rhonda, the pourer. "You used to live in the same apartment complex as me in Santa Barbara. You turned your bathroom into a darkroom. I'll never forget that smell."

That's when the winemaker took my wine glasses away and my wife took me away to the restaurant we were now seated at.

"Can I help you," the Hitching Post waitress asked me.

"Probably not," Pat said. "But you wouldn't be the first to try."

~

The next day, we were back in Santa Barbara for that other October tradition...

"Please tell me that was your elbow!" Pat said.

"Actually, it was my trusty lance."

She looked at me as best she could from her current position and arched an eyebrow.

"See?" I held up the medieval weapon, which had been skillfully reproduced in cheap silver plastic. "They probably don't have these in Kansas. By the way, you look great as Dorothy."

"Yeah, right. If I weighed ninety-five pounds maybe. Look at this." She raised her hands over her head and the puffy blue-striped dress rose higher than would probably be socially acceptable in any country except France.

"I'll give you five bucks to advertise my website on your underwear," I said.

She kicked me in the shin and I felt it right through my double-thick nylon armor.

We were sharing a dressing room the size of a phone booth at a crowded costume shop on State Street on Sunday afternoon. Our friends, David and Claudia, had sent us a thoughtful invitation to a Halloween party, which we carefully posted on the refrigerator, right behind the phone number for Rusty's Pizza. We were ordering an extra large with everything on it on Saturday evening when we found it and realized it was the very next night.

We were relieved that we hadn't missed the party — to be honest, we don't get out all that much. Plus, the invitation indicated there would be free food and wine and prizes for the best costume. But time was not on our side in the monumental search for a pair of winning outfits.

Also, we were not alone in the search.

"Excuse me," said a voice just outside the thin curtain. "Is Fred Flintstone in there?"

"Nope. Just Dorothy and Sir Lancelot," I said

The woman sighed and started to amble off in search of her husband, then stopped and leaned back toward the curtain. "What size is the Dorothy?"

"You in fifth grade?" Pat asked.

The woman sighed again and headed off.

"I thought we looked good as the sheik and the harem girl," I said.

"I'm not going to a party with you wearing a harem girl outfit," she said. "Now help me out of this thing before I lose the blood flow to my arms."

We performed a series of intricate ballet moves — "Your arm left, my arm right, head back, now turn and dip, turn and dip..." In just moments we were back into our street clothes. The instant we left the dressing room, three harried women holding nun outfits squeezed in.

"Hope you don't make a habit of this," I offered good-naturedly.

One of the nuns cursed at me.

Actually, I love the idea of Halloween. It presents an intriguing opportunity to be someone I've always wanted to be for one night. The problem is most of the people I would have liked to switch places with were nowhere to be found.

"Brad Pitt?" I asked the sales clerk.

"Gone," she said.

"George Clooney?"

"Gone," she said.

I flexed. "How about Ahhhnold?"

"They don't make it in your size — or shape."

She turned to help some bald guy wiggle into a Dolly Parton bustier and wig, so I returned to the racks to find my wife.

"How about Mickey and Minnie Mouse?" I suggested. I hefted the huge Mickey head off the shelf and slipped into it. "Whoa," I

echoed. "The last guy to try this one on had Italian food for lunch."

"I'm not wearing any giant heads," Pat said. "Last time I did that I ended up drinking wine through a straw all night."

"Oh boo-hoo," I said. "If you remember, I was the rear end of that moose. You know where I had to stick my straw?"

We poked around for another half hour or so, trying every combo from Sleeping Beauty and Buzz Lightyear to Tinkerbell and Jabba the Hut until we finally came to the conclusion that "one size fits all" really means "one size fits someone else but not us."

"I'm going to find something in my closet," my wife said, "and call it good enough."

"But what about first prize?"

"Who cares?" she said, then hesitated. "Unless some skinny woman in a Dorothy costume wins it. Then, we got a problem."

~

Well, we didn't win the contest. My wife ended up renting a crown from the costume shop and wore a formal dress and went as Queen Anne. I bought an earring, a patch and scarf and went as a pirate. I thought I looked pretty dang good, but I did keep bumping into everything on my right side because of the patch. The winner was a woman who went to the party dressed as a bag of groceries. I'm not kidding. It was pretty amazing. And it got me thinking about a new costume for Monday, which was Halloween. But first… I had to go to a job interview. The first one in almost a dozen years. No way was I going to be able to pull it off. Whew.

~

"I suppose you have a ton of applicants, huh?"

"No, not a ton," Joan said.

"Probably they have a lot more experience than me, huh?"

"No, you seem to have plenty of experience," Joan said.

"You're probably looking for someone much younger, though, right?"

"Age really isn't a factor," said Joan.

I left the interview with a sinking feeling: I might just be in the running. How in the world had that happened? Joan was really nice. Turns out she was a screenwriter at one time, so we had a bunch of stuff in common. The company seemed like a great place to work. I already knew three people that worked there and they all put in a good word for me. In short, I was probably doomed.

To take my mind off my worries, I threw myself into a Halloween idea that had come to me on the way home. It just happens that way sometime. I come up with an idea so brilliant that I just can't help wrapping my arms around myself and rocking back and forth in my office chair. Oftentimes, I even break out into song with something like: "For Once in My Life I Have Someone Who Loves Me..."

This was the position I was in when my wife came home from work.

"Either you got the job," she said with a hopeful grin on her face. "Or you've been watching the Self-Help Network again."

"No decision on the job yet."

"They didn't escort you off the premises?"

"Nope."

"Good, then there's still hope. What's that?"

I handed her a large plastic bag, then I went back to rocking and singing: "I Did it My Way..."

She reached into the bag and pulled out eleven bags of Halloween candy.

"Eleven bags?" she questioned. "Last year we only had five kids show up and, if I remember right, you gave them each two pieces of candy and ate the rest yourself. What the heck are you going to do with all this?"

"Gabaplamm," I said, trying out one of the pumpkin-shaped Snickers Bars.

"Say what?"

I swallowed. "I've got a plan," I repeated.

"Does this plan involve you consuming three bags of..." She held up a package. "...Ghoulishly Good Gummee Worms?"

"Nobe," I said, sucking a Gummee Worm out of my molar. "I'm just testing the products to ensure that the customers will be happy."

"Did you say customers? Because if you think kids are going to pay for this candy, you'd better go back and read the part about tricks in the Trick or Treat manual."

"Of course I don't think kids will pay. I dismissed that idea hours ago — before I got my brainstorm." I reached into another bag and pulled out a tiny business suit, a briefcase with an "I Love New York" sticker on it, and a pair of black-rimmed glasses, all of which I had purchased at the thrift store.

"See?" I said proudly.

"Ahh, no."

I sighed. Wonder if Albert Einstein had to tediously explain his ideas to laypersons, too?

I grabbed another Snickers. "You know how I've been trying to find new ways to promote *Ernie's World the Book?*"

"Oh-oh." Pat said.

"Well, I've come up with a marketing plan that even Jack Canfield would be jealous of. Matter of fact, I'll bet when he hears about it, he'll want to use it to sell more Chicken Soup books. See, instead of waiting here for a bunch of kids, who might not be interested in buying my book anyway, we're gonna go to other people's houses, give them free candy and the opportunity to purchase an autographed copy right there on the spot!"

"We?"

"Me and Leila." Leila is a real looker, and the cornerstone of my brilliant marketing scheme. I held up the tiny business suit and glasses. "I mean... Leila the Agent."

Pat still looked confused.

Then I realized I hadn't showed her everything yet, so I grabbed

the giant cardboard book cover, slipping it over my head like a sidewalk sandwich sign. Then I handed her a piece of paper titled: "Leila's script."

Pat read it out loud. "Hi my name is Leila and I'm a hard-working literary agent. I'm here tonight to represent one of the greatest writers of our times."

"Is that cute or what?" I hugged myself again.

"Let me get this straight," my wife said. "You want to exploit an innocent seven-year-old, teaching her how to use bribery to sell door-to-door?"

Man, it sounded almost like a bad thing the way she described it.

That's when the front door opened and Christy walked in, followed by Leila, who was dressed up in a bumblebee outfit and Charlie who was something I didn't quite recognize.

"Trick or treat," Leila said. "I'm a bug."

Christy laughed. Pat grabbed the camera. I panicked.

"But I got you an outfit, Leila. Look." I held up my thrift store props. "Wouldn't you rather be a famous New York agent?"

"Trick or treat," she repeated. "I'm a bug."

Pat put on her coat. "We're going trick or treating," she said, handing me eleven bags of candy. "Be generous. Oh, and if I were you, I wouldn't mention this idea to Jack Canfield."

I watched them leave, hearing one last refrain of "I'm a bug," then I stepped over the box full of autographed copies of *Ernie's World*, ripped open a bag of Skittles, and waited for my next brilliant idea.

# Chapter Twenty-Three
## "OUR" FAMILY THANKSGIVINGS

A few days after my interview with Joan she called me in for a second interview. Did that mean I'd blown the first one and she was going to give me a second chance? What's the sense in blowing an interview if they just give you a do-over? Although, and I hate to admit this, I was thinking that maybe having a job might have some advantages. The only income I'd had recently was from my columns, which was diddly, and a check from my syndicate, which was squat. Besides, I was running out of material to write about and there just might be some interesting characters at this place. Also, the company was located right near Trader Joe's so I could still see my breakfast buddies on one of the many breaks I'm sure they must give their employees.

"Just one break in the morning and one in the afternoon? No way!"

I was talking with the guy I was going to replace. He seemed nice in a shaved-head, facial tattooed kind of way. I asked him why he was leaving.

"I want to do more design work. I hear it pays better."

Well, he had a great sense of humor. I was going to tell him he could have my client if he didn't need work or money for the next decade.

The other person was a cute redhead who was the other production technician. "I was surprised they had me come in at nine," I said. "Did you guys have to come in early just for this interview?"

They looked at each other. "We start at seven."

"A.M! EVERY DAY!"

We talked for a bit more then I left them another resume. They hadn't seemed all that impressed with me. Things were looking up. I headed to grocery store to work on my column. I got an idea from watching a rerun of an episode of Geraldo Rivera the night before.

~

Hold onto your giblets, my friends, because for the first time ever, I am presenting this special Thanksgiving feature live! That's right, it's just like reality television, except that I'm not actually on television and you don't have to watch me eat worms. Instead you get to be with me on location "in the moment" as my fellow front-line journalists Brian Williams, Barbara Walters and Conan O' Brien, are wont to say.

Today, I am at a well-known grocery store rubbing elbows with fellow turkey shoppers.

"Please stop rubbing my elbow."

"Sorry."

The goal today is to get the bird and I am entering the store now, plowing my way through hoards of adoring fans.

"Hey, you jerk, that's my cart."

"Sorry, no autographs. I'm working."

"Yeah, work this."

Wow, there's one bird already.

Working on location requires minimalization, of course, so my supplies today consist simply of a pen and notepad, some hot and spicy beef jerky I grabbed near the check-out stands, and a carton of diet egg nog I snagged from dairy.

I'm now heading through the vegetable section, past the condi-

ments and entering the meat department.

"Can I help you?"

Wow. It's a customer service rep out in the open. Very rare. Practically non-existent in some stores I have been in lately. I'm going to let him in on the mission.

"I'm working on location today, bringing the excitement of Thanksgiving to my readers. Have you had any strange turkey encounters?"

"Not until you showed up."

"Great. Just in time, then. See, I'm a journalist, but I'm incognito."

"That would explain the camouflage. So? Do you want a Butterball or what?"

"No thanks, I bivouacked in my own supplies." (I'm pointing out the beef jerky and egg nog, and I think he's impressed, as he is signaling someone —probably the store photographer.)

Hold on. Here come two fellow shoppers approaching the meat section now.

"I'm thinking, like, one of those pre-cooked turkey rolls for the party, dude."

"Cool. I think we should get a ham log, too."

"How interesting. You two both have purple hair, copious piercings, which I assume are part of some fraternity affiliation, yet you chose completely different foodstuffs. Can you explain that for our audience?"

"What audience? Dude, you're the only one here... Whoa, are you wearing night vision goggles?"

"Standard protocol for field operations. You never know when the power grid may go down."

"Whatever, Dude."

"Come on, let's go someplace less... real."

Interesting development. I'd like to track them and find out where they go next, but I see another customer. It's a single female adult who seems somewhat tentative as she approaches the meat

counter.

"I'm... I'm looking for a free-range turkey."

Ah ha. I think I may have uncovered something here.

"Free-range, huh? Have you heard something about the Butterballs? They have artificial breasts, right? Genetically altered implants of some kind?"

"What?"

"Please, don't hold back any incriminating information. You owe it to my readers to be forthright."

"Here's your turkey, ma'am."

"I've...I've changed my mind."

I knew it. Is this exciting or what? Excuse me while I take a little pick-me-up from the egg nog carton. Oops, get ready again. Here comes a really large adult male. Oddly, he appears to be sweating and frothing at the mouth.

"Stay calm sir I am familiar with the early warning signs of mad cow disease and I may be able to save your life."

"I should have known. It's you again. The weird writer guy from the *Montecito Journal*."

"Shhh. I'm trying to stay undercover."

"Yeah. Right."

Please note: the frothing male is heading toward the intercom.

"We have a loose husband — and I do mean loose — in the meat department. Will his wife kindly come and get him?"

Uh-oh. Here comes a cute — albeit angry-looking — woman.

"Not again. Didn't I ask you to stay in the car?"

"But dear, I was just looking for a turkey."

"We don't need a turkey. We're going north this year, for a normal California Thanksgiving with family."

"Oh yeah."

Hmmm. Normal? California? Thanksgiving?

Do those three words really belong together?

# Chapter Twenty-Four

## THE "FAM"

Okay music lovers, here's an updated version of an Old West family favorite...

"Home, home on the range. Where the deer and the organically grown turkey roam. Where cell phones are heard, ordering free-range birds, and the freeways are crowded all day."

Yes, folks, it's time, once again, for the traditional California Thanksgiving, which involves driving for hours in bumper-to-bumper traffic to be with family and friends who annually come together to share fellowship, good cheer and such tantalizing dishes as feta-crusted veggie shreds and garbanzo and yucca root salad with artichoke sauce.

Can you blame me for breaking out into song?

I remember my first Thanksgiving in California. I had just moved here from New Hampshire, land of the buttered Butterball, where gravy is made from drippings, and I think they put extra lactose in the milk.

I was lucky enough to be invited to a holiday dinner for new arrivals, and as was I sitting there on the terra cotta patio in seventy degree weather, watching the automatic pool cleaner suck up eucalyptus leaves full of sunbathing insects, I bit into my first slice of tofu loaf with sodium-free vegetable stock. That's when I knew that

I was not in Laconia anymore, Dorothy.

Plus, the conversation was different than I had been used to back east. In New Hampshire an entire meal's conversation might consist of something like this:

"How 'bout them Red Sox, huh?"

"Ayup."

But that first Thanksgiving in Santa Barbara I was seated between a guy who was channeling a fifteenth-century Cossack standup comedian named Ivan...

"Take my horse... please..."

...and a colon hydrotherapist, who proceeded to explain in minute detail the mentally stimulating advantages of the high colonic.

"I used to be, like, a foot reflexologist, but I worked my way up."

I was going to ask her if that meant she was now in middle management, but I thought it just might confuse her.

Of course, not everyone in California is new-agey like that. I was lucky to come from and marry into a relatively normal family — not counting my Uncle Duke who runs a clothing optional Volkswagen dealership in Redondo Beach and is waging a one-man campaign to legalize cars made of hemp.

"Dude, it's high time."

Right, Duke.

Now we were on our way to a gathering of the normal relatives in Carmel Valley, a picturesque artist enclave nestled between the world famous Pebble Beach golf course to the north and the spectacular Big Sur coast to the South, a mere four hours in the car through the heavily agricultural Salinas Valley.

"Okay, who wants to play count the broccoli plants and irrigation pipes?"

But family is worth it. In a recent poll I read family was listed as number two of all things that matter in life. Love was first, and "the group photo" had to be a close third.

~

It wasn't the first time someone attempted a "perfect family photo" at Thanksgiving. Heck, we'd all given it a shot — so to speak. The problem was we tend to be a bit... animated... at holiday functions.

"What was Harriet talking about?" I asked, as Bob filled my wine glass.

"State politics, then free-range turkeys." Steve said.

"There's a difference?"

"Apparently. She also said there was gonna be a group photo."

"No way!"

We stepped back as half-a-dozen kids raced across the patio. One of them, Kate, whacked me and said: "You're it, Ernie."

I tagged John then he stuck his hand out and caught his son mid-chest.

"You're it," he said, as Sean gasped for air, but kept going. "Gee it's great playing with the kids."

"Fore!"

A golf ball sailed by, bounced on the wooden deck, and landed in a bowl of as-yet-untouched kumquat-garlic-eggplant dip.

"Nice shot," Furman said.

"Anyone know how to stop a toilet from overflowing?" my wife asked, dumping out her shoe.

"Now that's a photo."

"Do you smell something burning?" Stacey asked.

"My buns!" Jon ran for the kitchen.

"Here you go." Patrick handed me a wet towel.

"What's that for?"

"The stuff on your shirt."

I looked down. "Yum. Bruschetta."

"Dick said everyone should get ready for the photo now," Anne said.

"He's really gonna go through with it?"

"Never gonna happen," Sally said.

"I've got five bucks says he pulls it off," said Matt...

"The cat's yakking up something that looks like sweet potato," Quinn said.

"...You're on," Laura said.

The kids came running. Several of the parents formed a barrier, causing a big pileup.

"Photo time," said Neal.

"It's gonna be baa-aad," said Leslie.

"Okay," yelled Dick from the front yard. "Let's line up."

Fifteen minutes later we finally jockeyed into something resembling a group.

A stuffed mushroom cap hit me in the eye. I turned. Max and Declan were looking way too innocent.

"I'm hungry," said Richard.

"I'm thirsty," said Willie.

"I gotta use the restroom," Terry said.

"Me too," echoed Lauren.

"Photo first!" commanded Dick.

There was a bit of mumbling, some name calling, and a few more mushroom caps found a few more heads, but finally Dick

Photo By Richard Norwood

235

pushed the self-timer and ran for his position.

"This is gonna be great!" he said.

"Ow, you're standing on my foot, tubbo."

"Who you calling tubbo, you nerd."

"Mommmm!"

"Smile!" Dick yelled.

Click.

We dashed to see the digital image in the little window on Dick's camera and stared in silence for a minute. Finally Pat said: "Oh well."

"Better than the last one," Bob added.

"You owe me five bucks," Laura said to Matt.

Furman held up his hand. "Come on, folks. It's Thanksgiving. And this was a valiant attempt, done out of love and respect for the family."

There were some mumbled apologies, then a light applause began, but just before Dick could take a bow, someone yelled: "Pictionary!"

I looked over my shoulder as we elbowed our way toward the house, and through the dust I saw Dick's swaying tripod and thought: We may not be perfect, but we sure got tradition and gamesmanship.

~

I think that first historic Thanksgiving was probably going quite well, until some over zealous Pilgrim suggested playing charades after lunch.

"We'll be shirts, you be skins. The category is favorite European explorers and pillagers," were probably the last words the Pilgrim spoke before being hit in the head with a turkey carcass.

The Pilgrims are long gone now, except of course for Ted Kennedy, who still breaks out his Mayflower Power T-shirt on special occasions in Congress. But the tradition of holiday games has

continued in many families, including ours, although we no longer play charades at our family get-togethers. We found that games that involve standing and flailing of arms can quickly get out of control.

"Illegal hand gesture! Illegal hand gesture!"

"Oh yeah. Well how about this hand gesture? Wait! Put down that turkey carcass... ahhhhhhggggg."

We have a much safer game now. A game where we all remain seated and well away from dangerous foodstuffs. I'm talking about the action-filled drawing game called Pictionary where one family member has to draw something, while the others guess what it is.

Yes, Pictionary is a fun family adventure involving artistic talent and the keen perceptual skills that loving family members develop after years of living in perfect harmony...

"What in the hell is that?" Bob asked Sally, after failing to identify the "Person, Place or Animal" that she had so carefully crafted.

"It's an orangutan for crying out loud. You know one of those creatures that would probably make a better partner than you."

"I can see it now," offered Harriet, this year's hostess and guardian of fragile glassware. "Isn't that the tail right there?"

"No! That's Clint Eastwood. You know... from that movie 'Nothing to Lose.' See. He's got his arm around the orangutan. There's his pick-up truck in the background."

"That's Clint Eastwood? Gee, he kinda looks like *a big blob of nothing*!" Bob ducked as the timer whizzed by his head and struck the wall.

"More wine anyone?" asked Furman. Eight glasses were thrust forward with "healthy determination."

"Whose turn is it?" I asked.

"I think we're up again," said Matt. He looked at the clue, picked up a pencil, touched it to the page, and his partner/wife, Laura, immediately yelled. "The Galapagos Islands!"

"That's it," said Matt. He flipped the timer back over and all three grains of sand returned to the pile.

"No way!"

"Give me a break!"

"Illegal hand gesture! Illegal hand gesture!"

"I can see it now," said Harriet. "Isn't that a turtle?"

"A turtle?" said Pat. She grabbed the paper and held it up. "It's a half-inch line!"

"That's the Equator," said Matt. "Everyone knows the Equator runs right through the Galapagos."

"He's right," said Furman. "The Equator does run right through..." A dozen "even-more-determined" eyes flashed at him. "...I'll just fill everyone's glasses."

Laura picked up the dice and rolled them. "Well, look at that. Twelve again! One... Two... Three..."

The rest of us watched as Laura finally ended up on a red spot three-quarters of the way around the board.

"Oh how fun," she said. "It's an All-Play. The wives will draw and the husbands will guess."

She pulled a card out the box, studied it for a minute then passed it around to all the wives.

We men eyed each other, then began our pre-answering drills, which included neck rolls, knuckle cracking and slugging down the rest of our manly Chardonnay.

Sleeves were rolled up. Pencils were touched to paper. The timer was flipped. And answers flew like wounded turkeys.

"Two moose dancing the cha-cha."

"An asteroid striking the moon."

"Ted Kennedy naked."

"That looks like the orangutan again," said Bob. Sally stabbed his hand with the pencil.

The timer sand continued to flow. Elbows began to fly. Voices were raised.

"Boise Idaho in fall."

"The Pope eating Spam."

"The Magna Carta."

Suddenly, out of nowhere, one of the kids spoke up. "Looks like

a buncha mean people playing a mean game."

"He's right," said Laura. "The answer is war."

There was a moment of sheepishness. Then another kid asked: "Anyone want to play Chutes and Ladders?"

We laughed, toasted each other, smiled our "good tidings and joy" smiles at each other...

Then Bob leapt for the spinner. "Men against the women. We go first."

"No way!" Pat and Sally dove for the floor.

Matt tried to grab Sally's leg. Harriet grabbed a falling vase, I shoved Laura aside and Furman filled our glasses.

Man, I can't wait until we retire so we can visit these normal relatives all the time.

# Chapter Twenty-Five
## FISHING FOR HUMOR

It's not often that I have a flashback. These days, I can barely remember last week, let alone the 60s. But when we got to the "Jellies: Living Art" exhibit at the Monterey Bay Aquarium the day after Thanksgiving, I was instantly tripping.

"Watch where you're going," Pat said.

We were in "the tunnel" surrounded by hundreds of swarming umbrella-shaped jellyfish called Moon Jellies. The room had no lighting, but blacklights in the huge tanks gave the white pulsating Moon Jellies an eerie glow. On each end of the tunnel was a huge mirror, so the exhibit seemed to go on forever.

Almost forever.

I felt my nose to see if it was bleeding, then I looked around in awe. "Whoa, man, they look like brains," I said.

"Totally," a short bald guy wearing plaid shorts and Birkenstock sandals agreed.

"They could be extraterrestrial, man," another guy with a gray beard and ponytail said. "Absorbing our thought patterns to send back to their home planet in another galaxy."

"Far out," I said.

I hadn't had a conversation like this since, well, the last time I was this close to San Francisco. I felt my mind expanding.

"What if our whole world is just one little molecule living under the fingernail of some superior creature?" I cleverly theorized.

"That's heavy," said a woman who smelled vaguely of jasmine incense.

Pat looked at me. "Do you know these people?" she asked.

"Ah, sort of."

We watched for a few minutes as the Moon Jellies swam to the top of the tank and parachuted back down — again and again and again.

"Did you know that Jellies are the deadliest creatures in the sea?" another guy wearing a Jerry Garcia necktie asked.

"Radical," we all said in unison.

After a minute the Birkenstocks guy asked, "Have you guys seen the Chihuly exhibit and the lava lamps?"

Dale Chihuly created an underwater world of blown glass that was incredible. Plus, there were eighteen blue lava lamps erupting in the next room. Color, color everywhere. It made me wonder what ever happened to my lava lamp and my beanbag chair and all my blacklight posters.

"I watched the lavas for about an hour," Gray Beard said. "Then my wife came and got me."

I looked around for my wife, but she was gone. She probably told me where she was going next, but I couldn't remember. The Moon Jellies must have emptied my mind already. Bummer.

I wandered out of the tunnel, just as a couple of teenagers with nose rings and low-slung jeans entered.

"Dude, they look like brains or something," one of them said.

"Dude," the other agreed.

It made me feel good that another generation was around to keep the groove going.

I found my wife sitting on the floor in front of the Outer Bay exhibit, looking through the largest window in the world, along with a couple hundred other people. Dozens of huge yellowfin tuna, barracuda, sharks and sea turtles swam right in front of us.

"This tank," a docent was explaining to the group, "holds more than a million gallons of water."

"Does the floor feel wet to you?" I asked Pat.

"Is it going to leak, Mommy?" a kid beside me anxiously asked his mother.

"The glass is thirteen inches thick," she told him, then frowned at me.

I felt bad for scaring the kid, so I told him, "Don't worry. Chances are good that one of those Hammerhead sharks would eat you long before you drowned."

The mother grabbed her kid and moved away.

Someone above the tank dropped sixteen hundred pounds of squid and smelt into the tank and we watched a feeding frenzy.

"The yellowfin tuna have been clocked traveling up to fifty miles per hour," the docent said. "And can weigh up to fourteen hundred pounds."

"Man, that's a lot of casserole," I said.

"I've got the munchies," Garcia Tie, who was now sitting behind me, said.

"Me, too," the others from the tunnel said. "Let's hit the cafeteria."

I looked at my wife.

"Go," she said. "But before you decide to leave the aquarium and hitchhike to a rock concert with your friends, remember that we have to head back to Santa Barbara. One of us has a job."

"Right on, dear. Right on."

# Chapter Twenty-Six
## A REAL "WORKING" WRITER

Actually, as it turned out… both of us now had a job. That's
right. Believe it or not, they hired me. Must have been a really sad
applicant pool that's all I can think. My wife was all excited, of
course, especially when I brought home that first paycheck, which
they gave me exactly on the day they said they would. That was
going to take some getting used to. The other was when I took it to
the bank I was pretty sure it wasn't going to bounce. Can't say as the
bank manager was all that happy.

"You got a job? With regular checks? But we count on you to
be overdrawn on a regular basis. Who's going to pay all those fines?
Oh, man, I hope the stockholders don't hear about this."

Pat was a little nervous, too, when I described the first day to
her.

"I got there at seven and they had a meeting at eight. Turns out
we have a meeting every Monday morning."

"Oh my god, you didn't describe anything as a naked fat lady
with a small yapping dog, did you?"

"No, I pretty much just checked everyone out. Turns out the
guy whose job I'm taking is named Sean but he spells it Xon. Joan
directs the meetings and starts off by having someone read a page
from a Zen book. There were two guys named Donald, one of whom

has his own tattoo machine and gives himself tattoos on a regular basis. There was a guy with a long gray beard and long gray hair that had a weird twitch and an androgynous-looking person in a cap that everyone called Michele, so I guess she's a she."

That made Pat feel better. "Sounds like you're going to fit right in."

Matter of fact, Pat was so happy she decided we should take a family ski trip for Christmas, so I took a few days off. That's another advantage to having a real job — you can take time off. I'd forgotten about that. They have sick days too and paid holidays. Amazing. I wonder if other writers know about this?

Pat did have one request for the ski trip, though.

"Don't be a basket case again, huh?"

See, a few years ago I came down the mountain in a ski patrol basket — in skiers' terms, a basket case.

It wasn't really my fault. I had to make one of those life-altering choices — run over the four-year-old, who had just skied right in front of me, ski off the side of the mountain into the ravine of no return, or bail out and slide down the mountain head-first on my back, with my skis hovering over my head dropping snow onto my face.

It's moments like that when you discover things you never knew — like how bumpy a ski slope actually is.

"Hey buddy, you okay?"

"IIIIIII ttthhhiiinnnkkk soooooooooooooo."

"Whatever you do, don't let your skis down."

"WWWhhhhyyyyyy?"

That's when I let my skis down and found out. Safety bindings don't release in that position, but calf muscles do. It did make me a temporary celebrity, though, because a lot of skiers skied up to see if I had any bones sticking out or a piece of broken ski in my ear or anything. But they quickly dispersed.

"Just a muscle tear."

"Bummer. I heard a guy on the Double Trouble run is stuck in a complete split. They may have to take him home in the back of a

pickup truck."

"Cool. Let's go."

Actually, I've had several less-than-stellar moments skiing over the years. Once, at Heavenly Valley in Tahoe, I crossed my skis getting out of the chair lift and became a human bowling bowl — scored high enough to earn applause from people on several other lifts.

Another time, at Mammoth Mountain, I ran into the ski fence that protects the people standing in line for the lift right in front of the lodge. That's when I first discovered I had a knack for making people laugh.

Then there was the time I accidentally skied onto a mogul run nicknamed The Mine Field. They tell me I set a record for most tumbles in a ten-minute period.

I think this year will be different, though. For one thing, I learned a few years ago to ask for really short skis that are much easier to control.

"Ow. Hey watch where you're swinging those things, huh?"

"Sorry!"

Plus, this year we are going to Badger Pass at Yosemite, which is not a really tough mountain.

"What difference does that make? You crashed on Easy Street."

"Thanks, dear, for bringing that up."

"Maybe you should just drive down into Yosemite Valley to the ice skating rink... Hmm, ah, never mind."

"Hey, that wasn't my fault. Those two lovebirds were holding hands and not even moving."

"That's because they were in line for the restrooms."

Anyway, you can see my dilemma. I am the skiing patriarch of the family. Therefore, the kids and grandkids all look up to me as a role model.

"You mean roll model, don't you?"

"That's funny, but it just cost you a four-carat diamond brooch I was going to buy you for Christmas."

"Look, all I'm saying is just consider hanging around the lodge this year. Take photos of the kids. Watch weird people walk by. Get some story ideas. Work on the humor book. Things that even you can't get hurt doing."

I thought about what she said. It does take longer to heal these days. And it would be fun to watch the grandkids ski for the first time.

That's when it hit me.

"I wonder if they rent snowmobiles anywhere in Yosemite? I've always wanted to try that. Maybe they have an obstacle course with jumps and stuff."

Pat grabbed the phone.

"Who are you calling?"

"The insurance company. I think I'll bump up your life insurance."

Turns out, she didn't even have to worry about it.

~

It was raining in the mountains. One of those relentless winter storms that force even the heartiest of road weary souls to seek shelter, tonight bringing together a motley band of eleven stragglers…

"Did he just call us motley?"

"I don't know, but someone's gotta change that music. Is that like Travis Tritt? Pass me the iPod willya?"

Without even the thought of sleep, before grog and grub, bath or shave…

"Oh man, you didn't bathe. We were hiking for hours."

"I wondered what that was. I figured it was the garbage disposal."

…the traveler's best friend makes its appearance. Many a lonely night has passed with nothing more than a deck of cards, and tonight was no exception.

"Why's Ernie talking like that anyway?"

"I don't know, man, I think he took a cold capsule or something."

I stared hard into her steely blue eyes, searching for that ever elusive tell — an eye cast suddenly downward, a quick blink, a nervous tic — but she was unyielding, hard as the granite that was the namesake of her home state of New Hampshire. Double Ought Ashley they called her because of her zero-zero waist size, but tonight she was sitting tall in her low-slung jeans.

"Double Ought? Hey Ashley, any of your friends actually call you that?"

"Ah nooooooo."

I looked around the table. We were cabined high above Yosemite Valley in a place they call the Falcon's Nest, and the game was no-limit Texas Hold'Em.

"Cabined? Is that a word?"

"I don't know, Dude, but nobody, and I mean nobody, give him anything to drink on top of those cold capsules."

They were all there of course: Patrick The Chef, Surfer Dude Carl, Stoic Stacey, Hollywood Jon, Christy Big C Parker, Momma Pat and Fenway Shane. But they had quit. Folded. Gotten out early. Now, it was just me — Dirty Ernie — and Double Ought. Sole survivors.

"Is this like the slowest game of poker ever or what?"

"Dude — I mean Dirty Ernie — it's still your turn."

I pushed a stack of white chips forward and said to Double Ought: "If you're playin', I'm stayin'."

A murmur went around the table — along with a bottle of rotgut whiskey and a plate of buffalo stew.

"Did he just call my Pinot Noir, rotgut? I paid twenty-five bucks for that bottle."

Double Ought checked her cards again, scanned the table, then grabbed some chips and tossed them into the huge pot, matching my bet.

"Whataya got?" she asked.

"Obviously, a whole lot of time."

"No kidding, Dude, Jeez."

I hesitated, a bead of sweat rolled off my forehead and down across the bridge of my nose. I flipped my hold cards:

"Two pair," I said. "Kings over Jacks. Read 'em and weep."

"This hand goes on much longer and I'll weep."

A look came over Double Ought's face. It was the look of the new gunslinger in town that's just learned she is now facing the fearless Dirty Ernie. The King.

"Dirty Ernie is right, Dude, but a shower could fix that right up."

I laughed a maniacal laugh as I reached for the pot. But Double Ought reached out, put her tiny, yet firm hand on mine and stopped me. I looked at her hand, then back into her face. She smiled through the glint of her golden-tipped teeth.

"Golden-tipped teeth? Is he talking about her braces?"

"Sorry, Grandpa," Double Ought said. Then slowly, methodically, she turned her hold cards over and said: "Three threes."

Sound muted. I dropped my head to the table. Off in the distance I could hear angry coyotes howling.

"Oh man, you got your hair in the cheese dip."

"You're crushing my taco chips."

"Dude, it's like twenty cents. Deal with it."

I stood slowly. A loner. A stranger among strangers.

"You got the strange part right."

"Whataya say we deal him out before he makes it another two-hour hand?"

"Agreed."

"Seconded."

"Ditto."

"Amen."

I didn't know what to do next, where to turn, when a soft voice behind me said: "Wanna play fish now?"

I looked at the young whippersnappers holding the wild animals

card deck. Leaping Leila and Charging Charlie. I'd heard of them, of course. Players for sure.

I reached for the cards. It was going to be a long night.

# Chapter Twenty-Seven
## WHAT COMES AROUND GOES AROUND

Well, we're back on our way to Sycamore Mineral Springs Resort in Avila Beach. My wife is stressed out again over another seemingly innocent incident that happened just after the first of the year.

See, she asked me to vacuum.

I told her I couldn't because I had to write my column.

She said okay.

Then I went to my office and turned on the football game. (No. Not on my new plasma from Costco. That didn't quite work out.)

A few minutes later, Pat came out to my office to ask me what all the shouting was about.

I pointed at the screen and told her the New England Patriots had just scored.

There was a moment of silence.

Somewhere in the far reaches of my guy mind, I heard a voice. It said: "Slap yourself in the forehead." So I did.

This released some guy cleverness, which came out as: "I forgot to tell you. See, I'm not really watching football, I'm doing research. I'm going to write about the many challenges of humor writing and how similar that is to the many challenges of football."

There was another moment of silence.

The voice told me to slap myself again. So I did.

More guy cleverness came to forefront. "Actually, I don't even like football. I wish I had something else to write about. But a humor columnist's gotta do what a humor columnist's gotta do."

I sighed heavily under the weight of my burden.

Pat smiled. Then she said: "Well, instead of football — which I fully understand you not liking — you could write about the many challenges of sleeping on a couch in the living room for, say, a week or so. Or, you could write about the many challenges of making your own dinner until further notice. That could be funny."

Without even being told to I slapped myself in the forehead again, but no guy cleverness came out this time.

My wife shut off the TV. "Or," she said, "you could write about the many challenges of vacuuming. I'll bet a lot of people would like to read about that. I certainly know I would."

Suddenly, that sounded logical. I mean, vacuuming is challenging. It requires a game plan. Like, what's the most efficient way to perform vacuuming duties so that it takes the least amount of effort and gets me back to the game the quickest?

I grabbed the vacuum. Then I sized up the opposing living room, looking for its vulnerability and figured I'd start with a run up the middle. Done properly, I might even be able to win with just a couple strategic runs over the main traffic areas.

I hit the power button.

That's when Sam, my cat, leapt up from behind the coffee table. He looked around, but he had no room to maneuver. He was going to have to come straight on if he wanted to advance out of there.

Now, I had a challenge.

I bent over and revved the vacuum. No way was he coming through me. I'd show him the kind of defense that the New England Patriots had been displaying.

Bring it on, you pussy.

Sam backed up a few steps. I moved in closer. He looked over his left shoulder. I started left. Then, he quickly reversed himself and

headed right. Great move — but not good enough.

Sam stopped. He looked me right in the eye. He had guts. I'll give him that. I moved in. Sam leaped over the vacuum. He was going to try an end-around.

I quickly shifted positions. Sam meowed really loudly, then leapt the other way. Again, I saw it coming. He paced back and forth, tauntingly meowing at me. He was trying to sucker me into an open-field assault, but I knew he had cat-like moves, so I hung back.

Sam meowed. I revved. He meowed. I revved.

Then I heard a voice. Only this one was not coming from inside my head. It was coming from right behind me. I turned. It was my wife.

"What in the hell are you doing?" she asked.

I hesitated. "Vacuuming?"

She grabbed the vacuum and shut it off. Sam ran right over my foot and raced down the hallway in victory. Rats.

"Go back to your office and don't come out until I find the cat and let the poor thing out."

"But I was just getting to the really challenging part."

She didn't speak, just pointed at my office door. So, I went in and turned the Patriots back on. I'd only used up five minutes on the game clock. Not bad. Except I had the feeling at the time that — once again — I may not have handled the situation all that well.

~

Turns out I was right, which was why we were just about to turn into the parking lot at Sycamore Mineral Springs.

"I trust there won't be any accordion players taking up the entire Gardens of Avila Restaurant this year, right?" my wife said.

"Ah, right." Moroccan vegetable tagine and roast duck with foie gras stuffing here we come.

"You will be happy to know that I've set some stringent goals for the upcoming year. I wrote them down again. Here."

I handed her the list.

"Number one," she said, "no more vacuuming of the cat or messing up birthdays and/or anniversaries."

"Told you they were stringent."

She scanned the rest of the list, which did indeed have some similarities to years past. I mean, when you've got great goals that you haven't quite used yet, why throw them away?

Pat came to the newest addition to the list. "Professor Ernie? What's that about?"

"Glad you asked. You know how I've been giving all these humor workshops? Well, I figured once I got a few more under my belt, and now that I'm used to working…"

"You've had a job for two months."

"…Right, that's what I'm saying, I'm used to working now, so maybe after I master this job, I'll finish my novel and write that award-winning humor book you're always talking about and my next job could be one of those hundred and fifty thousand a year positions at the university. Doctor Ernie, Professor of Humor. Whatya think? Catchy huh? I'm gonna insist on a corner office, of course, and summers off with pay. "

Pat shook her head. "You never cease to amaze me."

I basked in that moment of glory then I saw a group of women in robes carrying yoga mats heading across the parking lot. Wonder who makes Yoga mats? What if a guy named Matt made them. He could call them Matt's mats. Wonder if you can get them designed with say your book cover or website on them? And if you fall asleep during an extended Yoga stretch does anyone even notice?

I might just have to check that out after lunch. Stay tuned.

# About the Author

## WHAT ELSE COULD YOU POSSIBLY WANT TO KNOW?

Ernie Witham lives in Santa Barbara, California, with his wife and star of most of his humor stories. As you know from reading this book, he has a slew of children and grandchildren, some interesting relatives and friends — especially his writer friends — and he is willing to do almost anything to find a story. He also loves to talk about writing, so feel free to  email him at ernie@erniesworld.com. You can also read his latest adventures on his website: www.erniesworld.com and listen to his podcast available on iTunes. His latest writing venture is a humorous iPhone application called "Office Water Cooler" also available on iTunes.